Turner

IN THE BRITISH MUSEUM

Drawings and Watercolours

Turner

IN THE BRITISH MUSEUM
Drawings and Watercolours

Catalogue of an Exhibition at the Department of
Prints and Drawings of the British Museum, 1975
by
Andrew Wilton
Assistant Keeper in the Department

Published for
The Trustees of The British Museum
by
British Museum Publications Limited

Cover:
Zurich
Watercolour *c.*1842 (catalogue No.286)

©1975, The Trustees of the British Museum
ISBN 0 7141 0746 8 cased
ISBN 0 7141 0745 X paper
Published by British Museum Publications Ltd,
6 Bedford Square, London WC1B 3RA

Designed by Harry Green
Set in 11 on 12pt Monotype Bembo and
Printed in Great Britain by
Balding & Mansell Ltd, London and Wisbech

Contents

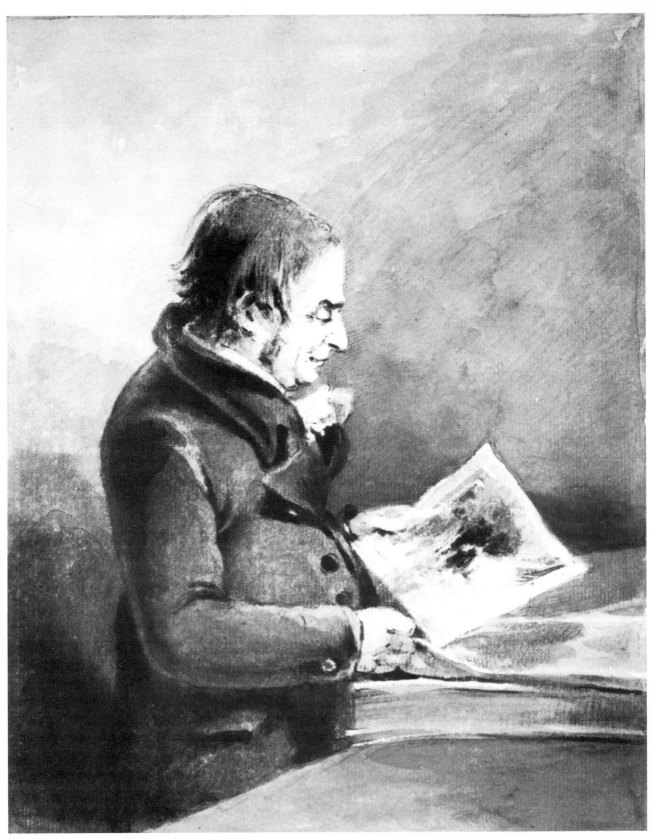

Turner in the British Museum Print Room
J T Smith 1766–1833, Keeper of the Print Room 1816–33

Foreword

Although the British Museum lent a large number of Turner's watercolours, drawings and sketchbooks to the Bicentenary Exhibition at the Royal Academy no excuse is necessary for the presentation of this supplementary selection of some 300 watercolours. The range and variety of Turner's achievement in the medium of watercolour can hardly be accorded full justice by one exhibition; and the holdings of the British Museum are so extensive that it seems fitting to take the opportunity provided by the bicentenary to display as much of them as possible.

Most of the material in the care of the Museum is part of the bequest of his works that the artist made to the nation, confirmed by a decree of the Court of Chancery in 1856. By the terms of the decree, all the paintings, drawings and sketches from Turner's own hand which were in his possession when he died were given 'for the benefit of the Public' to be 'retained by the Trustees for the Time being of the National Gallery'. Apart from the paintings, 19,049 drawings and watercolours were counted; this number included the individual leaves of some 260 sketchbooks, many of which were dismembered. By 1858 Ruskin, who was in charge of the Bequest, had put into operation a number of proposals for storing and displaying selected drawings; but his plans for a 'Turner Print Room' modelled on that of the British Museum were never realized.

Ruskin sorted all the material into categories which denoted its relative importance, designating several bundles as 'Bad', 'Rubbish' or 'Valueless'. The report of William Michael Rossetti that Ruskin had burned some which 'it seemed undesirable to preserve' has now been substantiated; if any drawings were destroyed it is certain that the Bequest still contains many which were considered by him to be of interest 'as evidence of the failure of mind only'. Those drawings which Ruskin labelled 'Fine', 'Interesting', or 'Good for distribution' were exhibited in a long series of carefully planned exhibitions at South Kensington, Oxford and the National Gallery. In spite of Ruskin's awareness of the dangers to which drawings and watercolours are vulnerable when exposed to light, many of the sheets which figured in these exhibitions suffered severely, and are now beyond restoration. Nevertheless, the large majority of the drawings in the Bequest are still in excellent condition and have indeed hardly ever been seen by the public.

The foundation of the Tate Gallery in 1897 was followed by the removal there of the whole of the National Gallery's British Collection. This included the Turner Bequest which continued to be shown in the circulating exhibitions arranged by Ruskin. In 1908 a new wing specifically to house the Turner collection was added to the gallery by Sir Joseph Duveen. The unexhibited part of the Bequest was, however, stored in the basement which was inundated during the Thames flood of 1928. Many of the drawings were damaged, and it was this event which led to the transfer of the drawings and sketchbooks to the Print Room of the British Museum. The restoration of the drawings and sketchbooks continued over a period of years, and many of the sketchbooks were rebound in their original covers according to the grouping published in the National Gallery's official Inventory of the Bequest, issued in two volumes in 1909. The Inventory was compiled by A.J. Finberg, who has contributed more to Turner scholarship than any other single person, except perhaps Ruskin. Finberg's numbering is invariably used in referring to drawings and sketchbooks in the Bequest, but the titles he allotted to many of the drawings have been altered in consequence of later research; similarly, much of his dating has been modified over the past sixty years. The sketchbooks are named after Turner's own labels whenever these have survived; elsewhere, Finberg's names are retained in almost all cases. It was felt appropriate, however, when cataloguing the sketchbooks for the Royal

Academy's Bicentenary Exhibition, to rechristen two of them, the *Scotland and Venice* sketchbook, which was renamed *Scotch Antiquities and London* (CLXX; R.A.no.203), and the *Dresden* sketchbook, renamed *Dresden and Berlin* (CCCVII; R.A.no.576).

Finberg's Inventory incorporated twenty-three drawings not in the Turner Bequest but left to the Collection in 1902 by Henry Vaughan. Nearly all these drawings were connected with the *Liber Studiorum* (see for example No.44); all of them were 'Student Material' rather than finished watercolours. Vaughan's collection of Turner watercolours was one of the most impressive ever to have been assembled; it was divided up by the terms of his Will between the National Galleries of Scotland and Ireland, with the condition that they were never to be lent. Finished watercolours like these, intended by Turner to be sold to patrons, are rare in the artist's own bequest, although certain categories are represented (see below, p.20). The bequests of John Henderson, George Salting and R.W. Lloyd, however, have accomplished the remarkable feat of providing a balanced and comprehensive representation of 'public' works that complements the vast store of Turner's 'private' output in his own bequest. John Henderson senior was an amateur artist for whom Turner made drawings in his youth rather as he did for Dr Thomas Monro; he collected a number of fine examples of Turner's work in the 1790s, such as *Christ Church Oxford* (No.6). His son bequeathed them to the Museum in 1878. The collection of George Salting came in 1910, and included drawings of several types, but was especially rich in finished watercolours of Turner's early maturity, including several of the north of England views for Whitaker's *Richmondshire* and other publications (see for example *Weathercote Cave*, No.55), and two superb specimens of the Fuller views in Sussex (Nos.45 and 46). There are also three of the *England and Wales* series (R.A.1974, nos.419, 421, 422).

On the whole the Salting Turners are in good condition, but like nearly all watercolours which have been hung in daylight for long periods most of them show signs of fading. This is not true of the collection of R.W. Lloyd, bequeathed to the Museum in 1958. This again includes several early drawings, but the larger part consists of finished watercolours chosen by Lloyd for their exceptionally fine state of preservation. The provenances of these drawings include the names of almost all the distinguished collectors of Turner up to the period of the First World War, notably Ruskin himself, Fawkes, Munro of Novar, Dillon, Quilter, Tatham, and more recently Sir Joseph Beecham. The immaculate condition of the collection testifies to the care with which the drawings were treated by their many owners.

Like many other Turner collectors, Lloyd acquired all his drawings through the agency of Messrs Agnews, who have a long and traditional association with the artist's works. The compiler of this catalogue owes a particular debt of gratitude to Evelyn Joll of Agnews, who has unfailingly provided most valuable help in various ways, especially in establishing provenances. Acknowledgements for advice and assistance of all kinds are also due to Martin Butlin, Malcolm Cormack, John Gage, Joseph Goldyne, Ann Forsdyke, Stephen Somerville and many others who have drawn attention to works by Turner or literature relating to him, and made available photographs and other information.

The catalogue is arranged chronologically as far as possible; measurements of drawings are in millimetres, height preceding width. Exhibitions have usually been recorded only when they occurred within Turner's lifetime. References to publications give abbreviated titles or dates only, following the author's name; full details are given in the Bibliography on p.162. Engravings are identified by reference to W.G. Rawlinson's two-volume catalogue of Turner's engraved works; plates from the *Liber Studiorum* are referred to as 'Finberg No.0'; Finberg's numbering is identical with that of Rawlinson's catalogue of 1878.

A Note on Turner's Technique

Turner's use of watercolour is the most inventive and varied ever devised for the medium. The examples in this exhibition show every aspect of it, and present such a confusing number of different styles that it would be possible to imagine that several artists had been involved, rather than only one. The speed of Turner's development, both technically and creatively, led to a broadening of the scope of the medium with practically every new project that he undertook. Still more important, his sensitivity to the localities that he visited drove him to invent new means of expression to answer new moods and purposes. This is particularly noticeable in the drawings made during his first visit to Italy in 1819, when he seems to recreate the medium of watercolour almost from first principles in order to comprehend the climate and atmosphere of the Mediterranean. An equally radical change of response is to be observed in the 'French Rivers' drawings of the later 1820s, or again in the Venetian views of 1840, which differ completely in feeling from those made in Geneva and Lucerne in the following year.

These modifications of style are, however, in a sense incidental to Turner's methods of work. In spite of the bewildering variety, there is an underlying uniformity of procedure which is what we should expect of a highly professional artist for whom style was always subservient to the compelling demands of the creative imagination. The most striking and important differences of technique are distinguishable not so much chronologically as by reference to Turner's purpose in each work. The perennial difficulties faced by scholars in dating the colour-beginnings indicate that Turner did not change his style year by year, but purpose by purpose. Within the broad sweep of stylistic development from 1800 to 1845, the finished watercolours throughout that period are built up according to an elaborate process that had been established in its essentials before the turn of the century. A description of Turner at work in 1804 shows that he had already at that date discovered many of the devices by which he was to create his drawings throughout his career. It can be applied to the watercolours he had been producing since about 1798.

'The lights are made out by drawing a pencil [brush] with water in it over the parts intended to be light (a general ground of dark colour having been laid where required) and raising the colour so damped by the pencil by means of *blotting paper*; after which with crumbs of bread the parts are cleared. Such colour as may afterwards be necessary may be passed over the different parts. A white chalk pencil (Gibraltar rock pencil) to sketch the forms that are to be light. A rich draggy appearance may be obtained by passing a camel Hair pencil *nearly dry* over them, which only *flirts* the damp on the part so touched and by blotting paper the lights are shown partially.'

Farington recorded this 'recipe' in detail in his diary (28 March 1804), and in doing so indicated the interest that Turner's methods had for artists at the time. Some of the effects he mentions are observable in works dating from as early as 1796 (see for example *Westminster Abbey*, No.9); and even before that year Turner had formed the habit of working the paint with his fingers: thumb-prints are to be found on several early drawings. They are nearly always present somewhere in his finished watercolours, though there is no reason to suppose that Turner intended them for a form of signature; they simply demonstrate his complete freedom from technical restriction when making watercolours. Ruskin alludes to 'an evident intentional graining given to a large block of stone in the right foreground [of *Tivoli – a Composition*, R.A.1974, no.181] by the pressure of a thumb in half-wet colour' (See Thornbury Vol. I, p.130). The well-known description of the painting

of Walter Fawkes's *First-Rate taking in Stores* (R.A.1974, no.194) gives a vivid picture of Turner's dynamic attitude to materials:

' . . . he began by pouring wet paint on to the paper till it was saturated, he tore, he scratched, he scrabbled at it in a kind of frenzy and the whole thing was chaos – but gradually and as if by magic the lovely ship, with all its exquisite minutia, came into being and by luncheon time the drawing was taken down in triumph.'

Those observations were made in 1817, and about a drawing finished in a morning; they give an impression of methods similar to those that Turner is recorded as using on some of his most carefully-wrought productions in the 1820s and 30s. William Leighton Leitch told his pupil, James Orrock, 'that he once saw Turner working, and this was on water-colour drawings, several of which were in progress at the same time! Mr Leitch said he stretched the paper on boards and, after plunging them into water, he dropped the colours onto the paper whilst it was wet, making *marblings* and gradations throughout the work. His completing process was marvellously rapid, for he indicated his masses and incidents, took out half-lights, scraped out high-lights and dragged, hatched and stippled until the design was finished.' (B. Webber, *James Orrock, R.I.*1903, Vol. I pp.60–61; quoted by Gage, *Colour in Turner*, p.32.)

The complexity of this process was largely a result of the extensive technical language that Turner discovered by working in oil. The date of his first oil painting, 1796, is also the date of his first important technical experiments in watercolour, that is, experiments away from the standard watercolour practice of his contemporaries. The most important change was perhaps the realization that watercolour could be used on a dark-toned ground and built up, like oil colour, from dark to light, with pure white bodycolour (chinese or lead white) applied last for the highlights. This was the opposite of the traditional water-colour process, which relied on the transparency of the pigment to allow the white paper to glow through it, providing both local highlights and overall luminosity. That process was itself subjected to important modifications during the years in which Turner was acquiring his skills. The work of John Robert Cozens (1752–1797) was perhaps the most influential on him at this time, and Turner was brought into direct contact with it by Dr Thomas Monro, a surgeon and amateur draughtsman who established an informal 'Academy' for young artists at his house in the Adelphi. There, between about 1793 and 1795, both Turner and his exact contemporary Thomas Girtin were set to copy water-colours by Cozens and several other modern masters; Farington recorded that 'Girtin drew in outlines and Turner washed in the effects. They were chiefly employed in copying the outlines or unfinished drawings of Cozens, &c &c of which copies they made finished drawings. Dr Monro allowed Turner 3s 6d each night.' (*Diary*, 11 November 1798.)

Cozens himself inherited one important technical characteristic from his father, Alex-ander (*c.*1717–1786), whose works were described by one critic as having 'a peculiar ex-cellence in which they resemble painting, for the effect is not, as is usually the case, produced from outline filled up; but is worked into light, shade and keeping by a more artful process, the masses being determined in the first working out or designation of the parts, and afford a harmonious effect unlike the ordinary compositions of scratches and lines just connected by a flimsy wash.'

This technical 'breakthrough' was accompanied, in the drawings of both the Cozens, and especially in those of the son, by a more sensitive response to the mood of landscape than had previously been present in the work of watercolourists. Turner imbibed at the Adelphi both J.R. Cozens's use of colour to convey mass and atmosphere, and his tech-nical methods, which consisted firstly of a subtle, nervous pencil outline and secondly of a building up of washes with small strokes of the brush to create volume, depth and space.

Each of these features was adopted by Turner as a basis for his own watercolour procedure, and his mature style, both in drawing and in the application of colour, developed directly out of them.

In absorbing Cozens's manner, he also took in the styles of a number of other topographers whose work he met with at Monro's and elsewhere; Edward Dayes and Thomas Hearne being the chief among them. Nos.6 and 11 in this exhibition show Turner imitating the manner of Hearne and Dayes respectively, with astonishing ease and conviction. The importance of Cozens becomes fully apparent only gradually, as Turner involves himself more and more with the mountainous 'Sublime'. The 'Scottish Pencils' of 1801 (No.27) and the Swiss studies of 1802 (Nos.31, 32) represent the accumulated benefit of Cozens's lessons as finally applied, fully absorbed, to subjects which Cozens himself had specialized in.

By this date, however, oil painting had become as important for Turner as watercolour; in fact, the years 1800 to 1805 were years of particular concentration on the task of establishing his academic reputation, and the watercolours that he executed at this time were in most respects as like oil paintings as he could make them. It was in these works that his complex technique began to be noticed, as in the quotation from Farington given above; and it is at about this period that the making of colour-beginnings becomes a regular feature of his working method. Large trial sheets like the two views of *Dolbadern Castle* (Nos.20 and 21) are common from the late 1790s onwards; and it is clear from the accounts that have already been cited that Turner might have worked on them further to produce finished drawings if he had so wished. We cannot easily decide whether any particular drawing was 'intended' to be left unfinished (see the remarks on colour-beginnings related to the *England and Wales* series on p.22). A broad blocking-in of colour may be the foundation for an envisaged design, as it might have been for an oil painting, or it may only be an experiment in which Turner concentrated deliberately on one single problem.

On the whole the colour-beginnings and other sketches made for his private reference do not make use of such elaborate processes as the finished watercolours, being for the most part simply washed in with a brush; but even when he was working at greatest speed Turner readily employed any medium that suited him in the achievement of an effect; and although his handling altered from drawing to drawing, the materials he employed remained in constant use. The device of using a pen dipped in ink or colour to provide detail in the form of outline is common among the late sketches of Switzerland and Germany (e.g. Nos.270 and 293); but it also appears in many of the 'French Rivers' drawings of about 1830; not only in those worked up for engravings but in some that do not seem to have been made with any immediate purpose in mind (see Nos.160 and 161); and it can be traced back to the use of pen outlines in the *Liber Studiorum* drawings of 1806 onwards. Another feature of the late studies is the introduction of flickering touches of coloured chalk (as in *Recess Bridge and Mount Pilatus*, No.278); but this again can be found in earlier drawings; there is white chalk drawing in *Duddon Sands*, for instance (No.161), and an interesting combination of watercolour and chalk appears in the colour-beginning of *Cockermouth Castle*, which may date from about 1810 (No.41).

While the finished drawings are more complex technically, they do not often make use of very varied media. Most of them are executed simply in watercolour, although of course many include bodycolour as well. It was in his inventive handling of the one medium that Turner achieved his greatest technical originality. Ruskin, describing the *Battle of Fort Rock* (No.43), lists some of the ways in which the colour is applied or removed:

'There are lights bluntly wiped out of the local colour of the sky, and sharply and decisively on the foreground trees; others scraped out with a blunt instrument while the

colour was wet, as in the moss on the wall, and part of the fir-trees on the right-hand bank; lights scratched out, as in one of the waterfalls; others cut sharp and clear with a knife from the wet paper, as in the housings of the mules on the mountain road; and then for texture and air there has been much general surface-washing.' (Quoted by Thornbury, Vol. I p.130.)

In addition to such analyses as this, we must remember the stories of Turner's 'eagle claw of a thumb-nail', specially grown (a true mark of his professionalism) for the purpose of scratching out lights, and of his free use of saliva in the manipulation of colour; see the anecdote concerning *Prudhoe Castle*, No.106. He is said to have advised a pupil to put her drawing when it was finished 'into a jug of water' to obtain softness and atmosphere, and it is evident from his own work that he followed some such advice as this himself: he had handles screwed to the backs of his drawing-boards so that they could be immersed in baths of water at different stages of execution (see Gage, *Colour in Turner*, note 70 p.230). Ruskin describes in some detail the methods Turner used to create the broad atmospheric schemes of his watercolours, and goes on to point out that 'When these primary modifications of the wet colour had been obtained, the drawing was proceeded with exactly in the manner of William Hunt, of the old Water-Colour Society (if worked in transparent hues), or of John Lewis (if in opaque); that is to say, with clear, firm, and unalterable touches one over another, or one into the interstices of another; NEVER disturbing them by a general wash; using friction only where roughness of surface was locally required to produce effects of granulated stone, mossy ground, and such like; and rarely even taking out minute lights; but leaving them from the first, and working round and up to them, and very frequently drawing thin, dark outlines merely by putting a little more water into the wet touches, so as to drive the colour to the edge as it dried; the only difference between his manipulation and William Hunt's being in his inconceivably varied and dexterous use of expedients of this kind, – such, for instance, as drawing the broken edge of a cloud merely by a modulated dash of the brush, defining the perfect forms with a quiver of his hand; rounding them by laying a little more colour into one part of the dash before it dried, and laying the warm touches of the light, *after* it had dried, outside the edges.' (Introduction to the Marlborough House Exhibition Catalogue, 1857, pp.95–6.)

The purpose of so highly developed and sophisticated a technique was to create the most articulate possible language for the expression of Turner's perception of the world; and in the finished works it can be summed up as being the means by which he could be both infinitesimally precise and, at the same time, exhilaratingly free and bold. The clue to this principle was one that he must have spotted in J.R. Cozens's poetic vistas, where, in a simpler form, the same combination of fine brush-strokes with broad washes is to be found. But Turner's watercolours defy an exact analysis into areas of wash and areas of precise touches. The whole surface is an involved mixture of the two contrasting methods. Turner takes them both to much greater extremes than Cozens, being far looser on the one hand and far tighter on the other. His vignette illustrations (Nos.179 to 188) show how fine his work could become, and are of a chromatic richness and technical delicacy that would normally be associated with a miniature portraitist rather than with a landscape painter of Turner's scope. What is extraordinary about them is that even within such a small space he achieves immense breadth. It is not merely a question of technical freedom: it is a matter of the overall vision; the vignettes, as much as the more imposing watercolours, have breadth because they are conceived with grandeur and executed with a skill that knows no material restrictions.

Turner's Watercolours: Life and Landscape

'The interest of a landscape consists wholly in its relation either to figures present – or to figures past – or to human powers conceived. The most splendid drawing of the chain of the Alps, irrespective of their relation to humanity, is no more true landscape than a painting of this bit of a stone.'

That was Ruskin's pronouncement at a lecture delivered in 1871, 20 years after Turner's death. It was not made with Turner specifically in mind, but all Ruskin's judgements on landscape were made by the yardstick of Turner's achievement, and his reference to the Alps immediately evokes one of the most fertile of all Turner's sources of inspiration. Turner was drawn naturally and inevitably towards mountains as much as he was to the sea: the two grandest and most sublime elements in nature lent themselves above all others to his purposes as a landscape artist. Those purposes, however, also involved the notion of landscape as defined by Ruskin – landscape in relation to human figures past or present, or to 'human powers conceived'.

Turner's idea of landscape was formed at an early stage in his career. He was brought up in a world which estimated the value of 'high art' by its 'sublimity'; its ability to move the spectator to awe or pity. The idea can be traced back to the Aristotelian definition of tragedy as conducive to pity and terror, and it was brought to the status of a philosophical dogma in the eighteenth century, applicable to life as well as to art, but, in the end, specifically to painting and to the appreciation of natural landscape. The eighteenth century was only three-quarters over when Turner was born on 23 April 1775, and its greatest aesthetic lawgiver, Sir Joshua Reynolds, was still producing the annual Discourses at the Royal Academy prize-givings which established a code that was to remain in force for 100 years. By that code, creative activity was divided into higher and lower branches, and 'the expression of the passions', as Sir Joshua said, was 'the most essential part of our art.' History pictures portraying grand moral ideas and preferably obeying the Aristotelian rule that the protagonists should be princes or gods were considered more admirable than portraits, landscapes or still life. Reynolds himself rarely deviated from his chosen career of portrait painter, admitting sadly that his abilities lay in no higher field. But he nevertheless understood better than any of his English contemporaries how to infuse into a portrait that suggestion of the heroic which high art required. His scholarly temperament taught him to achieve this by a subtle, often extremely witty adaptation of motifs from Classical, Renaissance or Baroque models to suit a modern purpose, and his portraits in the 'grand manner' are perhaps more remarkable as examples of the style than many of the large, turgid historical compositions that his more idealistic colleagues were producing.

If portraiture could be elevated in this way, by judicious emulation of classical models, landscape, still lower in the hierarchy of art, was also capable of improvement by the introduction of serious themes and allusions to a nobler past. One man in particular, Richard Wilson, earned a high reputation (though never a living) by his serene, often elegiac Italian and English scenes. His heroic landscape *Niobe*, engraved with great success in 1761, took its subject from Ovid's *Metamorphoses*; it is a composition of high drama, in which the landscape, wracked by wind and lightning, embodies the tragedy of the figures which occupy a comparatively small space in the foreground. It is landscape conceived 'in relation to humanity' as Ruskin stipulates; but a classic, heroic landscape designed to express a classical and heroic story. The most evident source for Wilson's storm-tossed trees and solid, square rock-formations is in the paintings of Gaspard Poussin who, with

Nicholas Poussin, Salvator Rosa, and above all Claude, was one of the seventeenth-century landscape masters most admired at the time. All these artists were well represented in English private collections.

The principle of 'high art' was, then, one that Turner would have been aware of from his earliest years. Yet his origins were very humble and the first works that he produced gave little hint of that awareness, or of any ambition to fly beyond the bounds of the lowliest application of landscape drawing: topographical view-making. His father was a barber and wig-maker in Maiden Lane, Covent Garden, and according to tradition his shop was the first place of public exhibition in which the young William Turner's works appeared. These were engravings coloured by the boy, or, later, his own drawings and watercolours. The engravings are most likely to have been views of English scenery executed in the unpretentious tradition of such works that had prevailed since the early part of the century. In the Turner Bequest there is a copy in watercolour of an engraving which shows Folly Bridge and Bacon's Tower, Oxford, dated by Turner 1787, the year of his first documented works (T.B.I. – A). The subject is a motif characteristic of the topographical types of the period, a view of buildings which, while achieving elegance and a certain simple charm, makes no pretension to any atmospheric effect or even the most obvious pictorial drama. It was from such direct record-making that Turner's early career sprang. The prints he copied were not all so prosaic. Turner also made imitations of more decorative and imaginative subjects: a view of ruins in Naples after Fabris (repr. Finberg, *Turner's Sketches and Drawings*, 1910, pls. I, II) and two subjects copied from the Rev. William Gilpin are also in the Bequest (T.B.I. – E, D, H). The Gilpin subjects introduced Turner to a most important aspect of contemporary landscape theory: the concept of the Picturesque. This was an aesthetic principle that grew up alongside the more grandiose notion of the Sublime and was expounded and made widely popular by Gilpin and other writers from the 1740s onwards. It provided a formal critical language in which topographical draughtsmanship could be discussed, while attracting topographers and their clients away from routine 'house-portraiture', and 'ground-breaking' as practised in the military drawing schools, towards a more expressive choice and treatment of subject. The greatest exponent of Picturesque landscape was Thomas Gainsborough (1727–1788), whose work, without being topographically specific, exemplifies the picturesque qualities of roughness, variety and natural charm which Gilpin advocated as necessary to painting.

We can see in Turner's early output the rapid triumph of the Picturesque over 'pure' topography. His interest was quickly attracted by 'Antiquities' such as Malmesbury Abbey and by natural spectacles such as the Avon Gorge at Clifton. There are several drawings, in both pencil and watercolour, of these sites in the *Bristol and Malmesbury* sketchbook of 1791 (T.B.VI). These are attempts to find more imaginative subject-matter than the views of the Oxfordshire countryside and its houses that had previously occupied him (see No.1), or the views of London that he modelled on the work of Edward Dayes (1763–1804). A Dayes-like view of Lambeth Palace was the first work he exhibited at the Royal Academy (see R.A.1974, no.2). This was in 1790 when he was fifteen years old and had for perhaps two years been an assistant in various drawing offices: he is known to have worked for the architect Philip Hardwick and was also working for Thomas Malton the architectural topographer in about 1789. There is even a story that he was for a while in the studio of Sir Joshua Reynolds, but this seems improbable.

The effect of Edward Dayes on Turner's work was of considerable importance. It was possible for a draughtsman who intended to represent only views of scenery and buildings to pay little attention to the human figure, adding staffage merely as a matter of picturesque form, according to the rules laid down by Gilpin. But Dayes's most elaborate views, and especially those of London which he produced in the late 1780s, contain figures which play a more significant role than that of mere compositional properties.

They are often drawn on a fairly large scale and occupy a significantly large area of the picture-space. Details such as costumes, carriages, and the equipment of street tradesmen are dwelt on with care; there is often an element of humour in the depiction of bustling town life, suggesting that Dayes had in mind the social satires of Thomas Rowlandson. In fact, a comparison of a large Dayes view of London such as *Buckingham House, St James's Park* of 1790 with Rowlandson's celebrated *Vauxhall Gardens* of 1784 (both in the Victoria and Albert Museum) seems to indicate that Dayes consciously borrowed Rowlandson's formulae: the grouping of the figures in *Buckingham House* is strikingly reminiscent of the composition of *Vauxhall Gardens*, and the whole drawing is intended more as a social record than as a topographical one. Turner's early views belong to the same tradition. *Lambeth Palace* is based on such watercolours as Dayes's *Queen Square* (coll. Mr and Mrs Paul Mellon) with an attempt to introduce similar groups of carefully observed and placed figures; and the *Pantheon, Oxford Street, after the Fire* (R.A.1974, no.7) is equally clearly modelled on a work like *Buckingham House*, with its foreground packed with large figures, forming a screen of varied activity that is the first thing to engage the spectator's attention.

Whether Turner actively imitated the work of Rowlandson or not is open to debate; though it can be shown that he was temperamentally inclined to copy the effects of any successful artist. But he very soon adopted a topographical style that allocated an important place to human incident and acknowledged the behaviour of people as a relevant aspect of the depiction of architecture and landscape. Even where figures occupy a tiny proportion of the total space, they are inventively conceived to throw into relief some aspect of the scene, and their costumes handled with the greatest delicacy and accuracy; see for example the young men and women dancing on a broken tombstone in front of Llandaff Cathedral (No.10). The interest in human beings for their own sake is more striking in such drawings as the sketch of *Sailors taking Pigs on Board a Boat during a Storm* (No.4), where Turner's concern with rendering the rough sea by no means overcomes his wish to record a comic and dramatic incident of real life. The water, in fact, is suggested very summarily, while the figures are given definition with a pen and details of their clothing and different functions in the complicated action are noted precisely. The lively, slightly droll way in which they are presented, no less than the vigorous organization of the composition, is more like Rowlandson than Dayes. (Finberg, in *Turner's Sketches and Drawings*, 1910, p.43, notes the influence of Rowlandson here, and mentions also the treatment of similar subjects by de Loutherbourg and George Morland.) On the evidence of drawings like this, which are not uncommon among Turner's early work, he might as readily have turned satirist as landscape-painter.

Turner was not only an exhibitor at the Royal Academy; he was also a student in its schools. He entered them on 11 December 1789 and thereafter underwent all the usual disciplines to which academic students were subjected. Figure drawing formed an important part of the programme; eighteen studies from casts of Antique sculpture, presumably made at this time, are in the Turner Bequest (v). Finberg (*Life*, p.19) observes: 'One can only say that they are the work of a patient, docile and hard-working youth.' They are certainly not very impressive; but they are evidence that Turner passed through the same stages of training as any other serious artist of the time; they show him equipping himself with disciplines beyond those of a picturesque topographer. In June 1792 he entered the 'Life Academy' and continued to frequent it until October 1799; some of the drawings he made there are probably among the miscellaneous life studies in T.B.XVIII. The *Academical* sketchbook of about 1798 (T.B.XLIII) contains about a dozen watercolour drawings from models, and at odd moments throughout his career he attended the life class and made studies there, using whatever sketchbook he had to hand. Throughout his career he took a considerable interest in the class, as in all the affairs of the Academy, of

which he became a full member in 1802. He was the Life Class Visitor several times between 1812 and 1823, and also held the post of Inspector of the Cast Collection in three different years.

Apart from the figure drawings that Turner made in the context of the Academy and its disciplines, many others occur among his working drawings for oil paintings. He began to show works in oils in 1796, when he exhibited a marine, *Fishermen at Sea*, which set a pattern for his marine pictures in its vivid realization of the conditions experienced by fishermen plying their trade. Its obvious debt to such men as Joseph Vernet and de Loutherbourg does not obscure Turner's strong sense of 'felt life', and in particular his understanding of the interdependence of men and nature both economically and emotionally; this was to become a major theme of his life's work. Most of the paintings of the late 1790s, however, were compositions of picturesque or sublime scenery similar to those which he was producing in watercolour (see No.18). It was not long before he began to incorporate 'historical' motifs into them in the manner of Wilson, especially after his tours of the north Welsh mountains in 1798 and 1799 (see No.20). This extension of the range of his landscape subjects led to further exercises in figure drawing; a sketchbook in use about 1797, that is during the early years of his practice as an oil painter, is labelled *Studies for Pictures. Copies of Wilson* (T.B.XXXVII); it includes, among an astonishing variety of subjects and technical experiments, several drawings of figures (e.g. ff.14, 16, 17) and an academy study of a female nude. The *Dinevor Castle* sketchbook of 1798 (T.B.XL) contains a number of studies of figures in strenuous action, some of which may have been intended for inclusion in pictures. The *Dolbadern* sketchbook of 1799 (T.B.XLVI) has in it colour studies of figures which appear to be related specifically to works that he had in hand at the time: for instance, the prostrate semi-nude women on ff.116 and 117 are evidently ideas for details of the *Fifth Plague of Egypt* which Turner showed at the Royal Academy in 1800, while the pencil study of a harp on f.1 is connected with a number of Welsh subjects that he was planning, including the *Caernarvon Castle, North Wales* which also appeared in 1800, with a bard reciting in the foreground (see R.A.1974, nos.43 and 70). The *Fifth Plague* was an oil painting, *Caernarvon* a watercolour; both were conceived as historical landscapes in the classical tradition, one imitating Poussin, the other Claude (through the medium of Wilson). The admission of watercolours to the Academy since its first exhibition in 1769 had provoked a gradual change in the aims of watercolour artists: they sought more and more to produce works which could hold their own in size, tonal weight and artistic 'significance' with oil paintings. Turner's work of the mid-1790s illustrates the development: his views of antiquities or picturesque scenery became very large and grand in conception, very rich and dark in colouring (see for instance *Westminster Abbey*, No.9), and he experimented with new watercolour processes that went still further to give watercolour the resonance and 'body' of oil (see Note on Turner's Technique, p.9).

These explorations were conscious steps towards a clearly understood goal: the large Claudian watercolour of *Caernarvon* and the grand Classical *Fifth Plague* proclaim Turner's ambition unambiguously. They exemplify the principles of the Beautiful and the Sublime as applied to landscape and show Turner advertising himself as a painter in the grand manner. The heroic landscape of North Wales led naturally to the romantic wildernesses of the Scottish Highlands, which Turner explored in 1801 (see Nos.27, 28), and it was a coincidental stroke of historical justice that in the following year the Peace of Amiens enabled him to consummate the progression and visit the Alps. His search for landscape that could express emotion of the strongest kind was, of course, fully rewarded by the scenery of Switzerland, which he found 'on the whole surpasses Wales and Scotland too'; and he made a series of drawings there which exploit the highly articulate language that he had built up for the purpose of note-taking (Nos.29 to 32). He worked

mainly on paper that he had prepared with a grey ground, often making only the most summary outline sketch in black chalk or pencil, with occasional touches of white body-colour; but sometimes he added watercolour to produce studies of great power, which were used as the starting-points for finished works in watercolour. Some of these were exhibited; all of them were sold to Walter Fawkes of Farnley Hall, Yorkshire, who was to become one of his closest friends and an assiduous patron.

The Swiss watercolours of *c*.1803–9 form the climax of Turner's development of the medium from formal eighteenth-century topography to 'sublime' art. For the most part they rely for their effect on the sheer power of the scenery they represent. So surely does he achieve grandeur of scale, that Turner sometimes omits figures altogether, being content to suggest life only by introducing a pack-horse or a mountain goat. He seems to be following the advice given to Constable by John Thomas Smith (Keeper of the British Museum Print Room from 1816 to 1833): 'Do not set about inventing figures for a landscape taken from nature; for you cannot remain an hour in any spot, however solitary, without the appearance of some living thing that will in all probability accord better with the scene and time of day than will any invention of your own.' In fact, of course, Turner's figures or animals, whenever they appear, are far from being casually introduced. They are conceived and grouped with the greatest artifice; but Turner, as much as Constable, took pains to create figures that 'accord with the scene and time of day'; they do more than that: they give meaning and interest to the scene and time of day, providing just the explanatory 'moral' significance that Ruskin expected to find in serious landscape. But whereas Constable considered that the incidental rustic life of the countryside, presented informally as it appeared to the casual observer, constituted a legitimate subject for art – linking the theory of the Picturesque with the informalism of the French *plein air* and Impressionist painters – Turner, committed to the academic idea of high art, elevated the life of ordinary people to conform to the grandeur of nature as he conceived it. *The Battle of Fort Rock* (No.43) illustrates the way in which he invented figures to enhance the meaning of his landscapes: the drawing on which the composition was based (in the Fitzwilliam Museum, Cambridge) has no figures; in the watercolour that was first developed from it, *Mont Blanc from the Val d'Aosta* (private collection) he introduced three girls looking over a wall into the gorge, and emphasized the height of the precipice by placing a waterfall behind them, which runs vertically down the mountain from above. The awe-inspiring nature of the view is reflected in the faces of the girls, which show astonishment and fascination; Turner uses the traditional method of introducing the spectator to the scene but handles it with exceptional delicacy and insight. The still later version that he showed at the Academy in 1815 makes use of the same composition but transforms it into 'history', depicting a scene from the Napoleonic invasion of Italy in 1796. It is historical landscape presented in a highly original way: the violent action on the left of the picture provides a human drama that complements and contrasts with the equally dramatic but purely natural subject-matter of the right-hand half of the design.

The continental tour of 1802 gave Turner the opportunity of studying the paintings in the Louvre, which at that time included many works plundered from Italy by Napoleon. The *Louvre* sketchbook (T.B.LXXII) contains notes not only on works by landscape artists such as Ruysdael, Poussin and Rubens but also on numerous subject pictures including Titian's *Entombment* (ff.29–32; see R.A.1974, no.91) and *St Peter Martyr* (ff.27–8). The latter, Turner considered, was 'an instance of his [Titian's] great power as to conception and sublimity of intelect [*sic*] – the characters are finely contrasted, the composition is beyond all system, the landscape tho' natural is heroic, the figures wonderfully expressive of surprise and its concomitate [*sic*] fear.' This criticism is felt and expressed in eighteenth-century terms: the language is that of Reynolds and his contemporaries. It illustrates how Turner, when confronted with a subject picture in which landscape takes an important

place, did not focus his attention exclusively on the rendering of nature, but studied carefully and with penetration the whole 'conception' and especially the emotional effect of the event portrayed. His appreciation of the landscape which 'tho' natural is heroic' sums up his own intentions as far as his finished 'public' works are concerned.

That Turner was aware of the many grades into which landscape could be divided, from the heroic to the mundane, is shown by the long series of prints that he published between 1807 and 1819 under the title *Liber Studiorum*. This work can be seen as a kind of aesthetic manifesto. It was calculated to demonstrate the range of Turner's powers, embracing the gamut of clearly differentiated categories: he adopted the academic notion of Categories of Art quite naturally, and the whole enterprise was conceived on thoroughly academic lines. Its inspiration was Claude's *Liber Veritatis* (now in the British Museum) and the series of engravings in etching and mezzotint made from it by Richard Earlom for Boydell in the 1770s. Turner took over in part Claude's idea of a visual catalogue of his compositions, and borrowed subjects from a number of his exhibited paintings; and although he carefully assigned a 'category' to each subject it is evident that he followed his own inclinations as to what themes he chose. The five headings, Historical, Architectural, Mountainous, Marine and Pastoral were comprehensive enough to cover much of what he produced, but even so he found it necessary to introduce an extra one which he used as frequently as any of the others: it appears on the plates as 'E.P.' which probably stands for 'Epic Pastoral' but may have been intended to mean 'Elegant' or even 'Elegiac Pastoral'. He evidently considered this heading more accurate than any of the others as a description of his Italianate, Claude-inspired subjects.

In practice, Turner infused grandeur into the landscapes in all his categories – except the 'Pastoral', which he deliberately included to demonstrate his scope, but in which he is not usually as successful as in the others. It is an interesting reflection on his attitude to landscape, and to art in general, that he felt it necessary to produce scenes of children sailing toy boats, or pigs in a farmyard. These were both topics that he handled with the greatest skill when he could relate them to a grander whole; see for instance the group of children sailing toy boats in *Dido Building Carthage* (National Gallery) or the pigs in *Sunshine on the Tamar* (Ashmolean Museum, Oxford, Herrmann no.76, pl.B); but which, divorced from a general landscape context, become unexpectedly awkward. In this respect Turner is at the opposite pole from the Picturesque tradition, and from Constable, who was an innovator in deliberately abandoning the 'heroic' as an essential of serious art. Yet Turner was quite as capable as Constable of observing and recording particular natural effects. It was simply that in constructing a picture he instinctively increased its dramatic content for his own aesthetic purposes, and we must be careful to distinguish between what he regarded as a finished work and what was for him only a note for private reference. As Claude had done before him, he spent much of his time making notes of what he saw; the vast majority of the 19,000 drawings in the Turner Bequest are studies of this kind. The sketchbooks consist predominantly of pencil notes, made rapidly while Turner travelled, as he frequently did, on extensive tours through England and Europe (see Biography). The separate watercolour drawings were made either in sketchbooks subsequently dismembered, or on large single sheets of paper. He would sometimes fold and tear a large sheet into small, pocketable leaves which he could carry about instead of a sketchbook (see Nos.116, 159, for instance). There are also a large number of studies evidently made in the studio as experiments or preliminary exercises in the process of creating finished works. These are sometimes mere washes or splashes of colour (e.g. Nos.99, 173) suggesting a general tonal or chromatic scheme; or they may be comparatively elaborate essays in atmospheric or climatic effect, showing sunsets, storms and other weather conditions (e.g. Nos.100, 144). Such studies are usually referred to as 'colour-beginnings'. The dividing line between watercolour studies made out of doors and those made at

home, in the studio, or wherever Turner happened to be staying, is difficult to determine. Accounts exist of his use of colour in the open air (see No.59) but it seems probable that as a general rule he was content to use only a pencil or chalk for drawing on the spot and worked up his outlines with colour later. For instance, the two views of the *Lake of Lucerne, looking from Brunnen towards Uri* (Nos.210 and 211), which belong to a series of watercolour studies of the same scene, appear to be based on an outline drawing in pencil (T. B. CCCXXXIII–14) which is very likely the only record that Turner actually made direct from life. His memory of visual effects was exceptionally vivid and detailed, and there can be little doubt that many of the studies that have the appearance of being immediate records of observed nature are in fact 'reconstructions', sometimes perhaps entirely invented, based on his broad and deeply felt experience of nature, and on the bare outlines that he preserved in his sketchbooks.

It was not necessarily a predetermined matter whether any particular colour sketch was to remain purely private, for reference only, or whether Turner would work it up sufficiently to deem it worthy of being disposed of commercially. From time to time throughout his career he seems to have been willing to extract drawings from his sketchbooks or portfolios to be given or sold to friends or other interested persons. But his practice in this respect changed during the second half of his career, and in the late '30s and '40s he frequently gave his agent leaves taken direct from sketchbooks; this applies especially to the late Swiss and Venetian watercolour studies, many of which are dispersed in collections outside the Turner Bequest. Even at this late period, however, the finished, 'public' work remained a primary medium for him. As a professional artist, and a member of the Royal Academy, he never lost his desire to express himself on a broader front than that of the intimate and informal sketch; and behind the plethora of 'private' material, in pencil and in colour, there lies the notion of the fully wrought work of art for exhibition and sale. Just as at the beginning of his career, the finished object might equally well be in watercolour or oil. Ruskin's account in his 'Epilogue' to the Fine Art Society's exhibition of his Turner watercolours (1878 and 1900) is the best known and clearest illustration of Turner's attitude at that late phase of his development.

'In the years 1840 and 1841, Turner had been . . . in Switzerland; and . . . had filled, for his own pleasure, many note-books with sketches . . . [fifteen of which were] placed by Turner in the hands of Mr Griffith of Norwood, in the winter of 1841–2, as giving some clue to, or idea of, drawings which he proposed to make from them, if any buyers of such productions could by Mr Griffith's zeal be found.
'There were, then, in all, fifteen sketches, of which he offered the choice to his public; but he proposed only to make *ten* drawings. And of these ten, he made anticipatorily four, to manifest what their quality would be. . .'
(A fuller quotation from this account is printed in R.A.1974, p.161–3).

Notwithstanding his willingness to sell certain of his colour sketches as they stood, therefore, Turner continued to regard them as a separate kind of production from the finished drawings that he wanted his patrons to buy. Compare, for example, the 'specimen' drawings from Swiss sketchbooks (Nos.281 and 285) with the finished views of *Zürich* and *Lucerne* which are among those referred to by Ruskin in the passage quoted above (Nos.286 and 292).

 Although this exhibition is drawn largely from the material in the Turner Bequest, and therefore consists principally of sketches and studies, it is intended to show how these studies relate to the completed works by which Turner wished to be known to his contemporary public, and to which he devoted immense care and labour. In fact, his

Bequest includes finished drawings of several periods: the *Llandaff Cathedral*, probably shown at the Royal Academy in 1796 (No.10), and the *Battle of Fort Rock* of 1815 (No.43) have already been referred to. In addition there are the two series of designs for publication in the 1820s as the *Rivers of England* and *Ports of England* (Nos.85–6, 91–2), and the drawings for *Wanderings by the Seine* of about 1830 (Nos.190–6). The Bequest also includes some of the finest of Turner's vignette illustrations to literature, in particular the series for Samuel Rogers's *Italy* and *Poems* published in 1830 and 1834 (Nos.179–188). These are all drawings which for various reasons Turner never sold, or which were returned to him according to the terms of publishers' contracts; sometimes Turner would buy up his own works in the sale-rooms, adding them to the enormous store of material that he kept until his death.

The Department of Prints and Drawings has been very fortunate, however, in benefactions which have endowed it with a comprehensive collection of finished works that balances the representation of Turner provided by the Bequest itself (see Foreword, p.8). Among these is the group of fine examples from the series of landscapes made for Charles Heath's *Picturesque Views in England and Wales* between about 1826 and 1837, which forms the central focus of this exhibition, and shows his mature genius at its most fertile and powerful, constituting as important a record of his greatness as any other part of his output.

The association of Charles Heath and Turner in the *England and Wales* project was one which might be said to sum up in two names the spirit of Art publication in the 1820s. Heath (1785–1848) was a professional engraver who had acquired a high reputation as an interpreter of Reynolds, Lawrence, Westall and other important painters, and had contributed engraved illustrations to many of the small popular editions of English classic fiction which began to have a wide circulation in the early years of the nineteenth century. He progressed from engraver to impresario, and in the mid-1820s was responsible for the inception of 'Picturesque Annuals', such as the *Keepsake* and *Amulet* and the *Literary Souvenir*, which became highly successful as works of middle-class entertainment, offering sentimental and informative snatches of literature together with well-engraved subjects from artists of all types. Compositions by Turner were used for a number of these annuals, including the *Bijou*, the *Anniversary, Friendship's Offering* and several others in addition to the three already mentioned. Heath also published in 1836 a *Gallery of British Engravings* which included seven of the Turner subjects that had appeared in the *Keepsake* since 1828. Heath seems to have conceived the idea of the *England and Wales* series in 1826, the year in which the first of his Annuals, the *Literary Souvenir*, began to appear. It was inspired by Turner's previous work for engravers, especially by the long series of *Picturesque Views of the Southern Coast of England* published and largely engraved by William Bernard Cooke, which had occupied Turner since 1811 and had consisted of forty elaborate and finely wrought watercolours of intricately composed panoramas along the coast from Watchet to Whitstable. The *England and Wales* format was to be about 6½″ × 9½″, a little larger than the modest 5½″ × 8½″ of the *Southern Coast*, a size to which Turner had adhered in his drawings for the work. This time he made no attempt to conform in his watercolours to the dimensions of the engravings. In his approach to the commission he seems to have referred back to another series, the illustrations for Whitaker's *History of Richmondshire*, published between 1818 and 1823 (see No.55). For that work he made twenty drawings which were among the most ambitious designs he had yet produced in watercolour, many of them depicting the grandest of Yorkshire's romantic scenery, enlivened with an inventive use of figures. The two other series that immediately preceded the *Views in England and Wales*, the *Rivers of England* and *Ports of England* were to be engraved in mezzotint on steel, a new process, and took an even smaller format than the *Southern Coast* designs; though even in these Turner achieved a remarkable sense of scale,

sometimes creating views that might fill a large canvas with ease (for example *Newcastle on Tyne*, No.85). In general, his single finished watercolours had, by the 1820s, settled down to a size roughly that of the *England and Wales* set; see for example *Florence from S. Miniato* and *Saumur* (Nos.145, 168). Gigantic 'Academy' exhibition pieces like *Fort Rock* were rare; the incident from Turner's journey across the Alps in 1829, *Messieurs les Voyageurs* (No.147), is exceptional for so late a date.

It was, therefore, a proposition highly congenial to his creative temperament that he should embark on a long sequence of loosely related scenes: the pattern was a characteristic one for him. Turner agreed with Heath to produce 120 views; no stipulation was made as to precise subjects, and the series is of particular interest as an anthology of sites that he found especially inspiring. According to Rawlinson (Vol. 1, p.xlvii) Turner 'received sixty to seventy guineas apiece' for his drawings; but Finberg (*Life*, p.375) considered this an exaggerated guess. The team of engravers included a number of men who had collaborated with Turner in the past, such as W. Radclyffe, W.R. Smith and R. Wallis; several younger engravers were also employed, and the general standard of the plates is as high as any made after Turner's designs, sometimes achieving exceptional heights of subtlety and expressive power (see R.A.1974, Nos.417, 432). Heath paid about £100 for each plate. Rawlinson says (Vol. 1, p.117) that 'the plates were usually engraved as fast as Turner supplied the drawings, so that the date on each print always corresponds within about a year with that of the drawings.' The subjects were issued as a serial; Turner began work on the watercolours in 1826 and the first twelve plates were completed in 1827. Sixty of the views were published together in one volume in 1832; only thirty-six of the second volume appeared however: the enterprise met with a poor response from the public and in 1838 Heath was forced to sell up his stock of plates and unsold prints. They were put up for auction at Messrs Southgate & Co., but 'just at the moment the auctioneer was about to mount the rostrum, Mr Turner stepped in, and bought [prints and plates] privately, at the reserved price of three thousand pounds, much to the vexation of many who had come prepared to buy portions.' (Alaric Watts, quoted by Finberg, *Life* p.374).

Turner subsequently sold off the prints, but kept the plates to prevent their being re-worked and spoiled, and they were not disposed of until the sales of his effects at Christie's in 1873 and 1874. He attached great importance to the engravings, and regarded them as an integral part of his own creative process; the watercolours he made should be seen not only as objects complete in themselves but as the starting-points from which he envisaged a further, equally eloquent form of communication would develop. The importance of the drawings themselves was immediately recognized, and Heath arranged that a large number of them should be shown to the public during the period in which the prints were issued. About forty watercolours by Turner were exhibited at the Egyptian Hall in Piccadilly in 1829, and *England and Wales* subjects apparently dominated the collection. Seventeen were mentioned in contemporary reviews; by that date Turner had probably completed about thirty or forty of the series. Sixty-six appeared at the Gallery of Messrs Moon, Boys and Graves, in June 1833, along with drawings for Scott's *Works* on which Turner was also engaged at that time. The catalogue of that exhibition gives the names of those who had lent the works, providing a list of some of the most prominent of Turner's patrons and contemporary admirers: it included Thomas Griffith Esq. of Norwood, his agent; Godfrey Windus Esq. of Tottenham; Thomas Tomkinson Esq.; J.H. Maw Esq.; the Rev E. Coleridge; Samuel Rogers Esq.; and Charles Heath himself, who lent work in the process of being engraved. To these names that of H.A.J. Munro of Novar must be added as the most important and extensive collector of Turner's work at that time. Munro was a personal friend of Turner, and made a journey with him to Switzerland in 1836. Fourteen of the *England and Wales* drawings appeared in Munro's sale of fifty-five water-

colours by Turner at Christie's, 2 June 1877; and another seven at a further sale on 6 April 1878 which included thirty watercolours and nine paintings. *Criccieth, Caernarvon, Coventry* and *Lowestoft* all belonged to Munro.

One of the *England and Wales* drawings, *Saltash* (No.90), is dated 1825, the year before Heath's project was begun; Turner must therefore have made use where appropriate of material he already had to hand. Certainly in choosing his subjects he drew on notes and sketches gathered at many different times, going back even to a sketch of 1793 for the view of *Llanthony Abbey* (R.A.1974, no.430). On the other hand, he availed himself of the excuse provided by this long series to make excursions with the express purpose of gathering new material for the work, and in 1830 he toured the Midlands, covering a wide area from Oxford to Birmingham, Worcester and Chester which provided him with numerous subjects (e.g. *Worcester*, No.200, and *Coventry*, No.197).

We can associate a group of Turner's more inscrutable colour-beginnings with this tour, and therefore probably with his preparatory work for the *England and Wales* watercolours. *Lichfield from St Michael's* (No.173) is a representative example. No finished version of the subject was made, but the style and colouring of the sketch is very similar to that of another showing *Tamworth Castle* (T.B.CCLXIII–184) which is related to an *England and Wales* drawing of the same view (now untraced). The sequence of colour-beginnings of *Oxford High Street* (R.A.1974, nos.443 to 447), based on a pencil sketch in the same book as the note at Lichfield which provides the identification for No.173, gives particularly detailed evidence of the way Turner explored the compositional potential of a subject, blocking it out in a very limited range of colours, emphasizing first one feature and then another but always concentrating on a general scheme. In two of the *Oxford High Street* studies figures are introduced, first tentatively, then in more detail, so that Turner seems to be on the point of proceeding with a finished design; but no final watercolour of the view exists. We have similar colour-beginnings for other works of this date (1830–5); see *Marly-sur-Seine*, and the sketch related to it (Nos.175 and176); but it is rare for so clear a progression to be observable as that in the *Oxford High Street* group, and we cannot yet say with any certainty how often Turner made repeated trial sketches before embarking on a final version.

The organization of the *England and Wales* designs is in itself a matter for lengthy study. Turner was free to invent each as he chose, independent of any outside requirements, and each drawing is an entirely fresh vision: even views like the *Llanthony Abbey*, which, as has been mentioned, had already been drawn in the early 1790s, are re-invented with compositions and colour-schemes unique to themselves, and with weather conditions conceived as a decisive factor in each. Ruskin often cited the *England and Wales* drawings when he was illustrating Turner's sensitive understanding of weather, and analysed his climatic effects in some detail (quoted where relevant in this catalogue). The selection of the views included in this exhibition can give only a sample of the subtly differentiated records of light and times of the day which, in the whole series, make up a comprehensive survey of the English climate. What must be added to Ruskin's account, however, is a note on Turner's extraordinary ability to observe, understand and convincingly record local climatic effects while transforming them into the grandest strokes of high art. The view of *Prudhoe Castle* (No.106) is perhaps exceptional in so closely aping the golden atmosphere of Claude; but it conveys very clearly Turner's ambitious intention in these drawings. More often, we find that he has chosen a heavy downpour of rain, as in *Coventry* (No.197) and *Derwentwater* (No.203); or a stormy winter morning as in *Lowestoft* (No.208); even his balmy summer evenings are generally unmistakably English ones, as in *Caernarvon* (No.199). In all these instances, Turner makes pictorial and dramatic capital out of observed local phenomena; he does not introduce any false notes, but he nevertheless succeeds in conveying more than the simple truth. He obeys Reynolds's dictum that 'what is particular and

uncommon' in the observed world should be subordinated to the universal, the ideal, most perfect and complete representation of the object: 'the whole beauty and grandeur of the Art consists, in my opinion, in being able to get above all singular forms, local customs, particularities, and details of every kind. . .' (Discourse III, 1770). This did not mean, of course, the elimination of all closely observed life; on the contrary, the generalization that Reynolds asked for was based on precisely such observation. So the storm in the *Coventry* watercolour is stage-managed to give us, not a careful, objective account of a meteorological phenomenon, but a *coup de théâtre* in which Turner deploys the elements of sunlight and cloud, rain and wind, with buildings and figures, in a complex and highly expressive pattern. He is as much concerned to produce art in the grand style here as in any of his oil paintings for the walls of the Academy.

The interrelation of the various elements to produce this new manifestation of the 'Sublime' depends for its emotional effect on two equally important factors. One of these is light. Turner's concern with light has dominated recent interpretative approaches to his work, and there is no need here for its significance to be further stressed. What should be pointed out, however, is the place given to light in the classic eighteenth century account of the causes of the Sublime, Edmund Burke's *Philosophical Enquiry into the Causes of our ideas of the Sublime and Beautiful* of 1757. This book provided Reynolds, and consequently all those who thought about the theory and practice of art, with many basic terms of reference. It was less specifically concerned with the visual arts than Gilpin's theory of the Picturesque, but it inevitably came to be applied extensively in art theory, Burke's terminology recurring in the writings of Barry, Fuseli and many others as well as Reynolds himself. Behind the scientific or quasi-scientific accounts of light that have been related to Turner's output and philosophy by John Gage and other scholars (see Bibliography), Burke's purely aesthetic discussion provides the basis on which the whole structure of an artist's attitude to light would have been founded.

'Mere light', Burke says (p.62, Sect.XVI), 'is too common a thing to make a strong impression on the mind, and without a strong impression nothing can be sublime. But such a light as that of the sun, immediately exerted on the eye, as it overpowers the sense, is a very great idea. Light of an inferior strength to this, if it moves with great celerity, has the same power; for lightning is certainly productive of grandeur, which it owes chiefly to the extreme velocity of its motion. A quick transition from light to darkness, or from darkness to light, has yet a greater effect.'

Burke, however, thought that 'darkness is more productive of Sublime ideas than light'; and in his discussion of 'Colour considered as productive of the Sublime' advocated 'sad and fuscous colours, as black or brown, or deep purple and the like.' Colours such as these characterize Turner's early attempts at sublime landscape, in his ecclesiastical interiors and views of the Welsh mountains (e.g. No.18). It was only as his understanding of light increased that he was able to exploit its capacity for the Sublime to such a degree that he could disprove Burke's view that it was inferior to darkness in this respect. To the twin sublimities of nature, mountains and sea, Turner was able to add light as an even more powerful third. But an understanding of darkness is of course implied in an understanding of light, and to the end of his career Turner employed 'quick transitions' between light and darkness as an essential feature of his pictorial vocabulary.

The other element in the *England and Wales* compositions that makes a crucial contribution to their sublime effect is the human figure. It has already been shown that figure drawing occupied an appreciable part of Turner's time, and the titles of his paintings exhibited at the Royal Academy throughout his career indicate that he was seriously concerned with the business of representing human beings, not merely as appendages to a design, but as vital ingredients in landscape which, to revert to Ruskin, is only interesting in so far as it relates to human life. An early sea-piece, *Dutch boats in a gale, fishermen en-*

deavouring to put their fish on board (R.A.1801, no.157) is a picture about men in relation to their profession as well as to the sea which provides the conditions in which they work. The same balance between landscape and life is the subject of *Richmond Hill, on the Prince Regent's Birthday* (R.A.1819, no.206), or *Whalers (boiling blubber) entangled in flaw ice, endeavouring to extricate themselves* (R.A.1846, no.494). Titles like these are typical of Turner. His finished watercolours are constructed on a similar principle, even if, as with many of the paintings, their titles indicate only place-names. Turner designs his figures carefully to express the significance of his whole subject. The girls bathing from the rowing-boat in *Caernarvon* (No.199) are as important in explaining the warm still beauty of the summer evening as is the ravishingly delicate sky with a crescent moon above them; and it is principally through our identification with them that we apprehend to the full the atmosphere of the scene.

Turner's figures are designed so that the spectator can be drawn into the picture and made to participate completely in the landscape. He invents them with the sympathy of a novelist who does not necessarily intend his characters to be likeable, but who makes them human like ourselves, and thereby engages our compassion. It is traditional to find Turner's drawing of the human form unsatisfactory, even repulsive. Even Rawlinson laments 'Alas that landscape art so perfect should have been marred by the banal and ill-drawn figures which too often he added at the last!' But Ruskin, who was aware of the criticism, justified 'the singular, and to the ignorant in art the offensive, execution of Turner's figures', pointing out that his shorthand is 'absolutely necessary to the faithful representation of space' (*Modern Painters*, Vol. I, p.186). One of the most prominent among late nineteenth century collectors of Turner's watercolours, Henry Quilter, defended the figures in his compositions with warmth and insight in *Sententiae Artis*, 1886 (pp.152-3):

'There is frequently a good deal of absurd talk about the inadequacy of Turner's figures; and from one point of view, perhaps, the talk may be substantiated. No doubt they are frequently, if you detach them from their places in the picture, anatomically incorrect and artistically poor. But leave them where they are intended to be, and it is impossible to deny that they absolutely fulfil their artistic object, they are essential parts of the whole impression conveyed by the work in which they exist. Nay, far more than that, they are not only right in relation to the meaning of the picture, they are right also in relation to its treatment. They take their proper places with regard to other portions of the drawing; they are suffused with atmosphere, and have that relative subordination to the objects around them, which is to be noticed in real life… Generally it will be found that his figures are as good as there is any necessity for them to be. That is to say, when they are only inserted in a landscape for the sake of forming patches of colour, or in order to lead the eye from or to some other point in the composition, or to add to the general sentiment of the scene, and increase its peace, its sadness, or its brightness – that in this case they are often carelessly drawn with a few rough touches; but when it is part of Turner's plan to show the occupation and interest of the people in detail, there is little left to be required. Indeed, though the figures are always kept subordinate to the landscape, as was necessary in Turner's scheme, yet they are distinctly an integral part of his pictures.'

It is true that sometimes the formulae that Turner employs to suggest human faces and limbs are too obtrusive, giving his figures a doll-like and occasionally clumsy appearance. But these criticisms do not apply in the majority of cases, and hardly ever are the figures 'banal'. Even in an example such as *Criccieth Castle* (No.206) where the figures are individually rather weakly drawn, their intention is evidently a serious one, and their disposition in the design very carefully calculated. They enhance the sense of the picture not only compositionally by providing essential movement across the foreground, but emotionally since the real subject is 'Customs Officers inspecting goods salvaged from a wreck'. Tur-

ner has deliberately chosen this motif to underline the theme of 'land versus sea' that here, as so frequently in his work, gives significance to coastal scenes. The action he has invented represents dramatically, in terms of the scene, the lives that men lead on both land and sea and how they interreact. In the context that he has created, the ferocious breakers and hostile sky play an essential role in what is first of all a human drama.

In drawings that show wild conditions such as these, the relevance of Ruskin's comments is clear enough: 'There is no more sublimity – per se – in a perpendicular fracture of rock, than in a horizontal one. The only thing that makes the one more interesting to you in a landscape than the other, is that you could tumble over the perpendicular fracture – and couldn't tumble over the other. A cloud, looked at as a cloud only, is no more a subject for painting than so much feculence in dirty water... That it is worthy of being painted at all depends on its being the means of nourishment and chastisement to men, or the dwelling place of imaginary gods.' But Turner's sense of the importance of human life in landscape can be better demonstrated perhaps in his scenes of calm and sunshine, where the 'Sublime' is exchanged for the 'Beautiful' – or becomes a matter of the scale and warmth evoked by his handling of figures. In *Saltash* (No.90), for instance, there is no landscape to speak of – the distant town on the hill, not in itself dramatic, is half obscured by haze and Turner makes no attempt to give it prominence. The watercolour is concerned almost solely with the lively, festive crowd packed into the boats in the foreground. It is a crowd specifically contrived to suggest the warm, calm weather; the brilliant and variegated costumes shine in the sun and create an atmosphere of gaiety; the women with children illustrate the peaceful nature of the occasion; the drummer and fife-player and cheering sailors can be clearly heard across the still water. All the features of the landscape are conveyed primarily through the figures. The same can be said of the view of *Richmond Hill and Bridge* (No.174), one of the most delightful of all Turner's inventions. The structure of the landscape here is strictly classical, with the sunlit bridge precisely in its centre, and complementary groups of trees at each side. As in *Saltash*, the principle natural features are unstressed, and the life that shoots palpably through the scene is supplied by a brilliantly free (though meticulous) technique, and by the figures whose movements, both individually and in groups, do all that is needed to evoke the pleasure of being in the open air on a breezy afternoon of sunshine and cloud. The combination of Claudian plan with informal, everyday life is typical of Turner's method of elevating the mundane to the level of 'high art'.

It is not only the choice and placing of figures that reveals his care in handling them. Their costumes and activities are always understood. Turner is sometimes laughed at for the technical errors committed in some of his titles – the 'Poissards' of *Calais Pier*, for instance (see R.A.1974, no.75). Such mistakes are, however, less the evidence of carelessness than of ignorance of technical terms; they are intended to give information conveying the *specific* nature of the activities in question. Much space is devoted in the sketchbooks to records of the people whom Turner saw in his travels, and he frequently jots down detailed notes of their clothes and occupations. The two studies made in France of *Soldiers in a Café* and *Peasants dancing in the Street* (Nos.159 and 160) are characteristic of the interest he took, though not as precise in detail as many of his pencil sketches. The finished view of *Marly* (No.175) offers further evidence of his fascination with costume, and both *Saltash* and *Richmond* are similarly rich in such detail.

Examples of Turner's felicity in the treatment of human life occur everywhere in his watercolours. The Petworth interiors (Nos.119 to 143) include dozens of studies of figures, observed for their own sake, or for their clothes, or for the association with particular friends, or for the dramatic effects created by their grouping in candlelit rooms. Even on the miniature scale of the vignette illustrations, he could evoke life with the greatest subtlety; note for example the effect of the empty chair standing on the lawn at *St Anne's*

Hill (No.181); or the crowded scene that he manages to bring to life in the tiny drawing of a *Village Fair* (No.179). In connection with the subject of this vignette, compare the *Horse Fair, Louth* in the *England and Wales* series, and Ruskin's comment on it (R.A.1974, no.422).

Turner frequently treated humanity rather as a mass, a force of life, than as individuals; in such subjects as the *West Front of Rouen Cathedral* (No.192), which also shows a market in front of a church, both the principal elements in the scene are generalized into broad, dramatic masses of movement; though here, as usual, there is retained a strong sense of the particular: the complexity of the gothic facade is wonderfully suggested, and the crowd animated with an economic indication of varied detail both of action and of costume.

This view of man, swarming in multitudes among gigantic buildings or mountains, is a further dimension of the Sublime. It is one that is associated particularly with the sensational, 'apocalyptic' scenes of John Martin (1789–1854), in which men are reduced to the scale of ants by the vastness of nature. Turner had experimented with effects of that kind as early as 1799, in sketches such as T.B.LXX–Q, and the architectural subjects of the 1790s often achieve similar results (e.g. *The Interior of Ely Cathedral*, R.A.1974, no.13). In the *England and Wales* drawings he rarely employs such a violent contrast of scale to obtain his effects, retaining even in so grandiose a design as *Coventry* the correct proportion of men to landscape. It was among the mountains of Switzerland that he could use the device with greatest effect, and with the greatest truth; and it became a standard feature of the late watercolours, of which the group made for sale through Thomas Griffith from 'specimen' sketches in 1842 and 1843 are typical. The *Zürich* (No.286) does not show mountains, but has been conceived nevertheless on the very grandest scale, and its foreground is a mass of figures, which cover the streets and buildings like lichen. The studies from which these watercolours were made do not generally include figures, but when they do it is frequently as indistinct crowds that the figures appear; see *Fribourg* (No.271) and *Bellinzona from the South* (No.280). The absorption of humanity into the structure of nature is even more apparent in some of the paintings; *Hannibal crossing the Alps* (R.A.1812, no.258) was one of the first of such pictures; and the two 'Goethe Theory' pictures (R.A.1843, nos.363, 385) show the same involvement of human beings in cosmic violence.

In these works, as much as in the calm domestic scenes at Richmond or Petworth, man is the touchstone of landscape. What distinguishes man as Turner sees him from the ants of John Martin is that Turner engages our compassion; he creates a humanity that can suffer, feel pain and pleasure, and indulge in simple jokes and joys. Men are not for him cardboard properties, necessary simply to 'relate' to the landscape in a purely theoretical way; if they were, they would have as little significance as Martin's, and would do no more than conform to the letter of Ruskin's rule. Turner's career lay between the age of Reynolds and that of Ruskin, and his work is an amalgamation of the ideas that stimulated them both. He could 'generalize' to satisfy any Reynolds, and 'particularize' to content the microscopic eye of Ruskin. Nowhere better than in his finished watercolours does this dual virtuosity make itself apparent technically; and in them it appears not simply in the handling of the medium but in the inspired welding together of the demands of life and Art.

Catalogue

1
Christ Church from Merton Fields 1791
pencil and watercolour, 273 × 332 mm
inscr. lower right: *William Turner*;
and on the artist's wash line mount:
CHRIST CHURCH OXFORD
T.B.VIII–A

Oxford provided Turner with many of his earliest subjects; his uncle, Joseph Mallord William Marshall, having retired there in about 1788. The first sketchbook of the series in the Turner Bequest, labelled *Oxford* (T.B.II), records a visit in the summer of 1789, when Turner spent most of his time noting the country houses in the surrounding neighbourhood. He must have made similar visits in the following years, and went on producing watercolour views in the city until the series of designs for the *Oxford Almanack* executed between 1799 and 1804.

The bright colour of this drawing, especially the yellow which expresses Turner's emerging interest in effects of sunlight, is typical of the palette he employed until about 1792. It has much in common with that found in the watercolours of his master Thomas Malton, whose style exerted a great influence on Turner's at this time.
For Colour Plate, see p.33

2
A storm off Dover c.1793
pencil and watercolour, 256 × 362 mm
T.B.XVI–G

Related to T.B.XVI–F, a pencil drawing which shows the same view of the superstructure of a pier, though without the background of sea and shipping.

The drawing, with the others in the same group, is apparently the product of Turner's tour of Kent in the late summer of 1793.

3
A scene on a rocky coast c.1794
pencil and watercolour, 212 × 269 mm
T.B.XXIII–V

Turner had already made a number of sketching tours by 1794; it seems probable that he had the southern coast of Wales in mind when he made this drawing and No.4, though it is possible that the subjects were encountered on the Kent coast which Turner seems to have visited in about 1792; and he is known to have gone to Dover in 1793. He was in South Wales also in 1792, and made a more extensive tour there, drawing many coastal views, in the autumn of 1794.

4
Sailors taking pigs on board a boat during a storm c.1794
pencil, pen and brown and black ink and watercolour, 216 × 275 mm

verso: A woman and child being helped ashore from a small boat
pencil
T.B.XXIII–T

See No.3.

5
The interior of the ruins of Tintern Abbey 1794
pencil and watercolour, 360 × 255 mm
T.B.XXIII–A

A variant of the drawing in the Victoria and Albert Museum (1683–1871) which was, according to Finberg, more probably that exhibited at the Royal Academy in 1794 (402) as *Inside of Tintern Abbey, Monmouthshire* (see R.A.1974 no.B16). The patch of bare white paper between the two mounds of rubble suggests that this watercolour is in fact unfinished. A detailed pencil study is T.B.XII–E; this was probably made in 1792.

The view of Tintern at the Ashmolean Museum, Oxford (Herrmann no.91), though similar, is of a different part of the interior, looking into the transept. The drawing in the Lloyd Bequest – B.M.1958–7–12–400 is a variant of this which Herrmann, following Finberg, suggests is 'probably not by Turner', but there seems little strong evidence of any other authorship and the drawing is consistent with Turner's style at the time if not with his best work. If anything the Oxford drawing, with its hard, summary detail and possibly false signature, is the imitation. The subject was exhibited at the Royal Academy in 1795 (589).

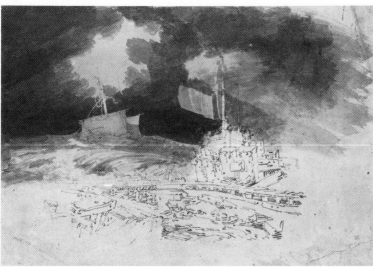

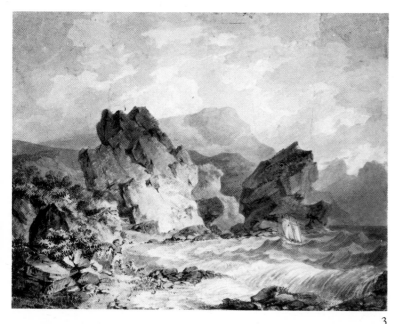

3

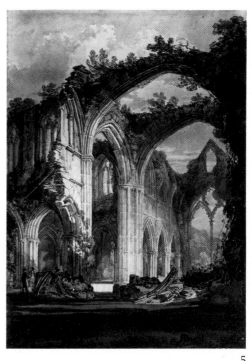

5

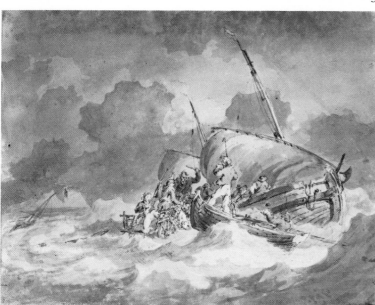

4

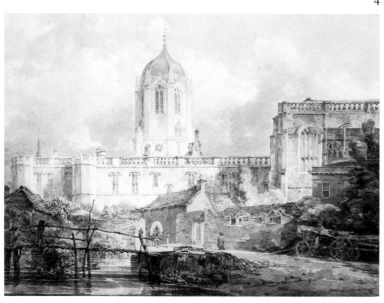

6

6

Christ Church, Oxford *c.*1794
watercolour over pencil, 321 × 426 mm
signed lower right: *Turner*
coll: John Henderson Sr; John Henderson Jr,
by whom bequeathed to B.M.1878–12–28–42
(L.B.18)

Turner executed a number of drawings of
Christ Church, predominantly in grey and
blue washes, for private clients in 1794, to
which year this striking example also prob-
ably belongs. A similar view of the college,
though from a more distant viewpoint,
apparently based on a sketch made in the late
1790s, was executed in 1798 for the *Oxford
Almanack* and is now in the Ashmolean
Museum (Herrmann No.1).

The palette, composition and drawing of
this watercolour all derive closely from the
work of Thomas Hearne, who with Dayes
was perhaps the leading topographical water-
colourist of the time. Turner mimics his
manner almost exactly but infuses into it a
grandeur which Hearne usually misses.
Although he would undoubtedly have been
familiar with Hearne's work from an early
age, Turner probably began to copy him
more specifically when he came under the
influence of Dr Monro in about 1794. This is
probably the drawing lent by John Hender-
son Jr to the Manchester 'Art Treasures' ex-
hibition in 1857 (Watercolours, No.300).

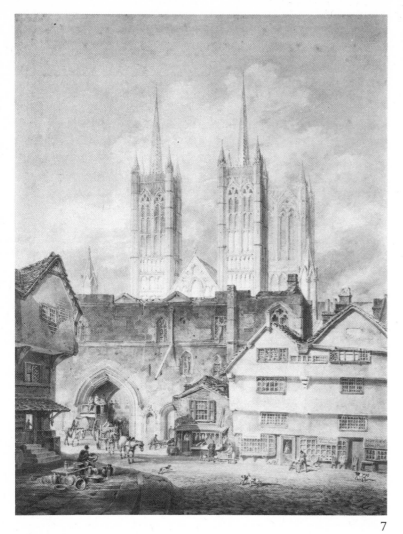

7

8

7

Lincoln Cathedral and Exchequer Gate from Bailgate 1795

watercolour over pencil, 450 × 350 mm
signed lower right: *W. Turner 1795*
coll: John Henderson Sr; John Henderson Jr, by whom bequeathed to B.M.1878–12–28–48 (L.B.19)
exh: R.A.1795 (621) as *Cathedral Church at Lincoln*

The view was noted by Turner during his first Midland tour of 1794 (T.B.XXI–O); the pencil sketch shows only two of the west towers with no pinnacles or spire; for the remaining detail Turner relied on another drawing, XXII–K, which gives all three towers, though with proportions considerably more squat to fit the sheet; Finberg suggests (*Inventory*, Vol. I, p.32) that the pencil studies of Lincoln, all on sheets of white paper approximately 8½″ × 10⅛″, were not originally in a sketchbook; they may have been quarters of a larger folded sheet, subsequently cut; ff.XXI–P and Q show other details of the cathedral, the south-east porch and ? south side of the nave (exterior) respectively.

8

York House Water-Gate 1795
pencil and watercolour, 300 × 421 mm
T.B.XXVII–W

Although Turner was a Londoner, and his first exhibited work was a London view, surprisingly few London subjects appear among his early drawings: from the first he concentrated his attention on sites of antiquarian and picturesque interest in the provinces. The London buildings that he chose to draw were conspicuously picturesque: Lambeth Palace, old London Bridge (T.B.XXVIII–J, K), the ruined Oxford Street Pantheon (see R.A.1974 no.7) and this wooden tower of the Waterworks in York Buildings beside the baroque water-gate of old York House. The group of buildings was drawn from the same angle by Canaletto during the construction of Westminster Bridge in about 1747 (coll. Mr and Mrs Paul Mellon, repr. *English Drawings and Watercolours 1550–1850 in the collection of Mr and Mrs Paul Mellon*, Pierport Morgan Library 1972, no.15).

9

Interior of Westminster Abbey, with the entrance to Bishop Islip's Chapel; looking from the ambulatory to the north aisle 1796

pencil and watercolour, 546 × 398 mm
inscr: WILLIAM TURNER NATUS 1775
coll: Lord Harewood; sale, Christie, 1 May 1858(36); John Dillon; sale, Christie, 17 April 1869 (47); John Heugh; sale, 17 March 1877(35); J. Morris; D. S. Thompson, 1912; Christie, 1917; bt. Boswell; Agnew; R.W. Lloyd, by whom bequeathed to B.M. 1958–7–12–402
exh: ? R.A.1796 (24) as *St Erasmus in Bishop Islip's Chapel*

Thornbury draws attention (*Life*, Vol. I, p.3) to the evidence of Turner's birth-date provided by the inscription 'ambitiously marked on a stone in the foreground pavement of this beautiful water colour drawing'. As he points out, 'The size of the Abbey is grandly exaggerated, yet one could scarcely wish it otherwise.' Although this drawing is smaller than many of the architectural interiors of the same time (e.g. *The Chapter House, Salisbury*, Whitworth Art Gallery, Manchester), it shares with them a dramatic attitude in the presentation of buildings which can be traced back to the engravings of Piranesi through such artists as Ducroz and Volpato.

10

Llandaff Cathedral, South Wales 1795–6
pencil and watercolour, 357 × 258 mm
exh: ? R.A.1796 (701)
T.B.XXVIII–A

Based on a pencil drawing in the *South Wales* sketchbook of 1795 (T.B.XXVI, f.4). The drawing, which omits many details of the architecture, is inscribed *verso: Dr Mathews / 2*; although this note may refer to a commission no other watercolour of the subject is known, and Finberg's conjecture that this is the drawing shown at the Royal Academy in 1796 is probably correct.

11

Abbotsbury Abbey, Dorset *c.*1796
pencil and watercolour, 142 × 212 mm
T.B.XXXIII–V

Both in colour and technique this drawing, and others like it executed in about 1795–6, are very close to the work of Edward Dayes. It is not clear from the sketchbooks that Turner actually visted Abbotsbury at so early a date, but it is in fact likely that he did so on

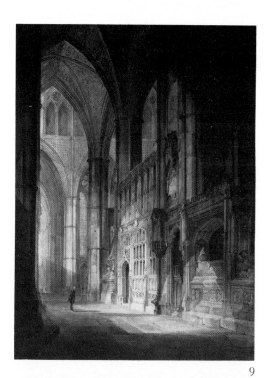

9

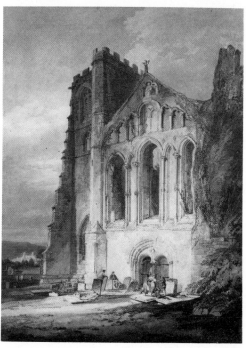

10

11

12

13

one of his journeys to Bristol or South Wales. An itinerary to Ludlow written out in the *Dinevor Castle* sketchbook of 1798 (T.B.XL, flyleaf) includes a reference to Abbotsbury. This watercolour may, however, have been adapted from a sketch by some other artist, Dayes himself, perhaps, or from an engraving.

12

A sailing vessel seen from the shore
*c.*1797
watercolour, 100 × 145 mm
T.B.XXXIII-X

13

Moonlight over the south coast *c.*1797
watercolour and bodycolour on coarse buff paper, 132 × 208 mm
T.B.XXXIII-N

One of a series of similar studies, all of marine subjects and usually with fishing-boats, which Turner made about 1797 at Brighton (see R.A.1974 no.36). Some are in the *Wilson* sketchbook, T.B.XXXVII, ff.104–14; others are separate in the Turner Bequest, XXXIII, K, L, Q, F etc. See also Nos.14 and 15.

14

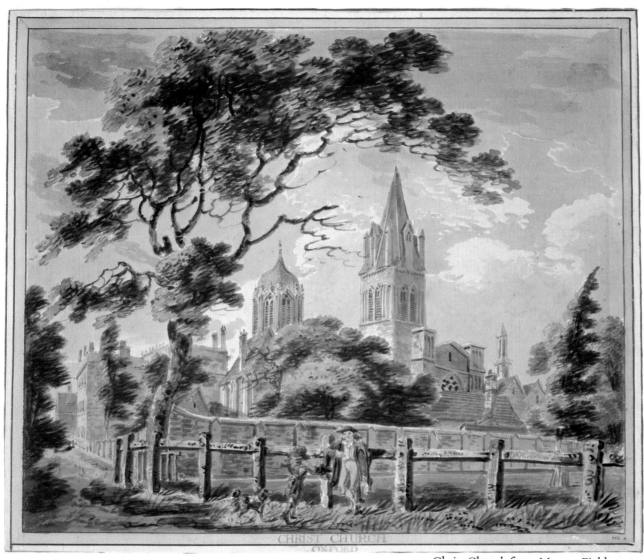

1 Christ Church from Merton Fields, 1791

14

Two sailing-boats near the shore *c.*1797
watercolour and bodycolour on coarse grey
paper, 195×274 mm
T.B.XXXIII–P

The subject-matter of this drawing, and
others like it in the Bequest (see No.13),
anticipates the sea-pieces of 1800–1802, and its
technique, though tighter, foreshadows the
free bodycolour sketches of breaking waves,
on a prepared tint, in the *Dunbar* sketchbook
(T.B.LIV ff.109 ff.).

15

Fishermen landing their boat in a storm
*c.*1797
watercolour and bodycolour on coarse buff
paper, 145×217 mm
T.B.XXXIII–L

See Nos.13 and 14.

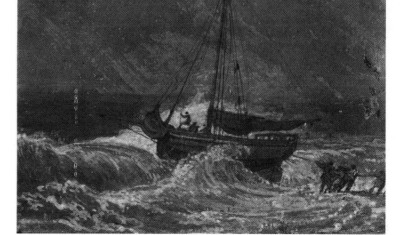

15

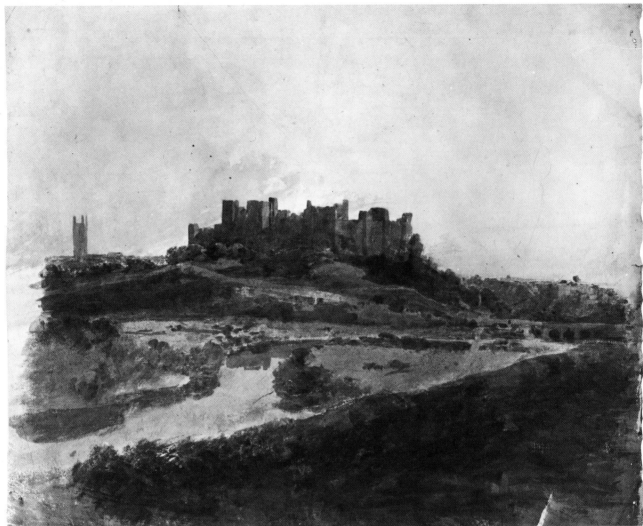

16

Imaginary landscape with Windsor Castle and a ? Welsh river *c.*1797
pencil and watercolour with some body-colour, 460×740 mm
T.B.XXXIII–H

The incongruous placing of Windsor Castle among mountain scenery derived from Turner's Welsh tours displays a whimsical humour totally uncharacteristic of the artist and hardly to be paralleled elsewhere in his output. The motif of shipping on a bend in a steep-banked river occurs in drawings related to the *Cyfarthfa* sketchbook (T.B.XLI) of about 1798, and the idea of the castle perched on a high cliff may derive from Turner's visit to Kilgarren Castle in the same year (see the *Hereford Court* sketchbook, T.B.XXXVIII, f.73 *recto*); but in terms of style this water-colour seems to belong to a slightly earlier date. For Colour Plate, see p.44

17

Ludlow Castle *c.*1798
pencil and watercolour, 438×532 mm
T.B.XLIV–i

17

Derived from a pencil study in the *Hereford Court* sketchbook of 1798, T.B.XXXVIII, f.63 *recto*. The sketch contains a group of trees at the right of the composition which is only barely indicated in this watercolour. Turner used a modified form of this view of the castle for the *England and Wales* subject of *c.*1830, Rawlinson, Vol. I, p.140, No.249.

18

A view among the North Welsh mountains *c.*1799
pencil and watercolour, 554×765 mm
T.B.LX(a)–C

Finberg in the *Inventory* called this drawing 'Great End and Scawfell Pike' and dated it to 1801, but in his *Life* (pp.159–60) reallocated the whole group LX (a) of eleven drawings to 1809 when Turner visited Westmorland to draw views of Cockermouth and Lowther in connection with commissions of Lord Egremont. He noted, however, that the *Cockermouth* in fact shows Conway Castle, and it is now clear that these watercolours are all of

North Wales scenes, and they may perhaps be returned to Finberg's original date of 1801, or even earlier, since they can be grouped with the series of large 'experimental' Welsh views of *c.*1798–9 (see Nos.20 and 21).

19
A view in North Wales *c.*1799
watercolour, 553×772 mm
T.B.LX(a)–A

One of the series of views supposed originally by Finberg to have been made in the Lake District in about 1801 but later redated 1809. It now seems likely that they belong to the group of Welsh views executed *c.*1798–9; see No.18.

20
Lake Llanberis with Dolbadern Castle
*c.*1799
pencil and watercolour, 553×761 mm
inscr. lower right: *53*
T.B.LXX–X

The development of Turner's art received an important impetus from his visits to North Wales in 1797, 1798 and 1799. The *Hereford Court* (T.B.XXXVIII), *North Wales* (T.B. XXXIX), *Dinevor Castle* (T.B.XL), *Lancashire and North Wales* (T.B.XLV) and *Dolbadern* (T.B.XLVI) sketchbooks contain many dramatic records of his response to mountain scenery which chimed in with his preoccupation with the 'Sublime'. In the *Studies for Pictures* sketchbook, in use about 1800 (T.B.LXIV), there is a series of highly atmospheric studies in coloured chalks of Dolbadern (ff.103 etc.) preparatory for the oil painting shown at the Royal Academy in 1800 (200), and this and many other exploratory watercolours presumably belong to the same phase of Turner's activity. See No.21. The imaginative, romantic quality of these essays was taken still further in a number of watercolours with historical themes based on early Welsh history, in particular the large *Caernarvon Castle, North Wales* shown at the Royal Academy in 1800 (381); see R.A.1974 no.43.

21
Dolbadern Castle *c.*1799
pencil and watercolour 677×972 mm
T.B.LXX–O

A very free essay perhaps based on sketches in the *Dolbadern* sketchbook (T.B.XLVI, ff.38, 39, 44) of 1799, and presumably one of the many bold experimental studies related to Turner's work on the oil painting *Dolbadern*

19

20

21

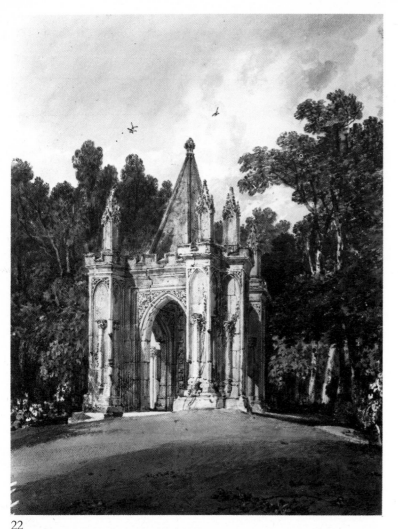

22

Castle shown at the Royal Academy in 1800 (see R.A.1974 no.48).

Turner appears to have mixed his colour with a vehicle thickened with paste or egg-white, as Cotman was to do in his later work. This has the effect of displaying more emphatically the unusual breadth and speed of the handling. Compare with the restrained and delicate technique of *Lake Llanberis with Dolbadern Castle* (No.20).

22

A Gothic arch in a garden at Salisbury
*c.*1800
watercolour over pencil, 379 × 293 mm
inscr. lower right: *W Turner*
coll: Sir Richard Colt Hoare, for whom drawn; Rev J. H. Ellis; H. A. Steward; sale, Christie, 28 July 1927(7); R.W. Lloyd, by whom bequeathed to B.M.1958–7–12–404.

Twenty 'drawings at Salisbury for Sir Richard Hoare' are listed on a sheet in the Turner Bequest in Sir Richard Colt Hoare's handwriting, CCCLXVIII–A (see also Finberg, *Life*, p.61). They include no. '3 Ancient Arch in Mr Wyndham's Garden', which must be identified with this drawing. Neither this nor

St Edmund's Church Salisbury (No.23) seems to have appeared in Sir Henry Hoare's sale in 1883. Turner was first commissioned to make drawings for Colt Hoare in 1795, and began the Salisbury drawings in that year or soon afterwards; he seems to have continued to be occupied with them, and with other work for Hoare, until the end of the decade or even later (see John Gage, *Turner and Stourhead*, 1974). Turner made some general studies of the cathedral and other buildings in Salisbury in his *Isle of Wight* sketchbook of 1795, (T.B.XXIV, ff.14–21), and again in the *Salisbury* sketchbook of about 1799 (T.B.XLIV); but there seems to be no first sketch for this subject, though a full-scale colour study for the composition is in the Turner Bequest, L–I. Two views of the cathedral were exhibited at the Royal Academy in 1797 (450, 517), and another in 1799 (335). Although Hoare's list is arranged in two groups of ten and is headed 'Size of the drawings' it is not very clear how the sizes were determined. On the whole, the first 10, of views in and around the city, seem to indicate a small format, the second 10, all of the cathedral, a larger; though the view of the *Cloisters* (Victoria and Albert Museum) is considerably smaller than the vast *Chapter House* (Whitworth Art Gallery, Manchester) and other interiors of the cathedral in that group. Nine of the subjects, all from the first 10, were sold by H. Arthur Steward at Christie's in 1927 (Lots 1–9).

23

St Edmund's Church, Salisbury *c.*1800
watercolour over pencil, 384 × 270 mm
inscr. lower right: *J M W Turner*
coll: Sir Richard Colt Hoare, for whom drawn; Rev. J.H. Ellis; H.A. Steward; sale, Christie, 28 July 1927 (9); R.W. Lloyd, by whom bequeathed to B.M.1958–7–12–403

See *A Gothic arch in a garden at Salisbury* (No.22). Referred to in the list of views for Sir Richard Colt Hoare, T.B.CCCLXVIII–A, either at No.7: '. . . church' (the blank partly filled in pencil 'St Ed'; and with 'by the Market [?Place]' added); or at No.9: 'St Edmund's Church'.

24

The Kitchen of Wells's Cottage, Knockholt *c.*1800
pen and black ink and oil paint on paper, 274 × 375 mm
inscr. *verso*: *101 Wells' Kitchen Knockholt*
T.B.XCV(a)–A

About 1800 Turner became an intimate of the

family of William Frederick Wells (1762–1836), a landscape artist and drawing-master; Wells's house in Mount Street became for Turner 'a haven of rest from many domestic trials too sacred to touch upon', and Turner also spent some time at Wells's cottage at Knockholt, Kent, where 'his visits . . . were one scene of fun and merriment'. Finberg dated the oil studies made at Knockholt on the evidence of a letter published by Rawlinson (*Liber Studiorum*, pp.xii, xiii) which states that Turner was at Knockholt in October 1806. But it is clear that he was there on many other occasions, and the studies may have been made earlier. The similarity of this rustic interior to the genre subjects that interested Turner in about 1806 seems most probably coincidental. In its experimental use of mixed media it is closer to Turner's studies of *c*.1799–1800. Other oil sketches in the same group (T.B.XCV(a)), including open-air studies of trees at Chevening in the same part of Kent (XCV(a)–B,ID) are close in style to work of *c*.1800. See also *A wild landscape with figures, at sunset*, No.26.

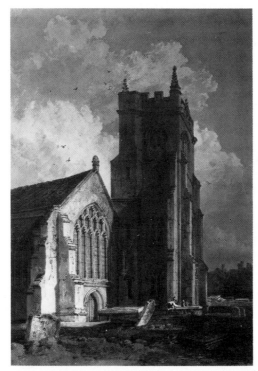

23

25

A path among trees in Chevening Park
?*c*.1800
oil and gum on paper, 272 × 373 mm
inscr. *verso*: *104 Chevening Park*
T.B.XCV(a)–D

One of the oil studies probably made while Turner was staying with the family of William Frederick Wells at Knockholt, dated by Finberg to about 1806 but perhaps done earlier. See No.24.

26

A wild landscape with figures, at sunset
c.1800
oil with some pen and ink on paper, 262 × 386 mm
T.B.XCV(a)–G

Associated by Finberg with a series of oil studies on paper made at Knockholt and dated by him to 1806–7. The use of the pen outline and the dark tonality are similar to those, although the subject-matter is evidently alien. The landscape may derive from a Welsh or Scottish scene. The figures appear to illustrate the parable of the Good Samaritan; these, and the colour, are reminiscent of Wilson. The mood of the whole sketch is close to that of some of the imaginative landscapes on which Turner experimented *c*.1798–1800, and the sheet may therefore perhaps be dated a few years earlier, as may all the Knockholt studies (see No.24).

24

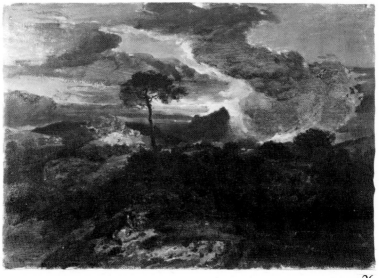

26

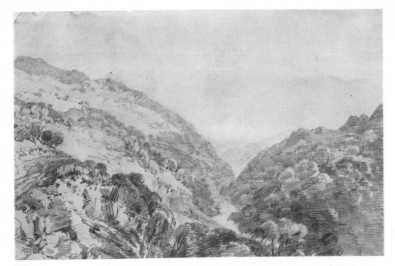

27

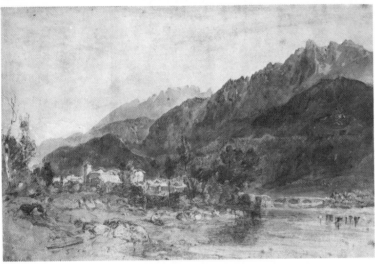

29

accents, the "serene" rejection of the unexpected, prove that they are not straightforward transcripts of actual scenes. Probably only parts of them were sketched from nature, and if we could see them in their earlier stages they would not be unlike the smaller line drawings in character. They were afterwards worked up at leisure into these extremely scientific compositions. All the pitfalls of vulgar topography were avoided; but poetry can be so feeble, so smug and genteel, that we sigh for prose.' This seems to miss the purpose of these drawings, which are primarily technical exercises expanding the range of monochrome notation, relying almost entirely on pencil which is used in a wealth of new ways developed out of the sketching style of J.R. Cozens and directly anticipating the studies made in Switzerland in the following year (e.g. Nos.29–32). In their use of a prepared surface (reported by Farington to have been made from 'a mixture of Indian ink and tobacco juice'; see Finberg, *Life*, p.74) they stand at the beginning of the long sequence of studies made in connection with tours that includes the 1817 Rhine views, and the 1819 Roman subjects in pencil over a grey wash.

28
Inverary Castle 1801
pencil and watercolour, 211 × 295 mm
T.B.LX–A

Very considerably faded, but one of the few Scottish watercolours in the Bequest to have survived exhibition: the remainder of the Series (T.B.LX), including the well-known *Loch Long, Morning* (LX–F) and *Edinburgh, from Caulton-hill* (LX–H; shown R.A.1804 (373)), are ruined. Turner's Scottish tour of 1801 may have been made in the company of a 'Mr Smith of Gower Street' mentioned by Farington (*Diary*, 19 June 1901). He planned to be away for three months, but appears to have completed his tour between the end of June and the beginning of August. Numerous sketchbooks were filled with rapid pencil notes: *Guisborough Shore* (T.B.LVI); *Helmsley* (T.B.LIII); *Dunbar* (T.B.LIV); *Edinburgh* (T.B. LV); *Scotch Lakes* (T.B.LVI); *Tummel Bridge* (T.B.LVII); and the *Scotch Figures* sketchbook (T.B.LIX) was used to make a few colour notes. In addition, Turner made the series of large 'Scottish Pencils' (see No.27). The tour resulted in a number of large watercolours, exhibited at the Academy (see R.A.1974 no.53), and formed a natural climax to Turner's exploration of mountain scenery in Britain. In the following year he was to visit the Alps.

27
Glen Lyon 1801
pencil, charcoal and white bodycolour on white paper prepared with a beige-grey wash, 662 × 525 mm
T.B.LVIII–20

Several drawings in the *Scotch Lakes* sketchbook (T.B.LVI) show Glen Lyon, e.g. ff.103, 104, 107; but none seems to relate specifically to the scene of this 'Scottish Pencil' drawing. It is one of a series of sixty more or less elaborate studies in pencil with some chalk, charcoal or bodycolour on prepared paper, made during or immediately after Turner's tour of Scotland between June and August, 1801 (see No.28). The title given to this series is Ruskin's; his original endorsement of the parcel containing them was: 'Scottish Pencils. Of very great value.' He later wrote that the ' "breadth" of effect' is 'carried even to dulness in its serene rejection of all minor elements of the picturesque'. Finberg (*Life*, p.74) remarks that 'they are probably the dullest set of drawings Turner ever made. The monotonous elaboration, the absence of

29

Bonneville 1802
pencil, watercolour and bodycolour on white
paper prepared with a grey wash,
314×472 mm
inscr. lower left: *Bonneville*
T.B.LXXV–7

The drawing on which Walter Fawkes's
watercolour (Finberg, *Farnley*, No.17) and
later the *Liber Studiorum Bonneville* (Finberg
No.64) were based. See also the version in the
British Museum (No.37). This study and
Nos.30, 31 and 32, are from the *St Gothard
and Mont Blanc* sketchbook, which Turner
prepared throughout with a ground of grey
wash. His use of it is an extension of the
technique of the 'Scottish Pencils' (see No.27)
with added colour in many cases. Although
most of the leaves are in the Turner Bequest
some were distributed; e.g. *The Great Fall of
the Reichenbach* in the National Gallery of
Ireland (Vaughan Bequest); *L'Aiguillette* and
Lake Thun at the Whitworth Art Gallery,
Manchester; *Mont Blanc from the Val d'Aosta*
in the Fitzwilliam Museum, Cambridge, and
Bonneville (a different subject) and *The Upper
Fall of the Reichenbach* in the Courtauld In-
stitute Galleries. Another series of Swiss
drawings in similar medium but on much
larger sheets of prepared paper is T.B.LXXIX
(see R.A.1974 no.60).

30

A ravine on the Pass of St Gothard 1802
pencil and watercolour with scraping-out on
white paper prepared with a grey wash,
318×475 mm
T.B.LXXV–35

Although this is one of the most fully worked-
up of the studies Turner made in Switzerland
in 1802 it does not appear to have been used
for any finished watercolour. See No.29.

31

The Mer de Glace, Chamonix 1802
pencil, watercolour and bodycolour on
white paper prepared with a grey wash,
314×468 mm.
T.B.LXXV–23

One of the studies of the Mer de Glace in the
St Gothard and Mont Blanc sketchbook. This
was the starting-point for the finished water-
colour of *c*.1806 bought by Fawkes and later
owned by Humphrey Roberts (Finberg,
Farnley, No.20). The other was used for
*Blair's Hut on the Montanvert, and Mer de
Glace, Chamonix* which was in Fawkes's
collection (Finberg, *Farnley*, No.12,) and now

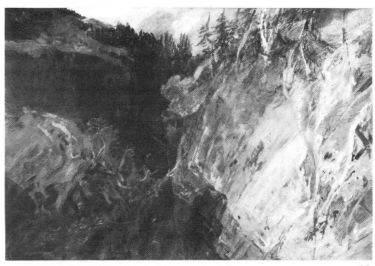

30

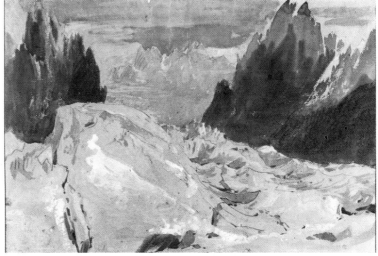

31

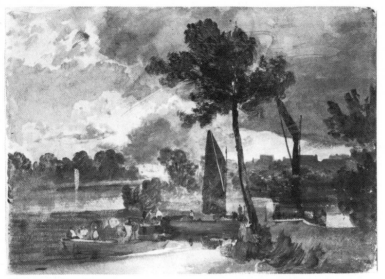

33

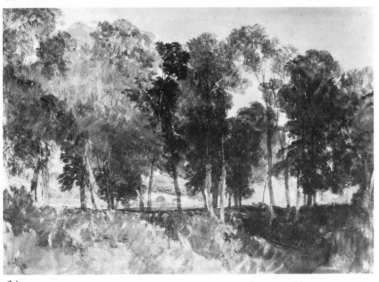

34

and colouring of those architectural subjects of the 1790s is transferred to natural scenery. Another of the Fawkes subjects (Finberg, *Farnley*, No.24) was reused in 1815 on the same large scale and exhibited at the Royal Academy in that year (No.43).
For Colour Plate, see p.43

33

Scene on the Thames with barges and rowing boats: Windsor Castle in the background *c.*1806
watercolour, 256 × 365 mm
T.B.XCV–12

This and No.34 are from a roll sketchbook watermarked 1797, and labelled by Turner: *Thames from Reading to Walton*. The series of watercolours in it has been associated with the open-air oil sketches of the Thames usually dated to about 1807 (see R.A. 1974 nos. 143–146) but they are in fact likely to be a little earlier. There are strong stylistic connections, as well as similarities of subject-matter, with drawings in the *Studies for Pictures: Isleworth* sketchbook, in use from about 1804 to 1806 (T.B.XC). These watercolours mark Turner's first mature use of the medium to create a group of fully developed studies for his own reference rather than for sale, exhibition or engraving.

34

A group of trees beside the Thames: A bridge in the distance *c.*1806
pencil and watercolour, 257 × 371 mm
T.B.XCV–46

The bridge is apparently that at Kew. See the *Scene on the Thames with barges and rowing boats*, No.33.

35

Scene on the French coast 1806–7
etching with pencil and sepia wash and scraping-out, 180 × 253 mm
T.B.CXVI–D

An early touched proof of the *Liber Studiorum* plate (Finberg No.4); the sepia wash added by Turner to his own etched outline before the plate was mezzotinted by Charles Turner. The completed plate was published in Part I of the *Liber*, 1807. Turner's sepia drawing of the subject is T.B.CXVI–C. Rawlinson's title is *Flint Castle, vessels unloading*; Finberg, without comment, calls the subject *Scene on the French coast*. If this identification is correct, the castle is presumably that of Wimereux; but it may be that Rawlinson's title was the original one. In his *Turner's sketches and*

in the Courtauld Institute Galleries (Kitson, *Turner Watercolours from the Collection of Stephen Courtauld*, 1974, No.4).

32

The Devil's Bridge, Pass of St Gothard 1802
pencil, watercolour and bodycolour and scraping-out on white paper prepared with a grey wash, 471 × 318 mm
T.B.LXXV–34

A view looking back to the Devil's Bridge from which he drew the subject of the large watercolour acquired by Walter Fawkes (now Abbot Hall Art Gallery, Kendal); the preliminary drawing is LXXV–33. Of the sixteen early Swiss watercolours owned by Fawkes two (this and *The Great Fall of the Reichenbach* (Cecil Higgins Museum, Bedford; repr. Finberg, *Farnley*, pl.IX)) were upright, exploiting soaring verticals as Turner had done in his views of Ely, Salisbury, Durham and Westminster (see No.9). The 'sublime' scale

Drawings in fact, (pp.75–77, Finberg discusses the design at length under the title *Flint Castle*. He points out that 'as the spacing and arrangement of the etching differ considerably from those of the drawing, it is most likely that an intermediate study was made'. Turner began work on the *Liber Studiorum* in the autumn of 1806; it was to be a comprehensive series of landscape compositions, emulating the *Liber Veritatis* of Claude as reproduced in etching and mezzotint by Richard Earlom for Boydell in the 1770s. The scheme apparently developed from a suggestion of Turner's friend William Frederick Wells (see No.24, and Finberg, *Life*, pp.127–8). Plates continued to appear until 1819, issued in sets of five representing landscape in distinctly labelled categories: Historical, Architectural, Mountainous, Marine and Pastoral (or Epic-Pastoral); see Introduction. The *Scene on the French coast* was published with the initial *M* (for Marine).

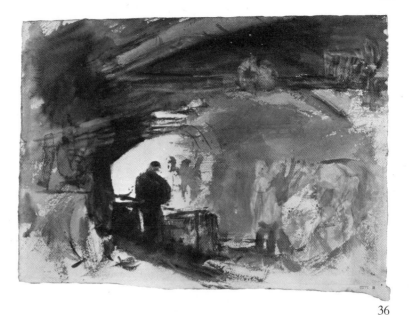

36

36

A blacksmith's shop *c*.1807
brush and black and brown washes,
195 × 274 mm
T.B.CXVI–H

Connected stylistically with the designs for the *Liber Studiorum* although not used for that work, and thematically with the *Country blacksmith disputing upon the price of iron*, shown at the Royal Academy in 1807 (135); see R.A.1974 no.133.

37

Bonneville *c*.1808
watercolour, 277 × 394 mm
signed lower right and possibly dated *08*
coll: Abel Buckley, 1904; Agnew, sold 1906 to George Salting, by whom bequeathed to B.M.1910–2–12–284

Finberg considered this drawing 'badly faded and almost certainly repainted'; but its condition does not seem to justify so severe a comment, although that it has apparently lost a certain amount of colour is noticeable especially in the foreground. None of the rapid pencil and chalk sketches in the *France, Savoy, Piedmont* sketchbook, T.B.LXXIII, ff.46 (*Nr Bonville*), 46a, 47 (*Bonville*), 48 (*Villeneuve before Bonville*) corresponds to it exactly; the last of these is the closest.

The composition is close to that of a pencil sketch amplified with watercolour and bodycolour (No.29) and inscribed *Bonneville*. (A sketch using similar technique to that of LXXV–7 in the Lloyd Bequest (1958–7–12–407) shows the town on a hill above the

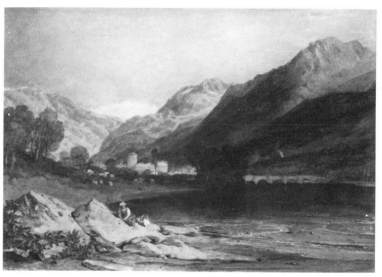

37

valley.) A further watercolour, less finished than the Salting drawing, shows Villeneuve from a slightly different angle. A modified version of the same view was used for the *Liber Studiorum* plate of *Bonneville*: T.B. CXVIII–J and Finberg No.64.

The watercolour of similar size executed for Walter Fawkes (now in a private collection, London) is the prime version of this view; an oil painting of the subject was possibly that exhibited at the Royal Academy in 1812 (149) as *A view of the Castle of St Michael, near Bonneville, Savoy* and now in the Johnson Collection, Philadelphia. Turner made other views of Bonneville including the oil painting R.A.1974 no.4. One watercolour, larger than those mentioned, belonged to Ruskin and is now in the Courtauld Institute Galleries (Kitson, *Turner Watercolours from the collection of Stephen Courtauld*, 1974, No.2) and another was made for either Sir John or Edward Swinburne in 1817. It is possible that the present *Bonneville* was commissioned by

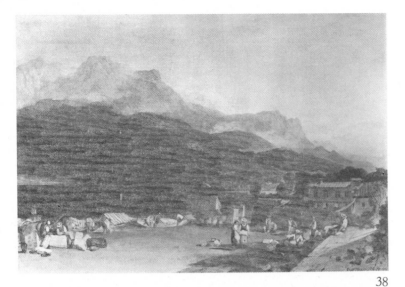

38

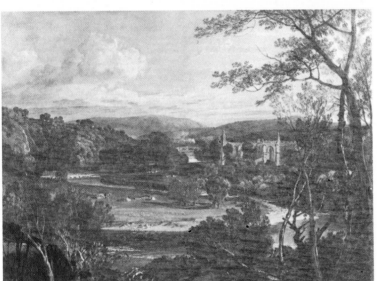

39

40

Swinburne, who often asked for subjects similar to those owned by Fawkes (see *The Lake of Thun*, No.38).

38

The Lake of Thun 1809
watercolour, 388 × 556 mm
signed and dated, lower right: *I M W Turner RA. PP 1809*, and inscr. again, top centre, with date
coll: 'A member of the Swinburne family', for whom drawn; Julia Swinburne, sale, Christie, 26 May 1916 (118); R.W. Lloyd, by whom bequeathed to B.M.1958-7-12-409

It is not certain which member of the Swinburne family it was who commissioned drawings from Turner. Thornbury (Vol. II p.43) speaks of 'Mr E. Swinburn, himself an accomplished artist' who 'was very intimate with Turner'; this was presumably Edward, elder son of Sir John Edward Swinburne, Bart., of Capheaton, Northumberland. Thornbury states that 'Turner used to stay in Northumberland, at the seat of Sir John Swinburn, Bart', and Kingsley mentions an incident which took place on one of these visits (see *Prudhoe Castle*, No.106). Edward Swinburne was born in 1788 and may possibly have taken drawing lessons from Turner, who was probably introduced to the family by Walter Fawkes. The Swinburne commissions seem to follow Fawkes's example closely; this view of the Lake of Thun is one of the few finished Swiss watercolours of the period not to have been owned by Fawkes; it is not the same as the *Lake of Thun* formerly at Farnley (see R.A.1974 no.68), but belongs to a group of drawings using Swiss material, made about 1809, among which the Salting *Bonneville* occurs (No.37). Later, the two views of *Biebrich Palace* and *Marxburg* (Nos.79 and 80) appear to have been specifically chosen from drawings in Fawkes's collection, which were used as models for the Swinburne watercolours.

39

Bolton Abbey 1809
watercolour and scraping-out, 278 × 395 mm
inscr. lower right: *I M W Turner RA PP 1809*
coll: George Salting, by whom bequeathed to B.M.1910-2-12-282
engr: by E. Finden, 1826, for *The Literary Souvenir* (Rawlinson, Vol. II, p.220, No.315)

Finberg considered the drawing 'faded, & very much restored and repainted' but although it has lost some colour from exposure to light it seems to retain much of its quality.

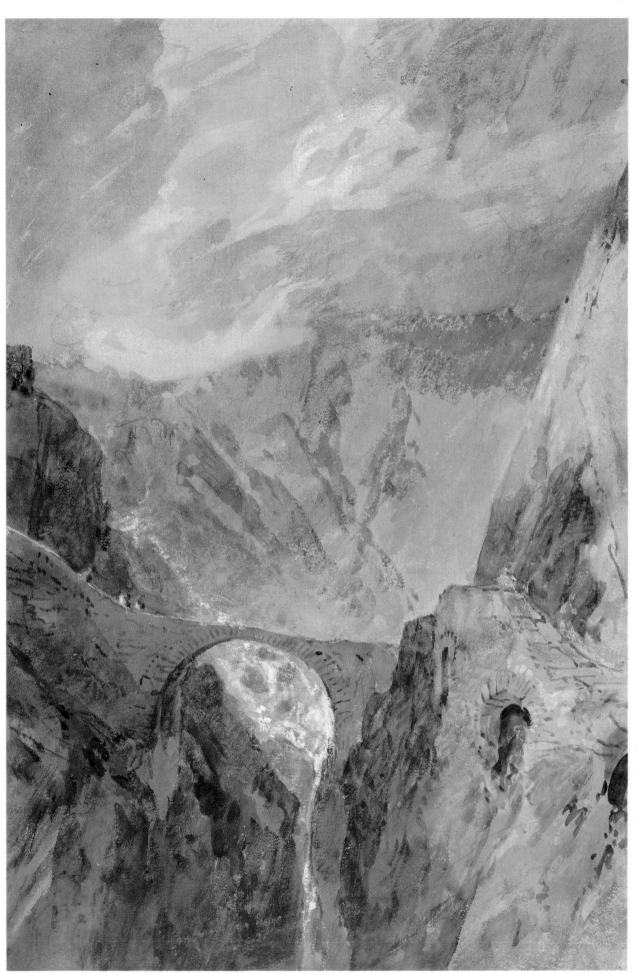

32 The Devil's Bridge, Pass of St Gothard, 1802

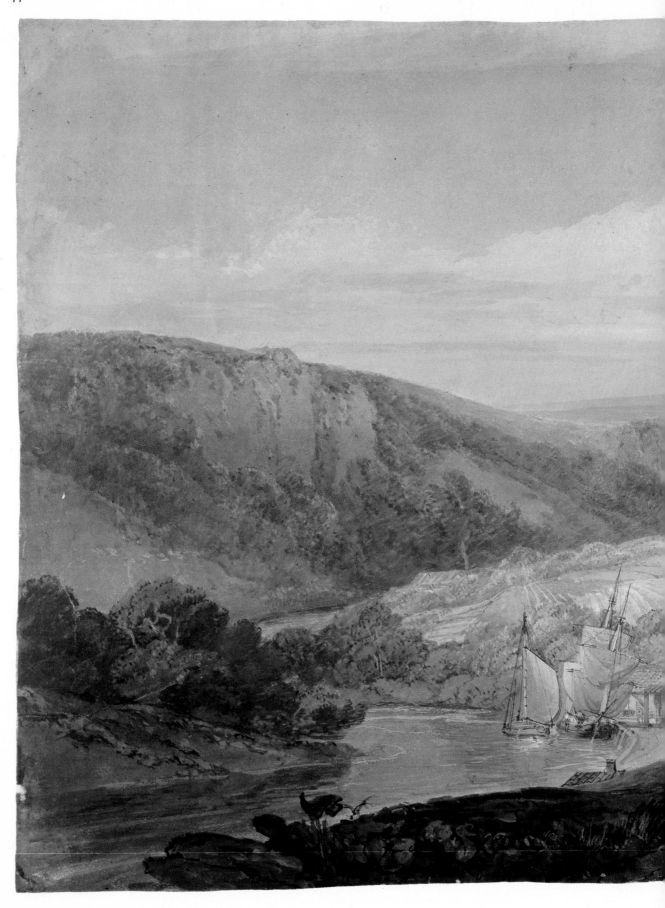

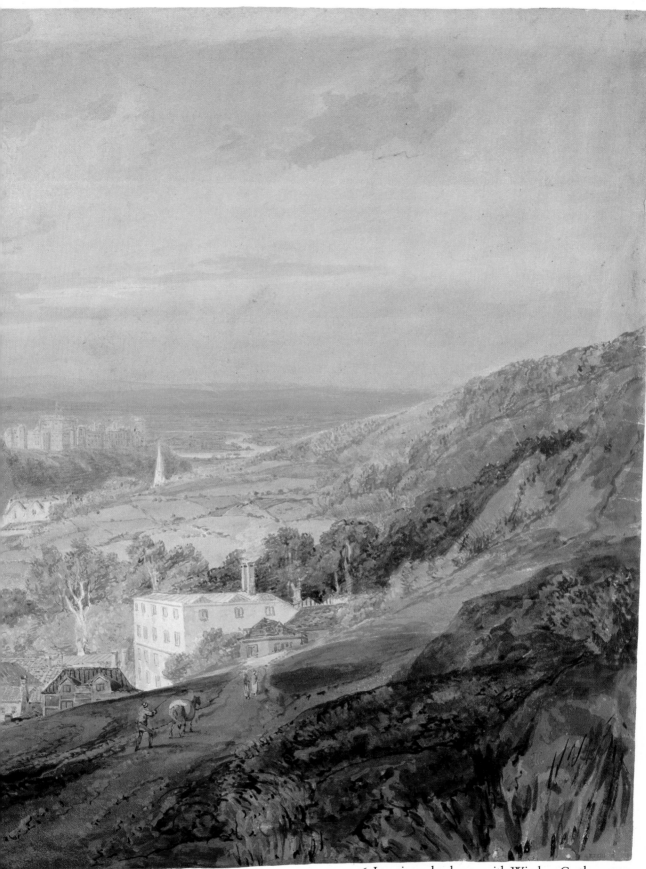

16 Imaginary landscape with Windsor Castle, *c.* 1797

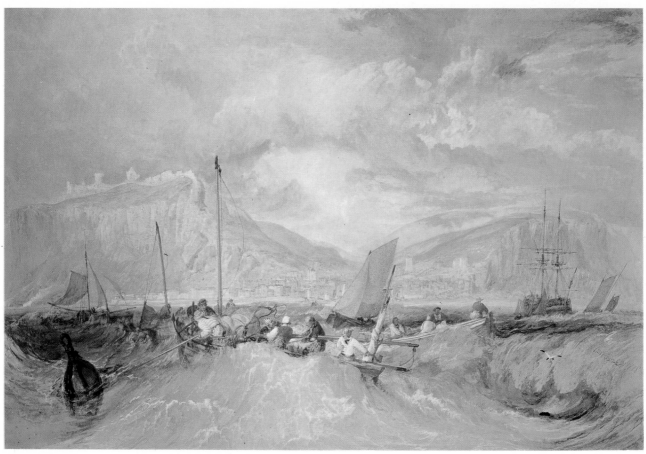

54 Hastings: Deep sea fishing, 1818

Any retouching is so discreet as to be difficult to identify precisely.

In general treatment the British Museum drawing is similar to some of the Fawkes 'Wharfedale' subjects. Turner made several finished watercolours showing views of Bolton Abbey, including one for Walter Fawkes which dates from about 1812 (Finberg, *Farnley*, No.80). It is not known for what purpose the present example was executed; no sketches of Bolton exist in the Turner Bequest before about 1811, except for a summary note of the architecture in the *Tweed and Lakes* sketchbook of 1797 (T.B. XXXV, f.68 *recto*).

40

A breaking wave *c.*1809
grey and brown washes, 229 × 375 mm
T.B.CXV-7

From the roll sketchbook *Studies for 'Liber'* (CXV) and executed in the characteristic medium of the *Liber* series, but not directly related to any developed *Liber* subjects. There are a number of similar studies in brown wash, either suggesting waves or indicating bands of light and one without a specific subject.

41

Cockermouth Castle *?c.*1810
watercolour with charcoal, red chalk and

bodycolour, 344 × 484 mm
watermarked: 1794
T.B.CCLXII-92

This colour-beginning, tentatively entitled *Windsor* by Finberg, appears to be connected with the painting of Cockermouth which Turner executed for Lord Egremont after Turner's visit to Westmorland and Cumberland in 1809, and now at Petworth (No.653, C.H. Collins Baker, *Catalogue of the Petworth Collection of Pictures*, 1920, p.126 (repr.)). It combines unusual media, and may have been executed round about the same time as the picture. Turner's pencil sketches of the subject are in the *Petworth* and *Cockermouth* sketchbooks, T.B.CIX, ff.13-24, and CX, ff.16-21.

42

Illustration to a perspective lecture: St George's, Bloomsbury *c.*1810
pencil, watercolour and bodycolour, 737 × 464 mm
inscr. top left: 7
T.B.CXCV-145

Turner used Bloomsbury Church for another of his perspective illustrations (T.B.CXCV-144, inscribed 6). He became Professor of Perspective at the Royal Academy in December 1807, but did not deliver his first lecture until 1811, after which he held the office until 1837; his

successor, John Prescott Knight, was elected in 1839. Turner's elaborate and carefully thought-out notes for the lectures are in the British Library Department of Manuscripts (Add. 46151), and the series of diagrams and illustrative drawings which were among the principal attractions of the lectures are in the Turner Bequest. His subject-matter was wide ranging, covering aesthetic theory as well as practical instruction, but it was sometimes criticized as irrelevant to the study of perspective as such. His mode of delivery was also found uncongenial; at first he was said to have 'got through with much hesitation and difficulty' (Farington, *Diary*, 14 January 1811), and later the lectures were 'much laughed at as being ignorant and ill written' (ibid., 10 March 1812). During the 1820s they were poorly attended and in 1828 he ceased to lecture altogether. For a detailed account of Turner as Professor of Perspective see W.T.Whitley, 'Turner as Lecturer', *Burlington Magazine*, XXII, 1913, pp.202–8, 225–9, and John Gage, *Colour in Turner*, 1969, ch.6, pp.106–17.

43

The Battle of Fort Rock: Val d'Aouste, Piedmont, 1796 1815

watercolour, 695 × 1010 mm
inscr. lower left: *I M W Turner 1815*
exh: R.A.1815(192); Marlborough House 1857–8(75)
T.B.LXXX–G

Shown at the Royal Academy with the following lines from Turner's manuscript poem *The Fallacies of Hope*:

The snow-capt mountain, and huge towers of ice,
Thrust forth their dreary barriers in vain;
Onward the van progressive forc'd its way,
Propelled; as the wild Reuss, by native glaciers fed,
Rolls on impetuous, with ev'ry check gains force
By the constraint uprais'd; till, to its gathering powers
All yielding, down the pass wide devastation pours
Her own destructive course. Thus rapine stalked
Triumphant; and plundering hordes, exulting, strew'd,
Fair Italy, thy plains with woe.

The subject illustrates an incident in the Val d'Aosta during Napoleon's invasion of Italy in 1796. Turner visited the Val d'Aosta on his tour of Switzerland in 1802, and made a note of this view in the *St. Gothard and Mont Blanc* sketchbook, T.B.LXXV (see No.29); the leaf is now in the Fitzwilliam Museum (No. 1585). Another drawing, on f.46 of the same book, is described by Finberg (*Inventory*, Vol. I, p.202) as bearing an inscription *Le Fort de St Rock Valley de Aoust* but no trace

of this is now visible. In his note on *The battle of Fort Rock* for the Marlborough House exhibition (p.31) Ruskin stated that 'there is nearly a duplicate of it at Farnley', referring to the *Mont Blanc from Fort Rock* which Walter Fawkes acquired from Turner possibly in 1804. (See Finberg, *Farnley*, p.22, No. 24, and p.2; the drawing is now in a private collection.) Q.F. Bell in his *List of works exhibited in public exhibitions by J. M. W. Turner R.A.* (1901, No.73) suggests that this was the work shown at the Royal Academy in 1815, describing the present version as a 'replica'; but the two compositions vary in important particulars especially with regard to the battle, which does not appear in the earlier one (see Introduction, p.17). The watercolour is one of Turner's most elaborate, comparable with the · *Scarborough* shown in 1811 (see R.A. 1974 no.113), and the *Tivoli* of 1817 (R.A. 1974 no.81.) There are signs of several pentimenti, particularly in the disposition of the foreground trees, which were modified apparently with the intention of emphasizing rather than breaking the vertiginous central stress. Flaking colour in some parts towards the top left corner of the picture has revealed a layer of rose-pink underpaint, a device which Turner had explored as early as 1799 or 1800 (see R.A.1974 no.639).

Kingsley noted that the *Battle of Fort Rock* 'was found after Turner's death, blocking up a window in an out-house, placed there no doubt to save window tax' (*Ruskin on Pictures*, 1902, p.421).

44

The source of the Arveiron c.1815

pen and brown and brownish-black ink and reddish-brown wash, 222 × 310 mm
engr. in mezzotint by J.M.W. Turner (etched outline probably by H. Dawe) for Part XII of the *Liber Studiorum*, 1816 (Finberg No.60)
coll: Henry Vaughan, by whom bequeathed to B.M.1902 (T.B.CXVII–6)

Categorized by Turner as 'Mountain Landscape'. The design is loosely based on drawings in the *St Gothard and Mont Blanc* sketchbook (T.B.LXXV, ff.20, 21) and on large loose sheets (T.B.LXXXIX–F,G) which were also used for the large watercolour of the *Mer de Glace and source of the Arveiron* in Fawkes's collection (now belonging to Mr and Mrs Paul Mellon; R.A.1974 no.65). Another watercolour of *The source of the Arveiron*, measuring 11″ × 15½″ (280 × 394 mm) is now in the National Museum of Wales (Turner House, Penarth; Wedmore 1900, No.13; Finberg, *Farnley*, No.22).

46

47

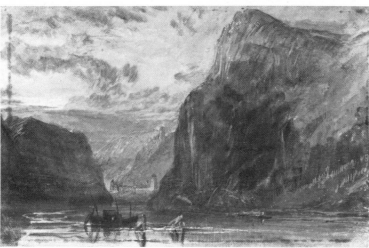

48

45
The Vale of Ashburnham 1816
watercolour, 379 × 563 mm
signed and dated, lower right: *I M W Turner RA 1816*
coll: J. Fuller; by descent to Sir Alexander Acland-Hood; sale, Christie, 4 April 1908 (91); George Salting, by whom bequeathed to B.M.1910-2-12-272
engr: by W.B. Cooke, 1817, for *Views in Sussex*, pl.4,(Rawlinson, Vol. I, p.71, No.131)

Based closely on a pencil drawing of the view in the *Vale of Heathfield* sketchbook, T.B. CXXXVII, ff.68-9 (R.A.1974 no.130), in which occur both the bullock-cart and the disposition of trees at the right of the composition. Beachy Head is visible in the centre distance. *Views in Sussex* was commissioned from Turner by John Fuller of Rosehill (Brightling Park) Sussex, who had been a patron of the artist since about 1810 (see Farington, *Diary*, 21 April, 1810, quoted in Finberg, *Life*, p.169). Only one of the two proposed parts of the book appeared; it contained five engravings by W.B. Cooke, and an emblematical cover design, etched by Turner himself. Three other plates were unused or unfinished. The original drawings by Turner were part of a series of thirteen large and elaborate watercolours completed for Fuller in about 1816, and sold by Sir Alexander Acland-Hood at Christie's, 4 April 1908 (85-97). Of these, another view of Ashburnham, looking inland, was aquatinted by J.C. Stadler issued privately with three other Sussex subjects (Rawlinson No.823; and see R.A.1974 nos.127-129 and B102).
For Colour Plate, see p.92

46
The Vale of Heathfield 1816
watercolour, 379 × 562 mm
coll: J. Fuller; by descent to Sir Alexander Acland-Hood; sale, Christie, 4 April 1908 (92); George Salting, by whom bequeathed to B.M.1910-2-12-273
engr: by W.B. Cooke, 1818, for *Views in Sussex*, pl.6 (Rawlinson, Vol. I, p.72, No.133)

Based on a pencil drawing of the view in the *Vale of Heathfield* sketchbook, T.B.CXXXVII ff.41 *verso*, 42 *recto*. See *The Vale of Ashburnham*, No.45.

47
Rose Hill, Sussex 1816
watercolour, 379 × 556 mm
coll: J. Fuller; by descent to Sir Alexander Acland-Hood; sale, Christie, 4 April 1908

(97) bt. Colnaghi; Rev. J.W.R. Brocklebank; sale, Christie, 25 November 1927 (92); R.W. Lloyd, by whom bequeathed to B.M.1958-7-12-411

One of thirteen watercolours of views of Rosehill and its neighbourhood made for 'Jack' Fuller; see No.45. This subject is not that aquatinted by J.C. Stadler under the same title (Rawlinson No.822) which was originally called *The Vale of Pevensey from Rosehill Park* (Acland-Hood sale, 1908, No.93).

A slight drawing of Rosehill, not from the same angle, is on f.65 *recto* of T.B.CXI (the first *Hastings* sketchbook); the second *Hastings* sketchbook (T.B.CXXXIX) has a more careful drawing of the house and grounds from the viewpoint of the watercolour (f.34 *recto*, 33 *verso* continued on 32 *verso*); this study was adhered to closely for the final composition.

48
Lurleiberg and St Goarhausen 1817
watercolour and bodycolour on white paper prepared with grey wash, 197×309 mm
verso: slight pencil sketch of mountains or clouds
coll: W. Fawkes 1817 (Finberg, *Farnley*, No.43); Frederick H. Fawkes; Agnew 1913; R.W. Lloyd, by whom bequeathed to B.M.1958-7-12-416

Drawings of St Goarhausen appear on ff.24 *verso* and 25 *recto* of T.B.CLXI; one of the Lurleiberg from St Goarhausen on f.26 *recto*. None shows the exact scene of this drawing.

One of the fifty-one Rhine views bought by Fawkes in 1817. It did not figure, however, in the 1890 sale in which as Finberg says 'nearly three-quarters of the series were sold... the 16 best drawings were carefully retained'; but these had left Farnley before the 1937 sale. The drawings were made, probably in Yorkshire, either at Farnley or at Raby Castle, in the autumn of 1817 immediately after Turner's arrival in England from his first Rhine tour. In style and technique the series are close to many of the views of Farnley that Turner made about the same date (see R.A.1974 nos.191, 192) and it is possible that they were executed under similar conditions, that is, at Farnley and as a specific commission from Fawkes. The spontaneity of the drawings is uncharacteristic of work intended by Turner to be exhibited or sold to a patron in the normal way (See Finberg, *Farnley*, p.8).

49
Johannisberg 1817
watercolour on white paper prepared with

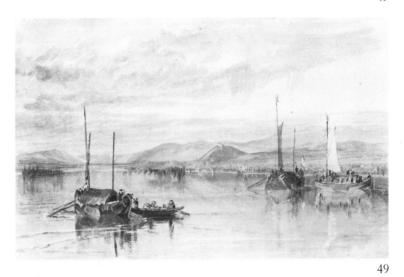

49

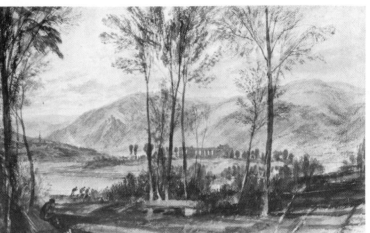

50

grey, 213×337 mm
coll: W. Fawkes; Frederick H. Fawkes; Agnew 1912; H.E. Walters; Agnew 1918; A.E. Lawley; sale, Christie, 25 February 1921 (127); R.W. Lloyd, by whom bequeathed to B.M.1958-7-12-418

A tiny pencil sketch showing Johannisberg from roughly this position occurs on f.70 *verso* of the *Waterloo and Rhine* sketchbook (T.B.CLX). The drawing was one of the Rhine series bought by Fawkes in 1817 (Finberg, *Farnley*, No.29, Pl.xxiii); see No.48.

50
Abbey near Coblenz 1817
watercolour on white paper prepared with grey, 195×313 mm
coll: W. Fawkes; Frederick H. Fawkes; Agnew 1912; R.W. Lloyd, by whom bequeathed to B.M.1958-7-12-412

The sketch used as a basis for this drawing is a pencil study on f.56 *verso* of T.B.CLX (*Waterloo and Rhine* sketchbook); it is inscribed *Abernath* (?). See No.48.

51

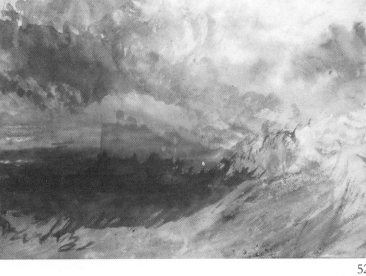

52

51

Durham Cathedral with a Rainbow

?c.1817
watercolour, 550×370 mm
inscr: *Durham/Willow Paper*
T.B.CCLXIII-125

A watercolour study of Durham with a rainbow occurs on f.98 *recto* of the *Helmsley* sketchbook (T.B.LIII) of 1801; this colour-beginning, however, probably dates from somewhat later. Turner was in Durham in the autumn of 1817, taking notes for illustrations to Surtees' *History of Durham*, and a number of sketches of the city, including the cathedral, appear in the *Durham, North Shore* sketchbook used on that trip (T.B.CLVII, ff.6–12). Although no specific connection is apparent, it may be that this colour study was a result of that visit. The sheet was originally half of a larger one, and part of this drawing remains on the other half (see *A Storm over a rocky coast*, No.52). Both halves were inscribed by Turner *Willow Paper*, presumably indicating that the sheet was a sample of some brand which he was trying out. It is rather inferior in quality to the Whatman paper he customarily used, though with a smooth, hard texture.

52

A storm over a rocky coast ?c.1817

watercolour with some pencil, 370×547 mm
inscr. lower right: *Stranded Vessel*(?) and
Willow Paper
T.B.CCLXIII-32

The strip at the bottom of this sheet forms the left-hand side of the sketch of *Durham with a rainbow*, No.51; Turner himself must have been responsible for cutting the sheet to separate the two studies, as he inscribed *Willow Paper* on both. There is no evidence of a 'stranded vessel' in the design, although the two pencilled circles in the water below the dark cliff may possibly indicate a vehicle of some description. This and other studies in the Bequest which show a rocky coast in stormy light (e.g. CCCLXV-33) may have been based on Turner's impressions of the coast near Land's End, some sketches of which appear in the *Cornwall and Devon* sketchbook of 1811 (T.B.CXXV-A, ff.17–29); but in view of the subject on the other half of the sheet, this may be a scene on the coast of Durham or Northumberland.

53

A fort by a stormy sea ?c.1817

watercolour, 335×437 mm approx.
T.B.CCLXIII-196

The subject may be a harbour on the southern coast, perhaps in Devon or Cornwall, and is perhaps connected with Turner's work on the *Southern Coast* designs between 1811 and 1826. In treatment it has certain similarities with the 'Land's End' series and other stormy coast scenes provisionally dated *c.*1817; but some of these subjects may be of northern scenery; see No.52.

54

Hastings: Deep sea fishing 1818

watercolour, 398×591 mm
signed and dated lower right:
I M W Turner R A 1818
coll: ?W.B. Cooke; Charles Sackville Bale;

sale, Christie, 13 May 1881 (197), bt Vokins;
S.G. Holland; sale, Christie, 26 June 1908
(258), bt Sir Joseph Beecham; sale, Christie,
3 May 1915 (150), bt R.W. Lloyd, by whom
bequeathed to B.M.1958–7–12–419
engr: by R. Wallis, 1851; Rawlinson, Vol. II,
p.344, No.665

A detailed study of the cliffs and town of
Hastings from roughly the same angle off the
coast is on ff.22 *verso* and 23 *recto* of the second
Hastings sketchbook (T.B.CXXXIX), used
when Turner was making studies for the
views of Sussex commissioned by John
Fuller of Rosehill in 1816 (see No.45). Two
large colour-beginnings of the same subject
are T.B.CXCVII–J,K. A watercolour of *Hast-*
ings from the Sea was exhibited by Cooke in
1822(9); this was identified by Finberg with
the drawing in the National Gallery of Ire-
land (Vaughan Bequest), which may how-
ever have been executed rather later. The
subject of *Deep-sea fishing* may be compared
with the later painting *Line-fishing off Hast-*
ings exhibited at the Royal Academy in 1825
(234) and now in the Victoria and Albert
Museum. For Colour Plate, see p.46

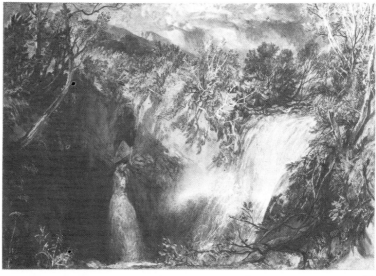

55

55
Weathercote Cave near Ingleton *c.*1818
watercolour, 301 × 423 mm
coll: Abel Buckley; Agnew 1904; George
Salting, by whom bequeathed to B.M.1910–
2–12–281
engr: by S. Middiman, 1822, for Whitaker's
History of Richmondshire; Rawlinson, Vol. I,
p.107, No.188

The full title of this design, as engraved on the
plate, is *Weathercote Cave when half filled with*
water. Turner noted the subject 'Weather-
cote' in a list of drawings for Walter Fawkes
in his *Greenwich* sketchbook (T.B.CII inside
cover and again on f.52) but no drawing of
the scene seems to have reached Farnley. The
pencil study from which this watercolour
derives is on f.33 *verso* of the *Yorkshire 4*
sketchbook (T.B.CXLVII), which is inscribed
Weathercote [?] *Water fall* or *upper fall*. Dr
Whitaker's *History of Richmondshire* was part
of a projected work on the history of York-
shire as a whole, incorporating earlier publica-
tions for which Turner had already made
designs: the *History of Whalley*, 1800–01; the
History of Craven (2nd edition), 1812; and the
History of Leeds, 1816. Although *Richmond-*
shire was very successful, the scheme was
never completed.

56
On the Washburn, under Folly Hall
*c.*1818

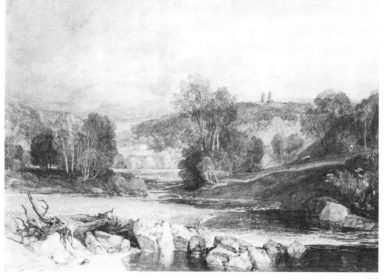

56

watercolour, 277 × 393 mm
signed lower left: *IMW Turner RA*
coll: Sir Henry Pilkington; John Dillon, sale,
Christie, 17 April 1869 (45); R. Leake; F.
Stevenson; James Orrock; Agnew, 1903; sale,
Christie, 4 June 1904 (40); George Salting,
by whom bequeathed to B.M.1910–2–12–287

A pencil drawing of the scene, with fore-
ground, river and hills touched with water-
colour and now badly faded, is on f.41 of the
Large Farnley sketchbook (T.B.CXXVIII).
Turner made numerous watercolour views
on the Washburn for Fawkes, and some in
the same area for Sir Henry Pilkington who
was the first owner of this one.

57
View over the roofs of an Italian town
1819
pencil and watercolour, 224 × 287 mm
T.B.CLXXXI–3

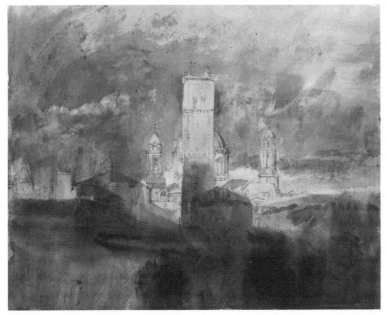

57

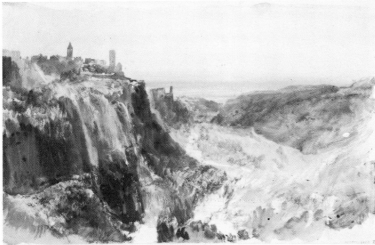

59

60

The exact location of this view has not been identified. The town is presumably one in northern Italy, near Como, Milan or Venice, since the drawing occurs on a sheet of the *Como and Venice* sketchbook, which Turner seems to have used only at the beginning of his Italian tour. He had intended to visit Italy for some time, but various engagements had made the journey impossible in the year immediately after the defeat of Napoleon. He left England in early August 1819, and travelled by Paris, Lyons and Chambéry to Turin, where he began to make sketches in large numbers. He then went through Milan to Venice and after about a fortnight continued his journey to Bologna, Rimini, Ancona and Rome, which he reached on 13 October.

58
Venice: The Zitelle and the Dogana, sunrise 1819
watercolour, 224 × 286 mm
verso: slight pencil sketch of two boats
T.B.CLXXI-6

Turner went to Venice from Turin and Como on his way to Rome in September 1819. He probably stayed at the 'Leon Bianco' on the Grand Canal, recommended by James Hakewill; on subsequent visits he used the Hotel Europa, from the steps of which, or near them, this view was taken. A pencil drawing which was probably used as the basis of the watercolour is on f.40 *recto* of the *Milan to Venice* sketchbook, T.B.CLXXV. This colour study is a sheet from the *Como and Venice* sketchbook, which contains all four watercolours of Venice (see R.A.1974 nos.212, 213, 214) and two views on Lake Como (see R.A. 1974 no.211), as well as the view over the roofs of a town, No.57 in this catalogue. The sketchbook also includes four leaves coloured with very slight washes which appear to have been preparations for more detailed studies (see R.A.1974 no.209). See Finberg, *Venice*, pp.22–5.

A painting of the same view was shown by Turner at the R.A. in 1842 (52); see R.A.1974 no.532.

59
Tivoli, with the Cascades 1819
pencil and watercolour, 253 × 403 mm
T.B.CLXXXVII-32

One of the two general views of Tivoli in watercolour which occur in the *Naples, Rome Colour Studies* sketchbook (see R.A.1974 no.218). Pencil drawings of Tivoli occur in the *Tivoli and Rome* sketchbook, T.B.CLXXIX, and in the *Tivoli* sketchbook, T.B.CLXXXIII. In spite of the remark quoted by Sir John

Soane's son to the effect that Turner did not make his coloured sketches on the spot (see *View from Naples looking towards Vesuvius*, No.72), it seems probable that many of the Italian watercolours were done in the open air (see R.A.1974 p.86, and Finberg, *Life*, p.262).

60

Extensive plain with distant hills ?1819
watercolour, 379 × 545 mm
T.B.CCLXIII–126

The view may well be of the Roman Campagna; in colour and handling this colour-beginning is very similar to the view of the Tiber (No.61) and other Italian subjects, and may even have been executed while Turner was in Rome.

61

The Roman Campagna, with the Tiber, from Castel Giubelio 1819
pencil and watercolour, 258 × 404 mm
T.B.CLXXXVII–35

The closest of the studies of the Campagna in treatment and colouring to the large colour-beginning, No.60, which appears to be a much simplified version of à view similar to this. Several other subjects of the same kind occur in the same sketchbook (*Naples, Rome Colour Studies*). For Colour Plate, see p.55

62

The Basilica of Constantine 1819
pencil, watercolour and bodycolour with pen and brown ink, 228 × 368 mm
T.B.CLXXXIX–38

The brilliant colour of the Roman drawings in mixed media, of which this is an example, suggests that Turner was consciously imitating the bright effects of artists such as Carlo Labruzzi (1748–1817) and Charles-Louis Clérisseau (1722–1820). A large drawing in watercolour and heavy bodycolour of a Roman archway with the dome of St Peter's beyond, executed in the manner of such *vedutisti*, belonged to Turner (T.B.CCCLXXX–18); it was considered by Finberg to be by a hand other than Turner's, but in many features resembles some of Turner's perspective diagrams (see No.42) and may therefore be a deliberate pastiche by him of the neo-Classical continental souvenir-painters, dating probably from before the 1819 visit to Italy.

63

The Colosseum 1819
pencil and watercolour and bodycolour on white paper prepared with grey wash (dis-

62

63

coloured), 229 × 369 mm
T.B.CLXXXIX–37

Compare with the finished watercolour of the Colosseum from the opposite side, No.74

64

Rome: St Peter's from the Villa Barberini 1819
pencil, watercolour and bodycolour on white paper prepared with a wash of grey,
226 × 368 mm
T.B.CLXXXIX–21

A view of St Peter's from a slightly closer viewpoint, but also from this terrace, is the pencil study CLXXXIX–7. The composition of this subject, with carefully organized *repoussoir* of trees, urns and figures closing a corner diagonally, is one of several which seem to imitate Wilson's Roman views for Lord Dartmouth, executed in the 1750s both as drawings in chalk and as oil paintings.
For Colour Plate, see p.58

65

The Colosseum 1819
pencil on white paper prepared with a grey wash (lights rubbed out), 232 × 368 mm
T.B.CLXXXIX–23

The study from which Walter Fawkes's *Colosseum* (No.74) was derived.

66

Rome: The Basilica of Constantine and the Colosseum 1819
pencil, watercolour and bodycolour on white paper prepared with a wash of grey,
228 × 368 mm
T.B.CLXXXIX–20

67

68

69

70

67

Rome: The Forum with a rainbow 1819
pencil, watercolour and bodycolour on white
paper prepared with a wash of grey, ·
229 × 367 mm
T.B.CLXXXIX–46

One of the most elaborate of Turner's studies
of atmospheric effect in Rome.

68

**Rome: The Portico of St Peter's with
the entrance to the Via della Sagrestia**
1819
pencil and watercolour, and bodycolour on
white paper prepared with a grey wash,
369 × 232 mm
T.B.CLXXXIX–6

This drawing has some of the features of the
Italian souvenir views of Volpato and Lab-
ruzzi (see No.62); its grandiose scale is
reminiscent of that characteristic of Piranesi's
Vedute di Roma.

69

**Rome: The Tiber and Castel S. Angelo
from S. Onofrio** 1819
pencil, watercolour and bodycolour on white
paper prepared with a wash of grey,
228 × 367 mm
T.B.CLXXXIX–3

70

**The interior of the Colosseum:
Moonlight** 1819
pencil, watercolour and bodycolour on white
paper prepared with a grey wash,
231 × 369 mm
T.B.CLXXXIX–13

71

**The Castel dell'Ovo, Naples, with Capri
and Sorrento in the distance** 1819
pencil and watercolour, 253 × 401 mm
T.B.CLXXXVII–6

72

**View from Naples looking towards
Vesuvius** 1819
pencil, partly finished in watercolour,
254 × 405 mm
inscr. lower left: (?) *Rock yellow*
T.B.CLXXXVII–18

The unfinished state of this watercolour,
reminiscent of the partially coloured Welsh
drawings of *c.*1795, suggests the freshness and
experimental nature of Turner's approach to
Italian subjects. Turner went to Naples from
Rome partly to observe an eruption of
Vesuvius which began towards the end of

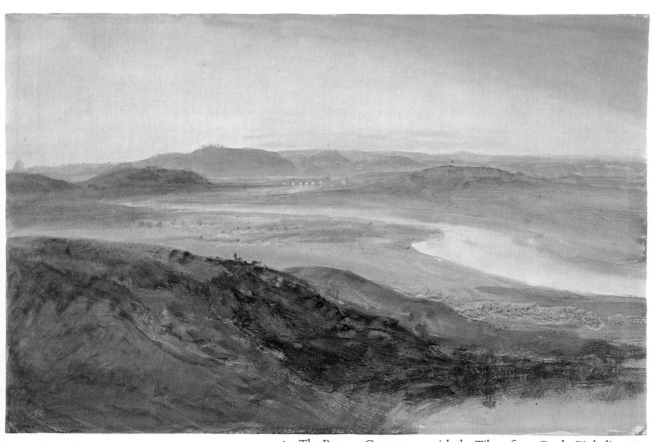

61 The Roman Campagna, with the Tiber, from Castle Giubelio, 1819

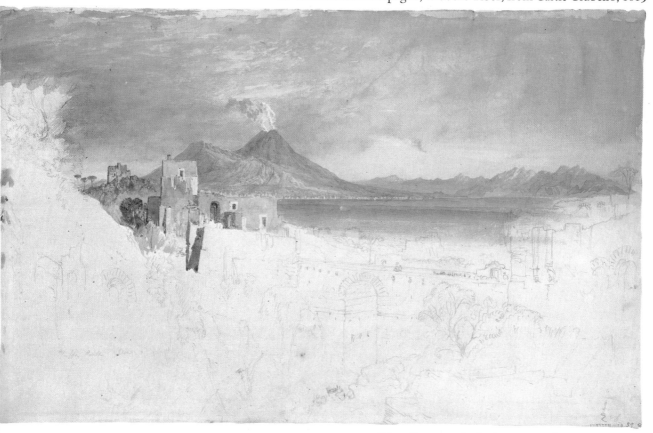

72 View from Naples looking towards Vesuvius, 1819

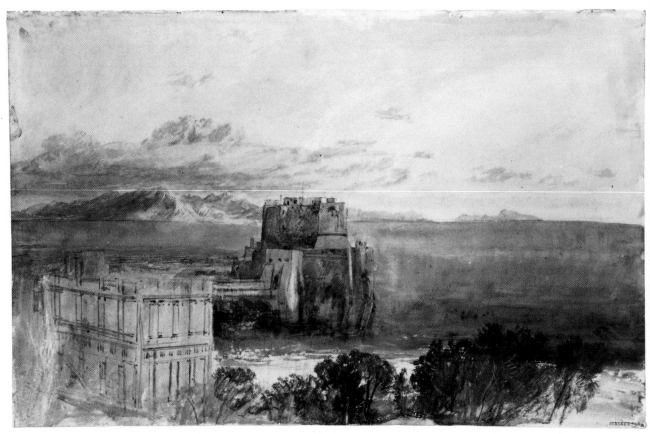

71

73

October 1819. He had made a watercolour of *Vesuvius in Eruption* for Walter Fawkes two years previously (now coll. Mr and Mrs Paul Mellon; see R.A.1974 no.184). He returned to Rome in the middle of November. A letter of 15 November (quoted by Finberg, *Life*, p.262) says that 'Turner is in the neighbourhood of Naples making rough sketches to the astonishment of the Fashionables, who wonder of what use these rough draughts can be – simple souls! At Rome a sucking blade of the brush made the request of going out with pig Turner to colour – he grunted for answer that it would take up too much time to colour in the open air – he could make 15 or 16 pencil sketches to one coloured, and grunted his way home.'

73

Daybreak over mountains *c.*1819
watercolour, 309 × 490 mm
inscr. lower right: (?) *Pilz* or (?) *PM*
T.B.CCLXIII–24

Possibly connected with the first Italian tour, in particular with the view of *Monte Gennaro*, CLXXXVII–41 (repr. Butlin, *Watercolours from the Turner Bequest*, No.3).

74

The Colosseum 1820
watercolour, 277 × 293 mm

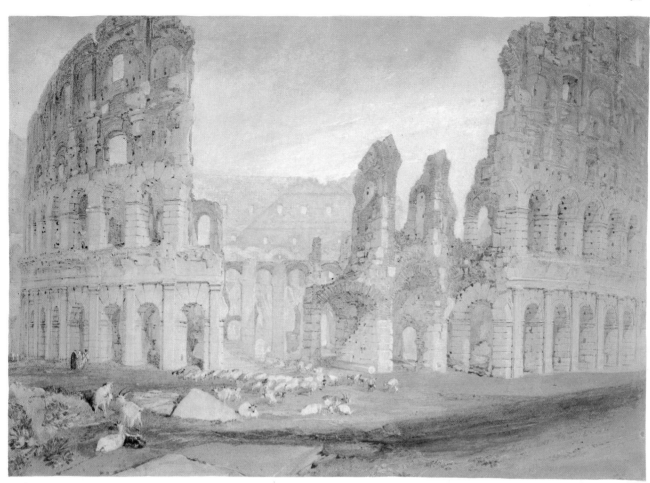

74

inscr. lower right: *Colliseum Rome W Turner 1820*
coll: W. Fawkes; Rev. J.W.R. Brocklebank; sale, Christie, 25 November 1927 (91); R.W. Lloyd, by whom bequeathed to B.M.1958-7-12-421

Derived from a pencil study of the subject made during the Italian journey of 1819 (No.65); for the purposes of the finished drawing Turner has brought the building closer to the spectator and raised the height of the wall on the right-hand side so that the masonry disappears out of the picture, increasing the scale dramatically. A view of the Colosseum from the other side, also coloured but evidently used simply as a record, is T.B.CLXXXIX-37 (No.63).

The Colosseum was one of nine watercolours of Italian views owned by Fawkes (see Finberg, *Farnley*, Nos.189-92, 194-8). Of these at least one, *Mount Vesuvius in Eruption* (R.A.1974 no.184), was made before the 1819 visit to Italy. An additional drawing derived from that visit was the *Passage of Mont Cenis* (Finberg, *Farnley*, No.193; R.A.1974 no.B90). This and the *Naples* (Finberg, *Farnley*, No. 197) as well as the *Colosseum* are dated 1820; the *Interior of St Peter's* is recorded in the Walter Ramsden Fawkes sale catalogue,

Christie's, 2 July 1937 (57) as being dated 1821; the reproduction in Finberg, *Farnley* (pl.v) confirms this though Finberg transcribes the date as 1820. *Rome from the Pincian Hill* (Finberg, *Farnley*, No.195), and *Venice, from Fusina* (Finberg, *Farnley*, No.198) were all acquired by Sir Donald Currie at the Ayscough Fawkes sale, Christie's, 27 June 1890 (50, 51, 54). This group was apparently Turner's total output of finished watercolours based on his Italian visit of 1819.

75

La Bastiaz near Martigny *?c.*1820
pencil and watercolour, 501 × 390 mm
watermarked: *1813*
T.B.CXCVI-Q

This study has features in common with the colour-beginning of *Tivoli* in the Whitworth Art Gallery, Manchester (D 31-1922), which may have been executed immediately after Turner's visit to Italy in 1819, or possibly in connection with the *Tivoli* of 1817 (R.A. 1974 nos.181-3). The palette resembles that of the Swinburne *Marksburg* (No.80) of 1820, and in both colouring and composition it has similarities with the *Val d'Aosta* (No.94) which is here associated with the Swinburne commissions of about 1820. There are no sketches

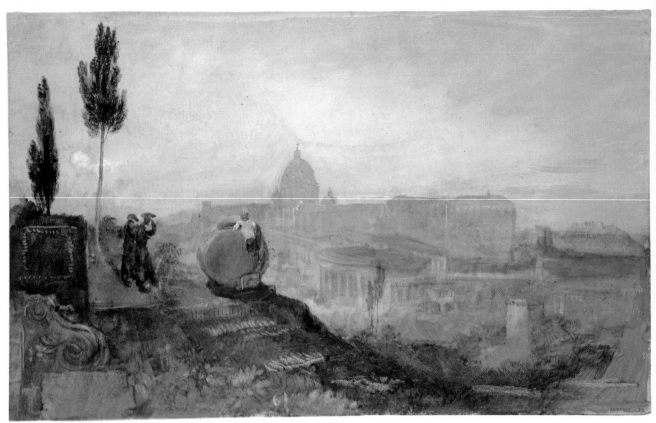

64 Rome:
St Peter's from the
Villa Barberini,
1819

of Martigny or its neighbourhood among those made in 1819. Turner was certainly at Martigny in 1802 (see the *Grenoble* sketch-book, T.B.LXXIV, f.2, 54ff) and again perhaps in 1836 on the tour with H.A.J. Munro of Novar to the Val d'Aosta.
For Colour Plate, see p.67

76
An Italian lake *c.*1820
watercolour and bodycolour, 385 × 480 mm
T.B.CCLXIII–25

The warm, rich colour range is characteristic of Turner's colour sketches of about 1817–20. The subject seems to be an Italian one; this view may show Lake Albano or Lake Nemi, in which case it was presumably based on sketches made near Rome in 1819. Finberg's title is simply *The River, Evening*.

77
A lake among mountains *?c.*1820
watercolour over traces of pencil,
340 × 425 mm
T.B.CCLXIII–195

This very broadly handled study is difficult to place. It was dated by Finberg to the decade 1820–30, and may perhaps be connected with the colour-beginnings which seem to have been done immediately after Turner's return from Italy in 1820; but its sombre colouring suggests that it may possibly date from the continental tour of 1802. The subject seems

to be derived from the scenery of Switzer-land, though it is possible that some location in north Wales or Scotland is intended.

78
Study of clouds with a shower passing over water *?c.*1820
watercolour with wiping-out, 318 × 487 mm
T.B.CCLXIII–80

Turner's habit of preparing his paper with horizontal strips of colour can be observed in this sheet. The upper, blue strip was evidently allowed to become much dryer than the lower ones which merge into each other. Wiping-out with the end of the brush-handle is used to make highlights on the upper surface of the clouds.

79
Biebrich Palace 1820
watercolour, 293 × 453 mm
coll: 'A member of the Swinburne family' (?for whom drawn); Swinburne family; N.E. Hayman; Agnew 1912; R.W. Lloyd, by whom bequeathed to B.M.1958–7–12–420
exh: Newcastle, Northern Academy of Arts, 1828 (74) as *The Palace of Bubvinitch near Mayence*

A view of the Palace of Biebrich was one of the series of 51 Rhine views sold to Walter Fawkes in 1817, made from sketches taken in August of that year (see No.48). (It was

76

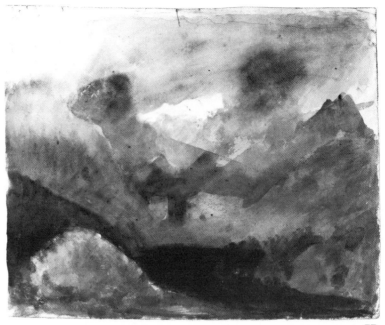

77

No.3 in the Ayscough Fawkes sale, Christie's, 27 June 1890, and is now in the National Museum of Wales, Turner House collection; Wedmore, 1900, No.13.) The present drawing was presumably made shortly afterwards, probably in 1820. This is the date given in the Royal Academy Exhibition catalogue of 1887 (No.61); the drawing was then in the possession of Emily Swinburne. Sir John Swinburne or his son Edward (see No.38) seems to have commissioned this and *Marksburg* (No.80) from Turner, selecting subjects from Fawkes's set of Rhine views. The date 1820 on the *Marksburg* confirms that they were executed in that year.

A small pencil sketch of the view (without the incidental details of the foreground) is on ff.67 *verso* and 68 *recto* of the *Waterloo and Rhine* sketchbook, T.B.CLX. Turner has greatly exaggerated the length of the palace wings in the watercolour.

For Colour Plate, see p.70

78

80

Marksburg 1820
watercolour, 291 × 458 mm
signed and dated lower right: *I M W Turner/ 1820* and inscr: MARXBOURG *and* BRUGBERG [Braubach] *on the* RHINE
coll: 'A member of the Swinburne family' (?for whom drawn); Swinburne family; sale, Christie, 1900, bt. Vokins; C. Fairfax Murray; 1912 R.W. Lloyd, by whom bequeathed to B.M. 1958–7–12–422
exh: Newcastle, Northern Academy of Arts, 1828 (71) as *Marxbourg on the Rhine*.

This drawing, like the *Biebrich Palace* (No.79), was probably commissioned from Turner by Sir John or Edward Swinburne, whose chose the subject from the Farnley Rhine views. The first version of the subject was No.19 in the Ayscough Fawkes sale, Christie's, 27 June 1890, and is now in the collection of the Museum of Art, Indianapolis (R.A.1974 no.195).

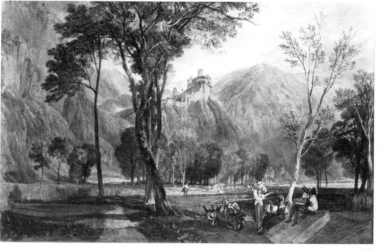

80

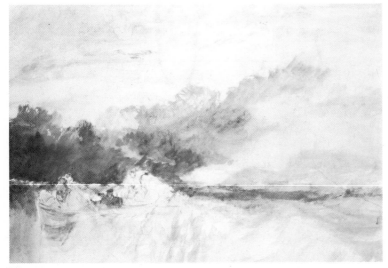

81

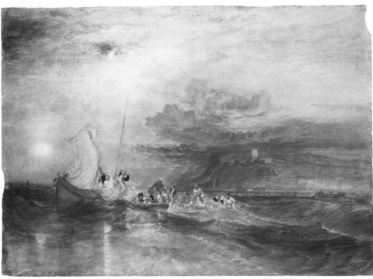

82

83

81

Smugglers off Folkestone *c.*1822
pencil and watercolour, 462×659 mm
watermarked: *1822*
T.B.CCLXIII–357

An elaborate colour-beginning related to the finished watercolour of about 1822 (No.82), which differs from this in many features, especially the distance of the coast and the sky.

82

Folkestone from the sea *c.*1822
watercolour and bodycolour, 487×691 mm
T.B.CCVIII–Y

A preparatory sketch in watercolour is T.B. CCLXIII–357 (No.81). This drawing is listed in the *Inventory* as one of the 'Rivers and Ports' series, though much larger than any of that group; it was not engraved. The subject is a variant of that of *Twilight – Smugglers off Folkestone fishing up smuggled gin*, shown at Cooke's Gallery in 1824; the *Southern Coast* drawing (Rawlinson, No.123) shows the smugglers burying their kegs in the cliffs; the view of Folkestone made by Turner for the *Picturesque Views in England and Wales* in about 1829 (Rawlinson, No.250; coll: Mr and Mrs Paul Mellon) also features smuggled goods which are being recovered in the presence of an exciseman. Another view of Folkestone, with a beached fishing-boat, is in the Vaughan Bequest, National Gallery of Ireland (2415).

83

St Agatha's Abbey, Easby *c.*1822
watercolour over traces of pencil,
393×503 mm
T.B.CCLXIII–360

A pencil study of the subject occurs in the *North of England* sketchbook of 1797 (T.B. XXXIV, f.25 *recto*); this was used as the basis for a large watercolour of about 1798, now in the Whitworth Art Gallery, Manchester (D.18–1904). Turner made another pencil drawing of St Agatha's Abbey from the same viewpoint in his *Yorkshire* sketchbook No.2, in use about 1816 (T.B.CXLV, f.112 *recto*) and it was probably from this sketch that he derived the finished watercolour (B.M.1915–3–13–48) engraved by H. Le Keux for Whitaker's *History of Richmondshire* in 1822 (Rawlinson, No.171) and shown by W.B. Cooke in his exhibition of 1823 (no.152). This colour-beginning was probably made in conjunction with the Whitaker illustration. A smaller colour study, using the same motif much simplified (and perhaps dating from a

considerably later period), was with Messrs
Agnew in 1974.

84

View of a castle on the Rhine *?c.*1822
pencil and watercolour, 391 × 500 mm
watermarked: *1819*
T.B.CCLXIII–387

Probably derived from a memory or a sketch
of a subject seen during the 1817 Rhine tour,
this colour-beginning, predominantly pale
blue, yellow and pink, may have been done
in the early 1820s. Finberg suggests that the
view may show Caub and Pfalz; another
study apparently of the same subject is
CCLXIII–388.

85

Newcastle-on-Tyne *c.*1823
pencil and watercolour, 152 × 215 mm
engr: in mezzotint by T. Lupton, 1823, for
The Rivers of England (Rawlinson, Vol. II,
p.365, No.753)
T.B.CCVIII–K

A pencil study, used as the basis for this illus-
tration, occurs in the *Scotch Antiquities*
sketchbook of 1818 (T.B.CLXVII, f.2 *recto*). It
omits the foreground detail entirely.

 The Rivers of England, also known as *The
River Scenery of England* was a project of the
engravers William Bernard and George
Cooke, with whom Turner had collaborated
to produce the *Picturesque Views of the
Southern Coast of England* since 1811. The new
series was designed to demonstrate the poten-
tialities of mezzotint engraving on steel, a
recently invented improvement on the old
mezzotint process on copper. Turner contri-
buted seventeen designs for the publication;
one subject after William Collins and four
after Girtin were also used. The plates ap-
peared between 1823 and 1827.

86

Arundel Park *c.*1823
watercolour, 159 × 228 mm
engr: in mezzotint by G.H. Phillip, 1827, for
The Rivers of England (Rawlinson, Vol. II,
p.369, No.764)
T.B.CCVIII–G

See No.85. Turner made a number of pencil
studies in Arundel Park in the *Brighton and
Arundel* sketchbook (T.B.CCX, ff.68–70 ff.). In
particular, sketches on ff.69 *verso* and 70
recto were used for this view. The book seems
to have been employed with *Rivers of England*
subjects particularly in mind: the subjects of
Kirkstall Abbey (T.B.CCVIII–M), *Kirkstall Lock*

84

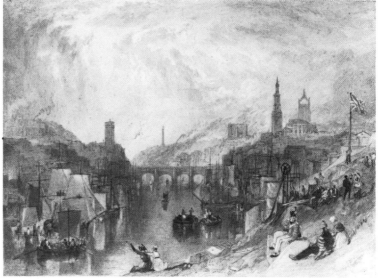

85

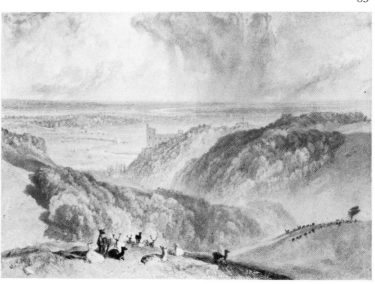

86

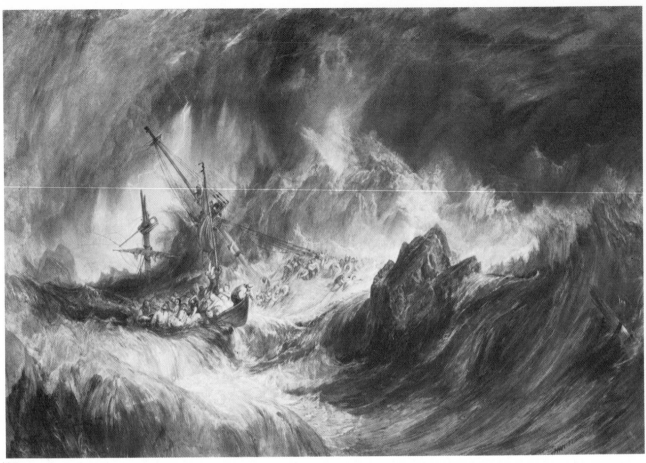

87

(T.B.CCVIII–L) and *Arundel Castle* (T.B.–CCVIII–F) all appear in it. The *England and Wales* view of the castle, in a private collection, London (engraved by T. Jeavons, 1834, Rawlinson, No.278) was derived from studies on f.63.

87

The Storm ?1823
watercolour, 434×632 mm
signed, lower right: *J M W Turner RA*
coll: W.B. Cooke; Lewis Loyd 1857;
R.W. Lloyd, by whom bequeathed to B.M.
1958–7–12–424
exh: W.B. Cooke, May 1823

Finberg (*Life*, p.280) records that 'on the 17th and 18th of May advertisements appeared in several papers stating that "Two superb Drawings by Turner will be added on the following Monday to Mr Cooke's exhibition in Soho Square and will be placed in the centre of the rooms. These powerful productions – 'A Storm' and 'A Sun-rise' (being just finished) will continue a few weeks only for Public inspection" '. Cooke paid Turner £189 for the two and another of *Dover*.

It is possible that this drawing is dated, after the artist's signature, 1818; but this is not borne out by the newspaper report quoted above that the work was 'just finished' in May 1823. The subject-matter is close to that of the *Wreck of an East Indiaman*, which was probably executed about 1818 for Fawkes (with Agnew 1973).

A copy by W.H. Harriott entitled *Shipwreck off Lands End* was made in 1825. In the catalogue of the 1857 Manchester 'Art Treasures' exhibition the drawing was called *Wreckers* (Watercolours, No.33).

88

Sunset over the sea with a crescent moon
*c.*1824
watercolour, 241×302 mm
inscr. lower centre: (?) *Moon Lits*
T.B.CCLXIII–311

The paper has been discoloured by exposure to daylight. This drawing is evidently related to No.89, and to a series of night scenes which Turner apparently made in connection with the *Little Liber* mezzotints of about 1825. This subject may be more specifically associated with one of the late *Liber Studiorum* plates, *Moonlight on the Medway at Chatham*, of which it is perhaps an adaptation. The *Little Liber* seems to have developed naturally out of Turner's increasing interest in the mezzotint process during the later stages of the publication of the *Liber Studiorum*, and although he is not known to have had any

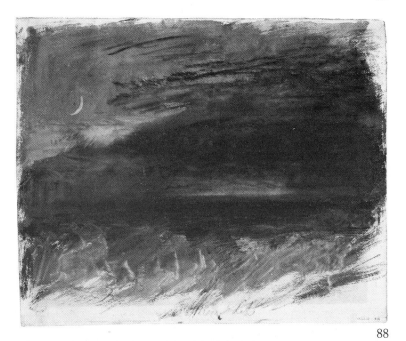

88

particular purpose in mind for the ten mezzo-tints, he produced in this highly dramatic sequence of night and storm scenes his greatest work as a printmaker; all the plates were executed entirely by Turner himself (see Rawlinson, Vol. I, pp.xliii–xliv and Vol. II, pp.385–91; and R.A. 1974, p.95).

89

A harbour, with full moon behind dark clouds c.1824
watercolour over traces of pencil,
260 × 310 mm
T.B.CCLXIII–192

A pencil drawing of a sailing ship is visible to the right of the mole. This study seems to be closely related to No.88, and to a similar moonlit marine view (T.B.CCLXIII-308) which is a preparatory drawing for the *Little Liber* mezzotint of *Shields Lighthouse* (Rawlinson No.801), and itself may well have been used in arriving at the design for that plate. Compare also the watercolour of *Shields* for the *Rivers of England* series (T.B.CCVIII-V), executed in 1823 and engraved, also in mezzotint, in that year (Rawlinson No.753).

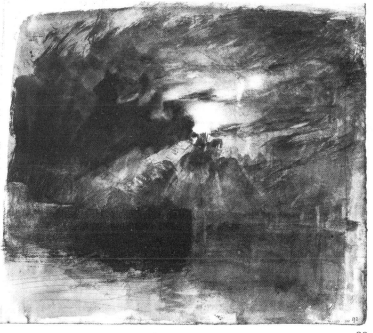

89

90

Saltash 1825
watercolour and bodycolour, 273 × 408 mm
signed and dated lower right: *JMW Turner RA/25*
coll: B.G. Windus; J.H. Maw; R.R. Davies 1857; J. Knowles 1865; F.R. Leyland 1872; S. G. Holland; Sale, Christie, 26 June 1908 (261); Sir Joseph Beecham; Sale, Christie, 4 May 1917 (152); R.W. Lloyd, by whom bequeathed to B.M. 1958-7-12-427
exh: Egyptian Hall, 1829; Moon, Boys and Graves Gallery, 1833 (48)
engr: by W.R. Smith, 1827, for *Picturesque Views in England and Wales*, Part III, No.2 (Rawlinson, Vol. II, p.124, No.218)

The characteristic outline of Saltash from this angle was noted by Turner in the background of his sketch of hulks on the Tamar (T.B.CXXXIII; *Devon Rivers No.2* sketchbook, f.23 *recto*); this was presumably made in 1813 during his second tour of the West Country. An oil painting of *Saltash with the water ferry* was exhibited by Turner in his gallery in 1812 (now Metropolitan Museum of Art, New York).

The date of 1825 which occurs on this drawing places it in the year preceding Turner's embarkation on the long series of watercolours which was to comprise Charles

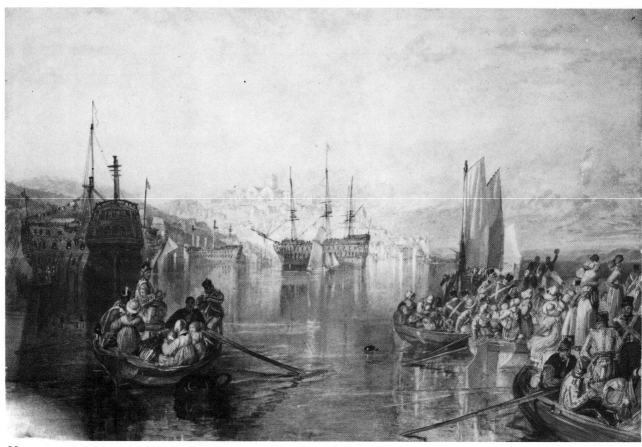

90

Heath's *Picturesque Views in England and Wales.*
That project was apparently not begun until
1826. It may be that the drawing was one
which Turner had ready and had not yet dis-
posed of, and that he therefore simply sent it
to the engraver with other watercolours made
specifically for the work. But it did not appear
in the first two issues and was incorporated
into Part III which came out in 1828.

Ruskin categorized the climatic conditions
shown in this watercolour as 'Afternoon,
very clear, after rain. A few clouds still on the
horizon. Dead calm.' He classed it with
Upnor Castle (R.A.1974 no.425) as giving
'the perfect truth' of calm water, as opposed
to Van de Velde's treatment of reflections
(*Modern Painters*, Vol. I, pp.263, 353–4).

91
Scarborough *c.*1825
watercolour over traces of pencil,
157 × 225 mm
engr: in mezzotint by T. Lupton, 1826, for
The Ports of England (Rawlinson, Vol. II,
p.376, No.779)
T.B.CCVIII–I

A considerably modified variant of the sub-
ject first explored in the watercolour from
the Farnley collection (R.A.1974 no.113). A

colour sketch for this illustration is T.B.CCII,
f.18. *The Ports of England* was conceived as a
sequel to the series of views of *Rivers of
England* (see No.85), and Turner produced
twelve drawings all of which were engraved
in mezzotint by Thomas Lupton. Of these,
only six appeared at once, in 1826 and 1827;
the remainder were not published until 1856,
when they were issued with text by Ruskin
under the title *The Harbours of England*
(Rawlinson, Vol. I, p.xliii and Vol. II, pp.
375–80, Nos.778–90). Turner also made a
drawing dated 1825, now in the Fitzwilliam
Museum, Cambridge, for the title vignette,
which may have been etched by Turner him-
self (Rawlinson No.778).

92
Dover *c.*1825
watercolour, 161 × 245 mm
engr: in mezzotint by T. Lupton, 1827, for
The Ports of England (Rawlinson, Vol. II,
p.376, No.781)
T.B.CCVIII–U

A colour sketch for this design is T.B.CCII,
f.14. See No.91. A large watercolour of
Dover from the Sea (Museum of Fine Arts,
Boston) was executed in 1822, similar in
conception and format to the large *Hastings*
of 1818 (No.54). This smaller view embraces

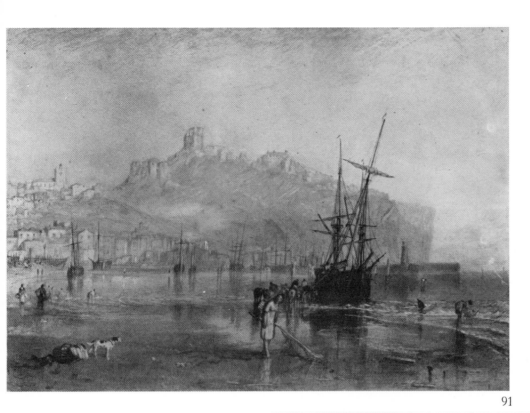

91

a wider panorama, and the height of the cliffs is much exaggerated. When the mezzotint plate was reissued in *The Harbours of England* (1856), Ruskin wrote (p.29):

'He has lost the real character of the cliffs by making the town at their feet three times lower in proportionate height than it really is: nor is he justified in giving the barracks, which appear on the left hand, more the air of a hospice on the top of an Alpine precipice, than of an establishment which, out of Snargate Street, can be reached, without drawing breath, by a winding stair of some 170 steps; making the slope beside them more like the side of Skiddaw than what it really is, the earthwork of an unimportant battery.'

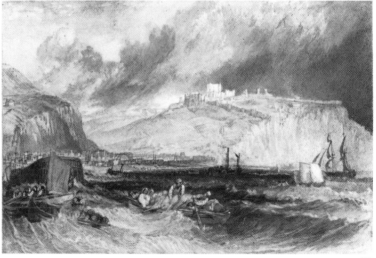

92

93

A paddlesteamer and rowing boats off the coast *c.*1825
watercolour, 255 × 280 mm
T.B.CCCLXIV-147

Finberg considered that this drawing probably dates from about 1840; it has certain affinities with the marine paintings of that period, especially, perhaps, with the *Snow Storm – Steam boat off a harbour's mouth* of 1842 (R.A.1974 no.504); but in technique and colour it resembles more closely the watercolour studies related to marine subjects of about 1820–30. Some of the preparatory drawings for the *Ports of England* series (see Nos.91, 92) in particular employ the same range of greys and greens.

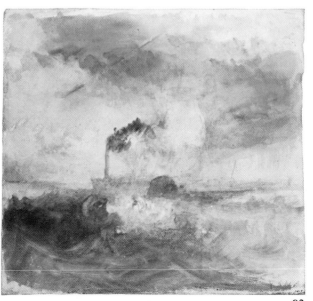

93

94

95

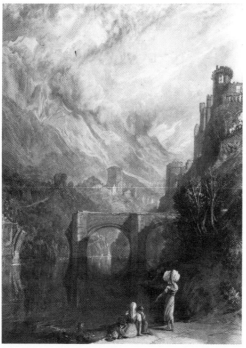

96

94
Landscape with a pink mountain
?c.1825
watercolour, 347 × 507 mm
T.B.CCLXIII–59

The pink headland in the background is reminiscent of some of Turner's views of the Rigi on Lake Lucerne (see R.A.1974 nos. 592–603) made in about 1841; but it is unlikely that this colour-beginning belongs to that late date. It may well have evolved out of the first Italian visit, and has points of resemblance with the *Tivoli* study at Manchester (Whitworth Art Gallery, D.31–1922; see No.75). The composition as a whole is similar to that of *Prudhoe Castle* (No.107), but this is probably coincidental; both subjects make conspicuous use of Turner's favourite device (derived from Claude) of an isolated pair of trees on the right-hand side.

95
Sheep grazing on Salisbury Plain ?c.1825
pencil and watercolour, 343 × 487 mm
inscr. lower right: *Stonehenge No 1 No 2 done*
T.B.CCLXIII–1

The completed composition of *Stonehenge* for the *England and Wales* series was engraved in 1829 (Rawlinson No.235); it is now in an English private collection. The only features it shares with this colour-beginning are the motif of the sheep, which are, however, grouped entirely differently here, and the storm-cloud (there is also lightning in the finished design). It seems likely that this study preceded the *England and Wales* drawing. Another colour-beginning which seems to treat a related theme is CCLXIII–37. There are studies of the monument itself in the *Studies for Pictures* sketchbook of *c*.1801 (T.B.LXIX, ff.79–80), in the *Devonshire Coast No. 1* sketchbook of 1811 (T.B.CXXIII, ff.2, 11, 12) and in the *Stonehenge* sketchbook, also of 1811 (T.B.CXXV–B). Turner had used the motif of Stonehenge in one of his *Liber Studiorum* plates (Finberg No. 81); the sepia drawing is in the Museum of Fine Arts, Boston.

96
The Val d'Aosta *c*.1825
watercolour, 408 × 302 mm
signed lower right: *J.M.W. Turner*
coll: Abel Buckley; Mrs George J. Gould; Christie 26 November 1926 (25);
R.W. Lloyd, by whom bequeathed to
B.M.1958-7-12-425

This is possibly connected with the drawing owned by Ruskin and catalogued by him

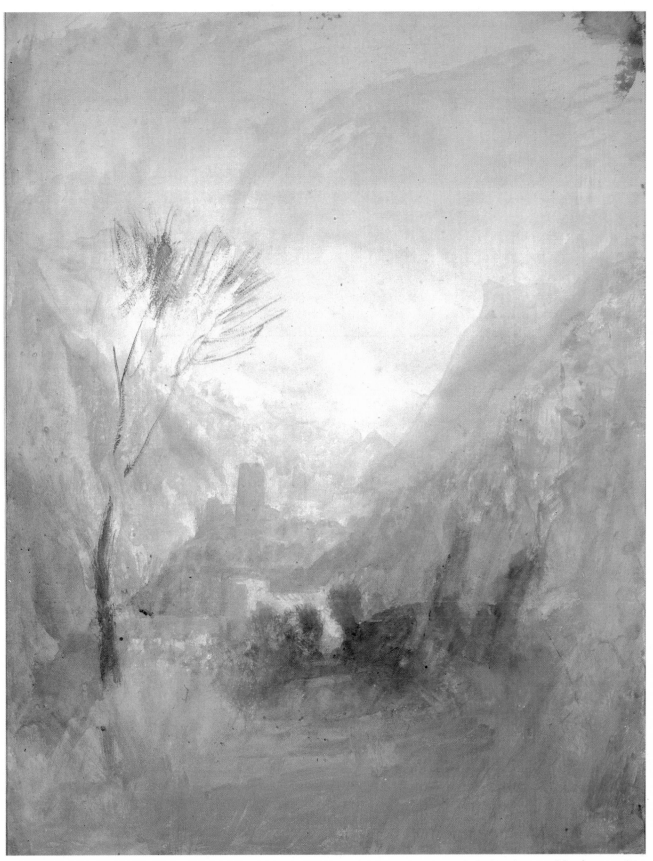

75 La Bastiaz near Martigny, *c.*1820

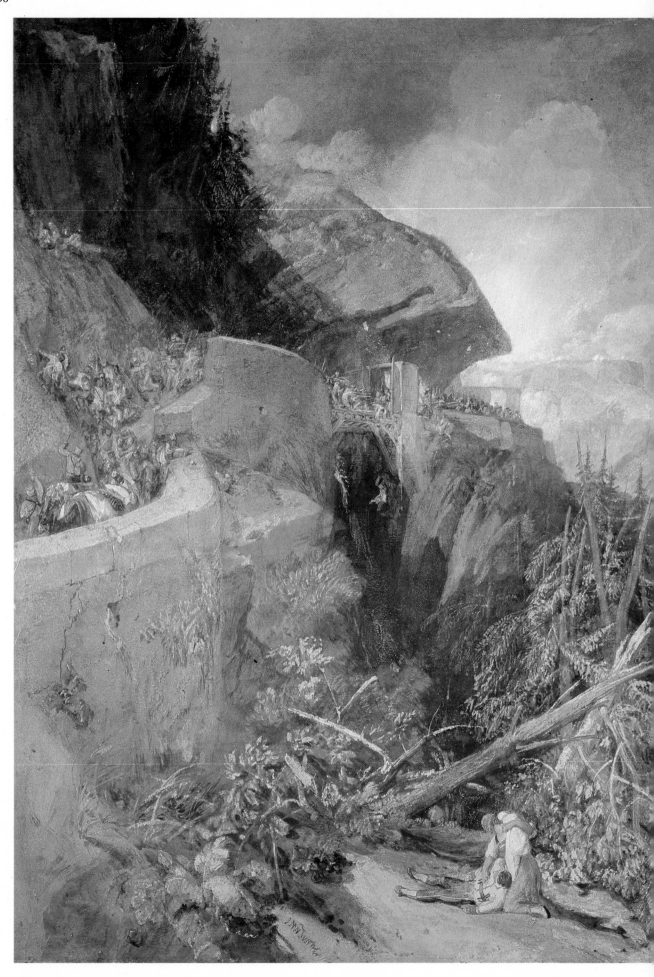

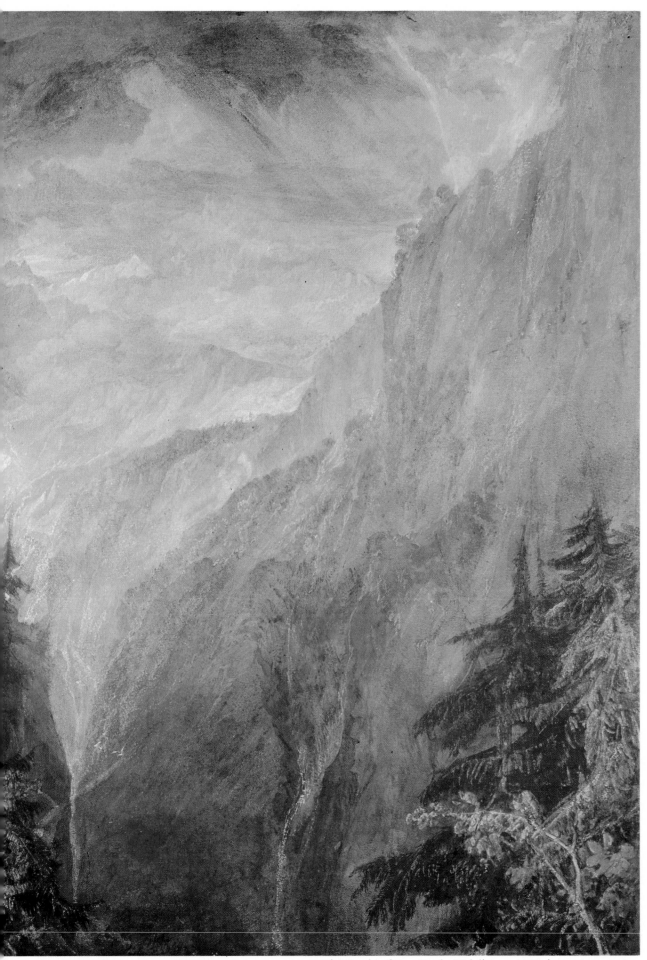

43 The Battle of Fort Rock: Val d'Aouste, Piedmont, 1796, 1815

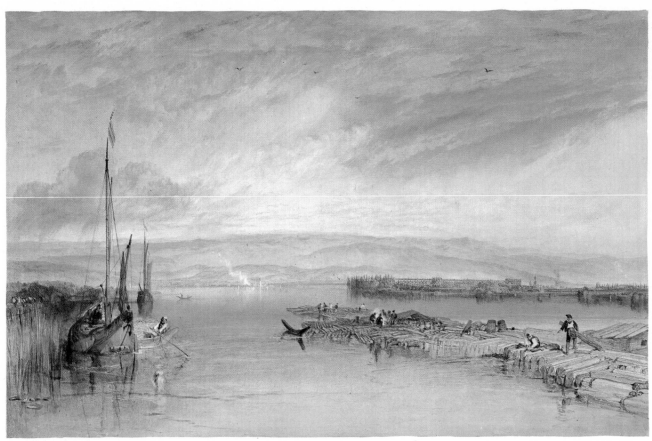

79 Biebrich Palace, 1820

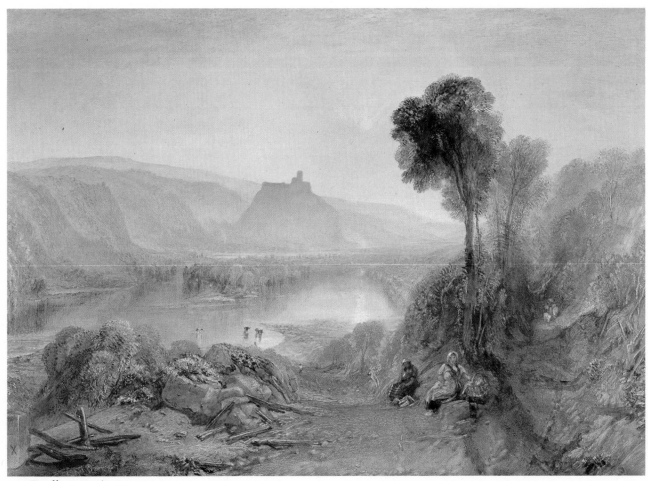

106 Prudhoe Castle, c.1826

(No.15 in the Fine Art Society Catalogue) as *In the Val d'Aosta*, with the date 1802–10. 'I am not quite sure', he says, 'if I am right in the name of this village; its remnant of (Roman?) bridge is, I think, some eight or ten miles above Ivrea. It has been erroneously sometimes called Narni.' In Finberg's opinion (manuscript note, British Museum) the title is inaccurate, although the drawing may represent some neighbouring valley; alternatively the subject may be a compound from various sources. The bridge and octagonal building beyond are apparently the same as those in the 1802 drawing of the *Bridge of Villeneuve, Val d'Aosta*, T.B.CXXIV–5; the castle to the right may have been added from another source. The same broken bridge appears as a faint pencil sketch in the large colour-beginning of *Tivoli*, T.B.CXCVII–A. If the composition is such an amalgamation of several dispersed features it is highly uncharacteristic of Turner's usual practice (see the *Imaginary landscape*, No.16). The date, like the title, is given in the Royal Academy *Old Masters* exhibition catalogue of 1887 (62); but the drawing may have been executed a few years earlier: it has much in common stylistically with the Swinburne Rhine views of *c.*1820 and may perhaps have been another of the drawings Turner made for Swinburne at that date (see No.79).

97

97

Study of a sunset ?*c.*1825
watercolour, 245 × 342 mm
watermarked: *1823*
T.B.CCLXIII–208

98

Like many of the colour studies of sunset skies, this and Nos.98–103 cannot be very accurately dated, though the watermark provides a useful *terminus post quem*. The rich colour and full-bodied paint suggest a date in the 1820s, rather than later, but do not furnish conclusive evidence. There are, however, resemblances between these studies and such sketches as T.B.CCLXIII–212, which appears to be one of the series connected with the *Little Liber* (see No.88); this confirms a dating of about 1825.

98

Study of a sunset ?*c.*1825
watercolour, 240 × 339 mm
T.B.CCLXIII–209

99

The sun setting over the sea in orange mist ?*c.*1825
watercolour, 243 × 345 mm
T.B.CCLXIII–210

99

101

102

103

100

The sun setting among dark clouds
?c.1825
watercolour, 273 × 470 mm approx.
T.B.CCLXIII–306

Dated by Finberg to the decade 1820–30, but very difficult to place exactly. The unusually sombre effect of black clouds here may point to a connection with the dramatic chiaroscuro and strong light of the *Little Liber* mezzotints of about 1825, but in size and technique this drawing is not like those known to have been done for that series (see No.88).
For Colour Plate, see p.80

101

A cloudy sunset ?c.1825
watercolour, 240 × 305 mm
T.B.CCLXIII–193

This may be one of the watercolours which Turner executed in connection with his series of mezzotints known as the *Little Liber* (see No.88), but its resemblance to drawings for that work is only of a general kind. It may represent a scene in Italy.

102

Trees on the bank of a river at sunset
?c.1825
watercolour, 483 × 605 mm
watermarked: *1819*
T.B.CCLXIII–372

Both in subject and in colouring this study seems to be connected with one on a sheet of two colour-beginnings, T.B.CCLXIII–375. Its large size and the character of the subject suggest that the sheet had some function as a preparatory study for a specific work, perhaps one of the earlier *England and Wales* views, but it has not been associated with any finished watercolour.

103

The sun setting over a low headland
?c.1825
watercolour, 265 × 435 mm approx.
watermarked: *1825*
T.B.CCLXIII–191

104

A group of sailing-boats stranded on a beach *c.*1825
watercolour, 305 × 488 mm; the lower right-hand corner has been restored
T.B.CCCLXV–28

The figure on horseback and train of animals suggests a location such as Lancaster Sands, which Turner made the subject of a watercolour in about 1818, and again for the

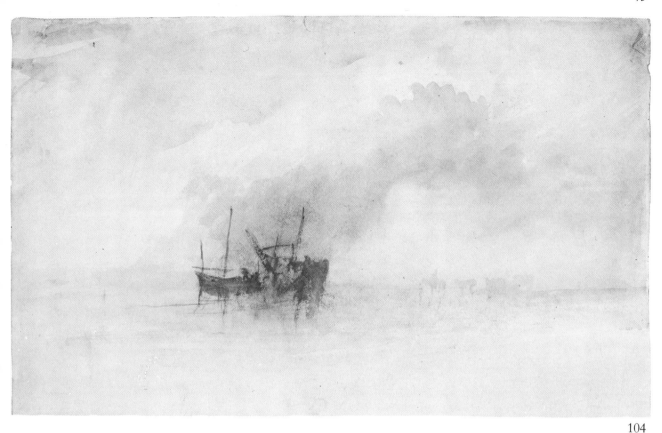

104

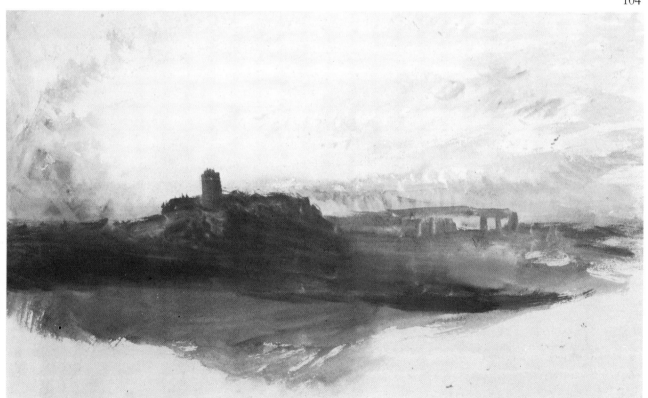

105

England and Wales series, in about 1826 (see R.A.1974 nos.179, 419). This colour-beginning is dated by Finberg to the decade 1830–40, but may well have been executed a little before that period. Broad studies of shore scenes occur in Turner's output from at least as early as the *Scarborough* of *c*.1810 (R.A.1974 no.113).

105

A round tower on a hill *?c*.1825
watercolour, 298 × 481 mm
watermarked: *1825*
T.B.CCLXIII–325

The technique and colouring of this expressive sketch have something in common with

the studies relating to the *Little Liber* (see No. 88), and is therefore tentatively dated to the year in which that project is thought to have been in hand. The watermark in the paper, 1825, suggests however that the drawing may have been made a little later, though it is quite possible that the sheet was used in the year of its manufacture.

106

Prudhoe Castle *c.*1826
watercolour, 292 × 408 mm
inscr. lower left: *J M W* [monogram] *Turner*
coll: Rev W. Kingsley; Agnew; R.W. Lloyd, by whom bequeathed to B.M.1958–7–12–428
engr: by E. Goodall, 1828, for *Picturesque Views in England and Wales*, Part IV, p.2.
(Rawlinson, Vol. I, p.126, No.222)

One of the earliest of the watercolours Turner prepared for Charles Heath's series of *Picturesque Views in England and Wales* (see No.90 and Introduction, p.12). Rawlinson quotes the Rev W. Kingsley as stating that the drawing was made by Turner 'from memory, he having been struck with the view as he was being driven past, whilst on a visit to the Swinburne family. He wanted to stop the carriage and make a sketch, but time would not permit.' Turner had, however, made sketches of Prudhoe in his *Durham, North Shore* sketchbook (T.B.CLVII) of about 1817, and one of these, on ff.78 *recto* and 77 *verso*, corresponds so closely with the composition of the watercolour that it is difficult to believe that it was not referred to. Turner's characteristic distortion, in the suggestion that the castle stands on an isolated rock instead of on a projecting spur of the hill, produces an effect close to that of some of his studies of Rhenish castles.

Another of Kingsley's stories related by Rawlinson is that:
'the drawing was afterwards damaged in the centre of the sun's reflection in the water, and on Turner's coming to see it, he said: 'I won't have that tampered with.' He moistened his finger with saliva, rubbed the colour off, and then touched it in again. It is now impossible to see the repair. At the same time he scratched in his name in the left corner of the drawing, which had previously been unsigned.
For Colour Plate, see p.70

107

A church by a lake ?1826
watercolour, 360 × 505 mm
T.B.CCLXIII–105

The dating of this colour-beginning is very uncertain; but it may possibly relate to Turner's plans for the series *Picturesque Views in England and Wales* (see No.90). If so it is unlikely to have been done after about 1830; its rich, rather dark colouring suggesting a fairly early date, perhaps about that of the watercolour *Louth* (B.M. 1910–3–12–278; R.A.1974 no.422), but there is a possible connection with T.B.CCLXIII–93 which apparently shows Lichfield and may therefore date from after the Midland tour of 1830 (see No.173). The drawing may also be related to that numbered T.B.CCLXII–158, which bears the inscription: *Aurora Borealis*.

108

A church spire ?*c.*1826
watercolour, 305 × 490 mm
inscr. lower right: ?[illegible] *Album*
T.B.CCLXIII–304

Finberg suggests that the spire may be that of Grantham Church. The problem of dating this drawing is similar to that of No.107, and the same arguments may apply to it.

109

A fortress on the Moselle? *c.*1827
bodycolour on blue paper, 140 × 190 mm
T.B.CCLIX–143

Finberg catalogues this drawing (*Inventory*, Vol. II, p.797) with the 'French Rivers' series, but suggests that the subject may be a view 'on the Rhine'. Technically it has many points in common with the first Meuse–Moselle series connected with the tour of 1826, and its subject-matter tends to support the view that it belongs with that group (T.B.CCXX, CCXXI, CCXXII). Turner may already have formed the intention of producing a series of views on the Meuse and Moselle for the 'French Rivers' project though his work on the *Loire* and *Seine* designs seems to have been begun in 1827 or later (see No.159). At this stage the Rhine may also have been considered for a similar scheme. In any case, the exact dates of the various drawings relating to the project have not been established.

110

Berncastel and the Landshut *c.*1827
bodycolour on blue paper, 140 × 190 mm
T.B.CCXXI–D

This and No.111 are typical of the series of views on the Meuse and Moselle that resulted from Turner's 1826 tour of those rivers. It will be noticed that they employ a different palette from that of the supposed 'Marseilles' views (Nos.149, 150, etc.) and are on blue paper.

107

108

76

109

111

111

A town on the Moselle? *c.*1827
bodycolour on blue paper, 140×191 mm
T.B.CCLIX–144

See note to No.109. The large church in this
view is similar to that of Karden, between
Cochem and Coblenz.

112

**A ruined castle on a rock above a town by
a river** *c.*1827
bodycolour on blue paper, 139×191 mm
T.B.CCXXI–F

Probably a view on the Moselle (see No.109).
For Colour Plate, see p.79

113

Dinant ?1827
bodycolour on smooth blue paper,
159×198 mm
T.B.CCXCII–37

This drawing is on paper which is different
from that of the rest of the series, and from
that of the majority of the *Seine* and *Loire*
drawings. Turner made several pencil sketches
of Dinant in the *Meuse and Moselle* sketch-
book of 1826, T.B.CCXVI, ff.53–6, and in
the *Huy and Dinant* sketchbook of the same
year, T.B.CCXVII, ff.16–20. He visited the
area again in 1834, making studies of Dinant
in the *Spa, Dinant and Namur* sketchbook
(T.B.CCLXXXVII, ff.1, 27 *verso*, etc.). The
present drawing may have been executed
after the second of these tours. In colouring,
however, it corresponds closely to such
Moselle studies as Nos.109 and 112.

114

Galileo's Villa *c.*1827
watercolour, vignette, 115×140 mm approx.;
sheet 239×305 mm
engr: by E. Goodall for Rogers's *Italy*, 1830,
p.115 (Rawlinson, Vol. II, p.235, No.360)
T.B.CCLXXX–163

Illustrating the lines:
. . . Nearer we hail
Thy sunny slope, Arcetri, sung of old
For its green wine; dearer to me, to most,
As dwelt on by that great Astronomer,
. . . Sacred be
His villa (justly was it called The Gem!)
Sacred the lanes, where many a cypress threw
Its length of shadow, while he watched the stars.

Samuel Rogers (1763–1855) commissioned
Turner to illustrate his long contemplative
poem *Italy* in 1826, allocating landscape and
architectural subjects to him while figure
subjects were to be supplied by Thomas

113

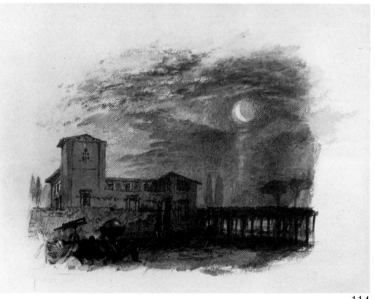

114

Stothard (1755–1834), who had been the illustrator of previous editions of Rogers's work. Turner contributed twenty-five engraved designs, and it has been suggested that his interest in the commission was stimulated by a partiality for Rogers's verse that was not shared by the public at large. A fee of £50 was originally agreed on for each accepted design, but Turner uncharacteristically allowed this to be commuted into a £5 hiring fee, to reduce production costs. The drawings therefore remained in his studio and are now (with one exception) in the Bequest, T.B.CCLXXX, together with many preparatory studies. The vignette form was a new one for him, but he produced a series of highly satisfactory designs which ensured the book's success. The set which he subsequently made for Rogers's *Poems* (see Nos.179, etc.) is even finer. Adele M. Holcomb, in 'A neglected Classical Phase of Turner's Art' in the *Journal of the Warburg and Courtauld Institutes*, 1969, Vol. XXXII, pp.405–10, argues that the design of the Rogers vignettes was influenced by Rogers's own interest in neo-Classical art. The design for *Aosta* (see R.A.1974 no.272) is dated 1826, and Finberg states that Turner had finished most of the vignettes before his departure for Italy in August 1828.

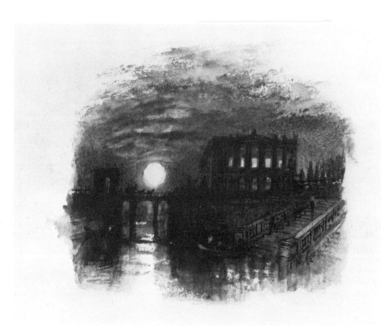

115

115

Padua, moonlight *c.*1827
pencil and watercolour, pen and brown ink, vignette, 94×110 mm approx.; sheet
242×307 mm
T.B.CCLXXX–165

Intended for Rogers's *Italy*, but not used. See *Galileo's Villa*, No.114.

116

Petworth: Sunset sky over the lake ?1828
bodycolour on blue paper, 139×189 mm
T.B.CCXLIV–3

The dating of the Petworth studies in bodycolour on blue paper (T.B.CCXLIV) must be linked with that of the similar drawings in the 'French Rivers' series (see Nos. 162, etc.), which are also in bodycolour on small sheets of blue paper. Turner's technique in Petworth landscapes such as this one is so close to that of certain French views (e.g. T.B.CCLIX–70) that it seems likely that they were executed at about the same time. There is also a close similarity between some of the pen and ink studies of 'French Rivers' subjects (T.B.CCLX)

116

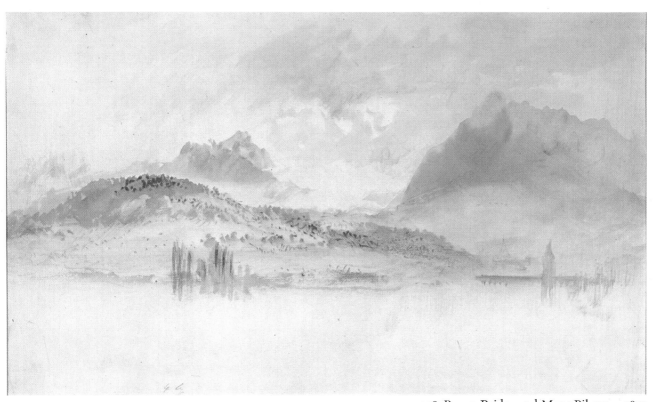

278 Recess Bridge and Mont Pilatus, *c.*1841

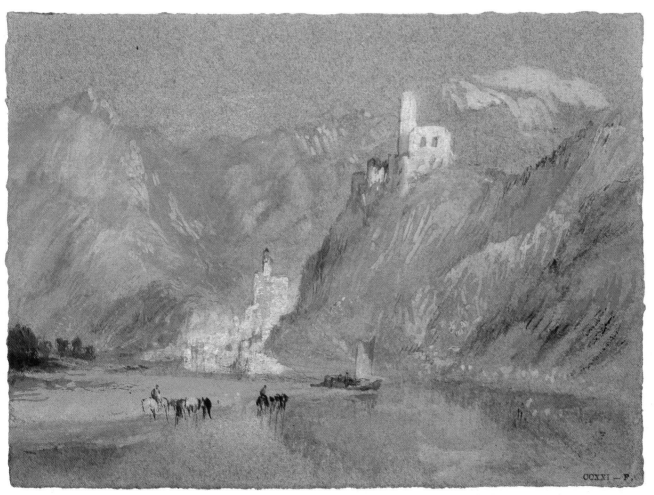

112 A ruined castle on a rock above a town by a river, *c.*1827

100 The sun setting amongst dark clouds, *c.*1825

and the pen sketches on blue paper made at East Cowes Castle in the summer of 1827 (see R.A.1974 nos.303–6), and Turner probably visited Petworth on his way home that summer (see Reynolds, *Turner at East Cowes Castle*, 1969). He was presumably working on the 'French Rivers' designs in the years immediately preceding their publication in 1833–5, but it seems likely that he began to plan the series as early as 1827 or soon after. The Petworth series may then also have been made in 1827 or 1828; though Finberg (*Life*, p.325) associates them with Turner's more frequent visits to Petworth after his father's death in 1830. Whenever they were done, it is probable that they were the product of one visit rather than several; they may have been made over a very short period, perhaps only a few days.

117
Petworth: Evening sky over the lake, with a boat and distant tower ?1828
bodycolour on blue paper (discoloured), 138 × 193 mm
T.B.CCXLIV–4

118
Petworth: Cloudy sunset over the lake ?1828
bodycolour on blue paper (discoloured), 139 × 190 mm
T.B.CCLXIV–18

118

128 Petworth: The White and Gold Room, *c.*1828

129 Petworth: The Library, with a spinet, *c.*1828

148 Windsor Castle, *c.*1829

174 Richmond Hill and Bridge, *c.*1831

119

120

121

119
Petworth: Several people grouped round a man with a white shirt ?1828
watercolour and bodycolour on blue paper,
140 × 188 mm
T.B.CCXLIV–31

Finberg's title for this drawing is 'Waiting for Dinner'.

120
Petworth: Ladies in the drawing-room ?1828
watercolour and bodycolour on blue paper,
137 × 192 mm
T.B.CCXLIV–32

The drawing cannot show, as Finberg suggests, the 'Ladies' drawing room', as no room of that name exists at Petworth.

121
Petworth: Two women in an interior, one lying on a sofa ?1828
watercolour and bodycolour on blue paper,
137 × 185 mm
T.B.CCXLIV–33

122

122
**Petworth: Portrait: study of a young
woman** ?1828
watercolour and bodycolour on blue paper,
191 × 139 mm
T.B.CCXLIV–39

123
**Petworth: A group of women seated
round a table** ?1828
watercolour and bodycolour on blue paper,
148 × 188 mm
T.B.CCXLIV–40

124
**Petworth: Interior with a musical
ensemble** ?1828
watercolour and bodycolour on blue paper,
137 × 188 mm
T.B.CCXLIV–34

123

124

125

126

125

Petworth: In the Chapel ?1828
bodycolour on blue paper, 137 × 192 mm
T.B.CCXLIV–35

In addition to this study, seven of the Petworth drawings record scenes in the chapel, most of them showing a service in progress (T.B. CCXLIV–62–68).

126

Petworth: The dining-room, with a meal in progress ?1828
bodycolour on blue paper, 137 × 187 mm
T.B.CCXLIV–36

127

Petworth: The Picture Gallery, with Flaxman's 'St Michael' ?1828
pencil, watercolour and bodycolour on blue paper, 138 × 189 mm
T.B.CCXLIV–13

The North Gallery at Petworth was devoted by Lord Egremont to the exhibition of his collection of British paintings and sculpture; he made a number of modifications to the lighting of the gallery during the 1820s, especially with regard to the semi-circular windows which can be seen on the left of

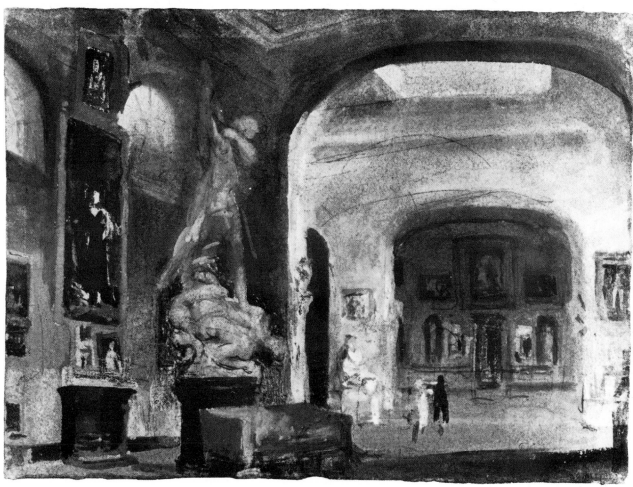

127

this drawing. Flaxman's colossal statue of *St Michael and Satan* arrived at Petworth in 1826; it had been commissioned in 1819. Behind the sculpture is William Owen's full-length portrait of *Mrs Robinson* (No.13, Collins Baker, p.91, repr.).

128
Petworth: The White and Gold Room
?1828
watercolour and bodycolour on blue paper,
133 × 190 mm
T.B.CCXLIV-14

According to notes made by Lady Leconfield in 1933 the oblong pictures underneath the portraits are by C.R. Leslie (1799–1859), a frequent guest of Lord Egremont's. Turner made a series of views in this unusual format to be hung in similar positions at Petworth, where they remain. Leslie's pictures were probably *Charles II and Lady Margaret Bellenden* (Collins Baker, No.221) and *Lucy Percy, Countess of Carlisle, bringing the pardon to her father* (No.224), which Turner imitated in his small historical picture of *Lucy, Countess of Carlisle and Dorothy Percy's visit to their father, Lord Percy* (R.A.1831 no.359) and perhaps also in *Watteau study by Fresnoy's*

rules (R.A.1831 no.361). The collection of paintings at Petworth had a considerable influence on his output; the two subjects mentioned also owe much to Van Dyck and Watteau respectively, and Turner's revived interest in Rembrandt at this period has often been noted (see R.A.1974 nos.332–337). Of the British artists he met there, either personally or through their works, besides Leslie, Henry Thomson (1773–1843), whose *Prospero and Miranda* of 1805 was acquired by Egremont (No.9, Collins Baker, p.121), may have inspired the *Vision of Medea*, shown at the Royal Academy in 1831 (No.358); and Benjamin West, in his sketch for the *Triumph of Death* (No.219, Collins Baker, p.133) seems to have provided the impulse for the *Death on a Pale Horse* (R.A.1974 no.335).
For Colour Plate, see p.81

129
Petworth: The Library, with a spinet
?1828
watercolour and bodycolour on blue paper,
140 × 190 mm
T.B.CCXLIV-16

The musical instrument in this drawing was called a spinet by Finberg in the *Inventory*; it

130

131

132

is more probably a piano. The same instrument figures in another scene in the Library, CCXLIV–37, which is usually known as *The Spinet Player*. For Colour Plate, see.p.81

130
Petworth: An interior with numerous people listening to a woman playing the harp ?1828
watercolour and bodycolour on blue paper, 139×188 mm
T.B.CCXLIV–28

Another sketch of the same scene is CCXLIV–43 (R.A.1974 no.353).

131
Petworth: A man seated at a table in a study, examining a book ?1828
watercolour and bodycolour, 138×189 mm
T.B.CCXLIV–29

Lady Leconfield identified the room shown in this drawing as the Old Library, a large room over the Chapel, which Turner used as a studio.

132
Petworth: An interior with a man writing at a console table ?1828
watercolour and bodycolour, 137×188 mm
T.B.CCXLIV–30

133
Petworth: The Hall, with a number of figures ?1828
watercolour and bodycolour, 140×192 mm
T.B.CCXLIV–71

134
Petworth: A doorway, with an enfilade of rooms beyond ?1828
watercolour and bodycolour on blue paper, 138×187 mm
T.B.CCXLIV–73

The drawing shows the principal vista of ground-floor rooms at Petworth; it is taken from the Somerset Room, looking immediately into the Square Dining Room. At the left can be seen the right-hand portion of Romney's group of *The Egremont Family* (No.381, Collins Baker, p.111, repr.).

135
Petworth: A lacquer cabinet and a chair by a bed ?1828
watercolour and bodycolour, 137×189 mm
T.B.CCXLIV–72

The cabinet, surmounted by a blue pot, appears also in CCXLIV–75 (No.140).

133

134

136

135

137

138

136

Petworth: A room with bookshelves and a rococo pier-glass, with several figures
?1828
watercolour and bodycolour, 138×193 mm
T.B.CCXLIV–24

Called 'Morning Room' by Finberg, but not so identified by Lady Leconfield. The sketch appears to record evening activities taking place by candlelight.

137

Petworth: A man and a woman playing backgammon ?1828
watercolour and bodycolour on blue paper, 140×189 mm
T.B.CCXLIV–27

138

Petworth: Six figures standing and seated near a table ?1828
watercolour and bodycolour, 140×189 mm
T.B.CCXLIV–38

139

Petworth: The interior of a bedroom with a lamp burning on a table ?1828
watercolour and bodycolour on blue paper, 140×190 mm
T.B.CCXLIV–74

140

Petworth: A bedroom with green bed curtains and a lacquer cabinet ?1828
watercolour and bodycolour on blue paper, 138×188 mm
T.B.CCXLIV–75

The same lacquer cabinet appears in CCXLIV–72. (No.135).

141

Petworth: A bedroom with yellow bed curtains ?1828
watercolour and bodycolour on blue paper, 141×190 mm
T.B.CCXLIV–76

139

140

141

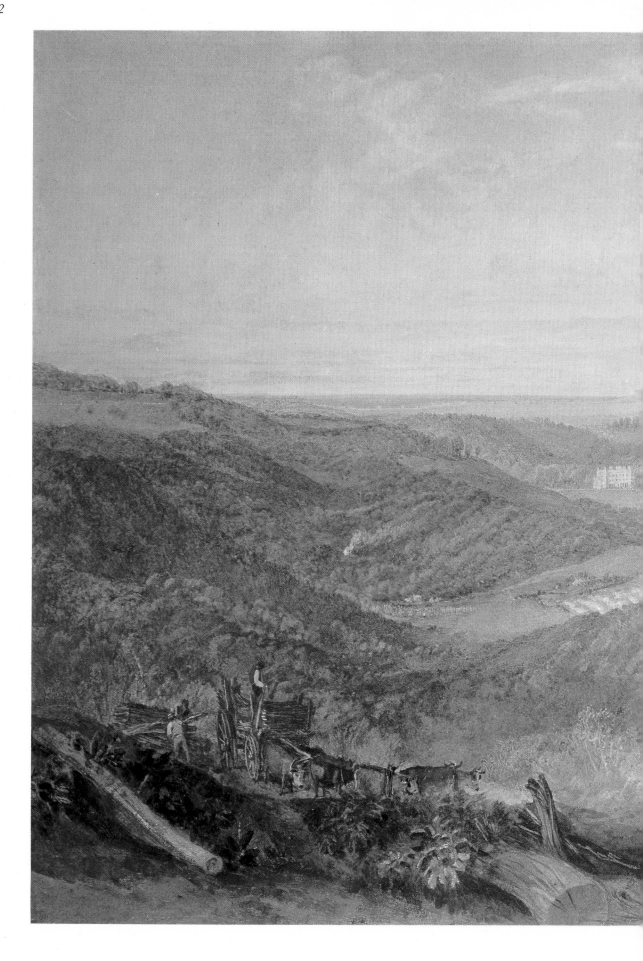

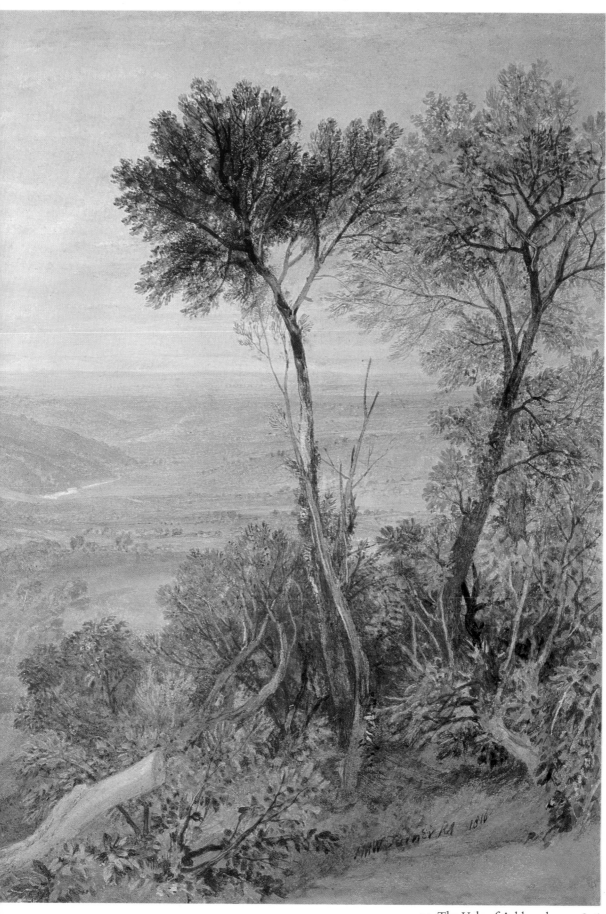

45 The Vale of Ashburnham, 1816

142

144

142

Petworth: A woman in black seated at a dressing table before an oval glass ?1828
watercolour and bodycolour, 192 × 138 mm
T.B.CCXLIV-79

The composition of this subject is reminiscent of that of the oil painting *The Letter* (Tate Gallery 5501), where the face reflected in the glass becomes a second girl peeping over the shoulder of the other. Ann Forsdyke has recently pointed out (in conversation with the compiler) that the group was introduced by Turner into his watercolour of *Gosport* for the *England and Wales* series (private collection; Rawlinson No.252), where the two women are seated in a boat. *Gosport* was engraved in 1830.

143

Petworth: A woman in blue seated reading to a lame man lying on a sofa in a room with a fire ?1828
watercolour and bodycolour on blue paper,
141 × 190 mm
T.B.CCXLIV-77

The lame man appears again with his crutch in CCXLIV-26.

144

A North Italian lake ?c.1828
bodycolour over pencil, 310 × 558 mm
T.B.CCLXIII-33

This study may have been executed in connection with Turner's Italian visit of 1828. It seems to be connected with CCLXIII-179 which has a watermark of that date. It may have emerged from Turner's preparations for the watercolour of *Arona on Lake Maggiore* which was engraved for the *Keepsake* in 1829 (Rawlinson No.321) though there are grounds for supposing that that watercolour (R.A.1974 no.466) was executed before Turner's stay in Italy in 1828-9 (see *Florence from San Miniato*, No.145). A less finished version of the same subject is CCLXIII-364.

145

Florence from San Miniato c.1828
watercolour and bodycolour,
286 × 418 mm
coll: Monro of Novar; Christie, 1897;
?Sir J. Pender; Hon W.F.D. Smith; bt. Agnew 1908; Sir Joseph Beecham; sale, Christie, 4 May 1917 (149); R.W. Lloyd, by whom bequeathed to B.M.1958-7-12-426

Two very similar subjects exist, differing only in details and in the disposition of the

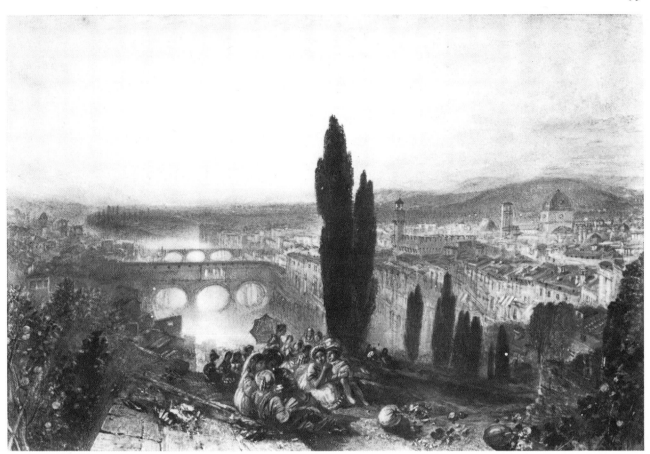

145

foreground figures: one is in the Herbert Art Gallery, Coventry and, with the *Margate* in the same collection, belonged in the nineteenth century to Lord Northbourne. The other belonged to Sir Donald Currie and is now in a private collection; it was engraved for the *Keepsake* in 1828 by E. Goodall (Rawlinson No.319). Turner had already made a drawing of Florence from the same spot, with a rather different composition, derived from a sketch made on the spot by James Hakewill, for Hakewill's *Picturesque Tour in Italy* (Rawlinson No.158). The vignette of *Florence from Fiesole* for Rogers's *Italy* (Rawlinson No.359) employs the motif of cypress trees in a somewhat similar way; and indeed despite their difference of scale and mood the *Italy* vignettes have strong affinities with the larger watercolour. They were executed between about 1826 and 1828; and *Florence from San Miniato* was also probably produced before Turner's visit to Italy in 1828; the three different versions of the subject all seem to have been made at about the same date, as they are uniform in style.

Ruskin wrote of the drawing which formed the original of the *Keepsake* engraving: 'a glorious drawing, as far as regards the passage with the bridge and sunlight on the Arno, the cascine foliage, and distant plain, and the towers of the fortress on the left; but the details of the Duomo and the city are entirely missed, and with them the majesty of the whole scene. The vines and melons of the foreground are disorderly, and its cypresses conventional; in fact, I recollect no instance of Turner's drawing a cypress except in general terms' (*Modern Painters*, Vol. 1, p.130).

There is possibly some connection between the three *Florence* watercolours and the reference in the advertisement for the exhibition at the Egyptian Hall, Piccadilly, 1829, to 'a projected work . . . on Italy', which was to be 'of a similar kind' to the *England and Wales* publication (see Finberg, *Life*, p.488, note). At that exhibition a watercolour of *Lake Albano* (untraced; ex. coll. Pierpont Morgan) appeared (No.343 in Finberg's list, p.489); this, like *Florence* and *Arona on Lake Maggiore* (see No.144, and R.A.1974 no.466), was engraved for the *Keepsake* (Rawlinson No. 320); all three subjects may have been intended to take their place in the projected *Picturesque Views in Italy*, for which, however, no other drawings suggest themselves as likely candidates.

146

146
An Italian bay *c.*1828
watercolour, 344×486 mm
T.B.CCLXIII–65

One of several colour-beginnings which may
be grouped with oil sketches made in Rome
in 1828 and apparently connected with the
evolution of the painting *Ulysses deriding
Polyphemus*, shown at the Royal Academy in
1829 (42); see R.A.1974 nos.475–80. The
location is presumably somewhere near
Naples, though these studies of sunset light on
rocks romantically grouped in a calm sea are
not as specific in their allusion to an actual
scene as those of the Bay of Baiae for *Apollo
and the Sibyl* of 1823 (R.A.1974 no.237).

147
**Messieurs les Voyageurs on their return
from Italy (par la diligence) in a snow
drift upon mount Tarrar, 22nd of
January, 1829** 1829
watercolour and bodycolour, 545×747 mm
coll: William Moir; Mrs Moir; bt. Agnew
1899; S.G. Holland; sale, Christie, 26 June
1908 (259); Sir Joseph Beecham; sale,
Christie, 4 May 1917 (157); R.W. Lloyd, by
whom bequeathed to B.M.1958–7–12–431
exh: R.A.1829 (520)

Turner had made a watercolour record of his
previous return from Italy in 1820, the *Snow-
storm, Mont Cenis* (coll. Mrs D.A. Willi006-
son, see R.A.1974 no.B90), and this much
larger subject continues the same theme,
which is unusual in being specifically auto-
biographical. Here, however, Turner con-
centrates on the details of life provided by
'Messieurs les Voyageurs' almost to the ex-
clusion of mountain scenery, though the

difficult conditions are suggested by the
economic selection of a few telling incidents.
A letter from Turner to Charles Lock East-
lake describing the events on which the water-
colour is based is published by John Gage in
Turner: Rain Steam and Speed, 1972, pp.38–
40:
'. . . the snow began to fall at Foligno, tho'
more of ice than snow, [so] that the coach
from its weight slide [*sic*] about in all direc-
tions, that walking was much preferable, but
my innumerable tails would not do that
service, so I soon got wet through and
through, till at Sarre-valli [i.e. Serrevalle] the
diligence zizd into a ditch, and required 6
oxen, sent three miles back for, to drag it out;
this cost 4 Hours . . . crossed Mont Cenis on a
sledge – bivouacked in the snow with fires
lighted for 3 Hours on Mont Tarate while the
diligence was righted and dug out, for a Bank
of Snow saved it from upsetting – and in the
same night we were again turned out to walk
up to our knees in new fallen drift to get
assistance to dig a channel thro' it for the
coach. . .'
 The watercolour is sometimes known
simply as *The Snowdrift*. As an instance of
Turner's use for pictorial purposes of the
perils he himself encountered while travelling
it can be grouped with the oil paintings of
Calais Pier (R.A.1803; R.A.1974 no.75) and
Snow Storm – steam-boat off a harbour's mouth
(R.A.1842; R.A.1974 no.504). As a study
from memory however it seems to belong
with the watercolour of the *Funeral of Sir
Thomas Lawrence, a Sketch from Memory*,
drawn in 1830 and also shown at the Royal
Academy, the last of Turner's works in the
medium to appear there (see R.A.1974
no.436). For Colour Plate, see p.116

148
Windsor Castle *c.*1829
watercolour, 288×437 mm
coll: Thomas Tomkinson; J. Smith; sale,
Christie, 4 May 1870 (59); William Moir;
Mrs Moir; bt Agnew 1899; R.E.Tatham;
sale, Christie, 7 March 1908 (84); Sir Joseph
Beecham; sale, Christie, 4 May 1917 (148);
bt in; sale, Christie, 10 May 1918 (85);
R.W. Lloyd, by whom bequeathed to B.M.
1958–7–12–432
engr: by William Miller, 1831, for *Picturesque
Views in England and Wales*, Part XII, No.1
(Rawlinson, Vol.1, p.142, No.253)
exh: Egyptian Hall, 1829; Moon, Boys and
Graves Gallery 1833(43)

The catalogue of the Royal Academy *Old
Masters* exhibition of 1887 (68) gives the date

of this drawing as 1836, but it was engraved in 1831 and seems to have been that exhibited with other *England and Wales* drawings at the Egyptian Hall in 1829. The composition of this subject makes use of two pencil sketches in the *Windsor and St Anne's Hill* sketchbook of about 1827 (T.B.CCCXV, f.2 *recto* and *verso*).

Turner's treatment of this subject is characteristic of his ability to reduce every observed fact to its essentials while conveying a precise and detailed sense of its reality. In particular, the schematised drawing of men and horses to the left of the view illustrates the remarks of Quilter cited in the Introduction (p.24). For Colour Plate, see p.82

149
The harbour at Marseilles *c.*1829
black chalk and bodycolour over pencil on grey paper, 138 × 186 mm
T.B.CCXCII–74

Perhaps showing the same lighthouse as that identified by Finberg as Marseilles, T.B. CCLIX–139; pencil drawings in the *Lyons to Marseilles* sketchbook of 1828 (T.B.CCXXX,

ff.52 *recto*, 53 *recto* and *verso*) show the scene in a broader context. Other studies on grey paper, making use of blues, pinks and purples similar to those in this drawing, can be grouped with it and provisionally identified as views on the Mediterranean coast between Marseilles and Genoa, which was on Turner's route to Rome in the autumn of 1828. The paper he used for these studies was folded and torn into convenient 4½″ × 7½″ sheets, like that of the 'French Rivers' and Petworth drawings; but it is grey and not the customary blue. Turner may have envisaged another series to be published *en suite* with his Loire, Seine, Meuse and Moselle designs, but its scope is not known, and it seems to have progressed no further than these few drawings. It is possible that Turner was using small sheets of blue paper throughout the Italian visit of 1828; three views of Vesuvius in bodycolour on blue sheets, in the collection of D.L.T. Oppé, may have been done on the spot in 1819; but it is more likely that they belong to some date about 1830. For a small drawing on blue paper showing a view in Venice see the entry to No.260.

CCXCII – 74

149

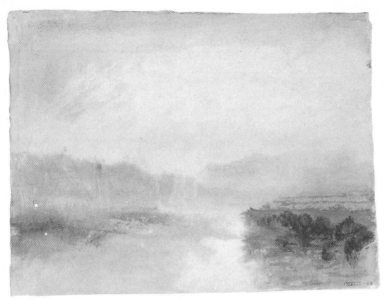

150

150
Evening sky over a lake with distant mountains *c.*1829
bodycolour on grey paper, 141 × 189 mm
T.B.CCXCII–68

This study appears to have been executed together with the view of Marseilles, No.149, and may therefore show a scene on the Mediterranean coast of France or Italy: it is, however, almost impossible to say precisely where sketches such as this and No.151 were done, or whether they were made on the spot. Although Turner probably added colour later to the pencil outlines he drew from nature, this, like the Petworth series, is executed directly in colour without under-drawing.

151
Clouds at sunset over a lake *c.*1829
bodycolour on grey paper, 139 × 184 mm
T.B.CCXCII–75

One of the views on grey paper, making marked use of pink and purple, which may have been made either during or shortly after the journey to Italy in 1828 (see No.149).

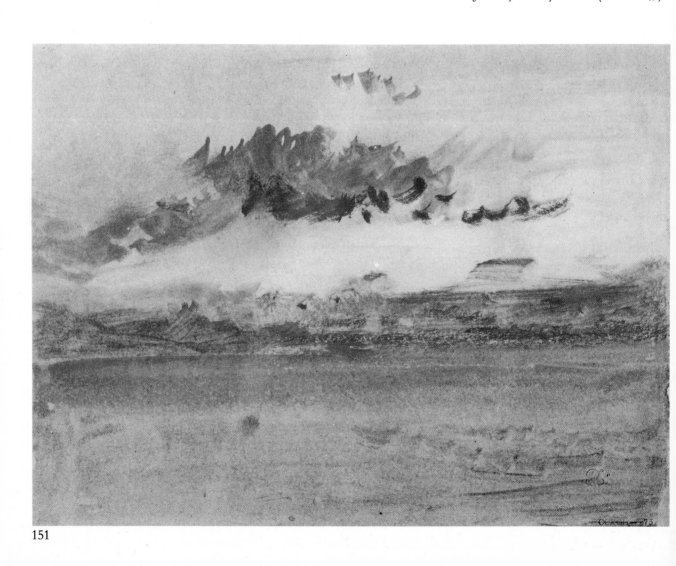

151

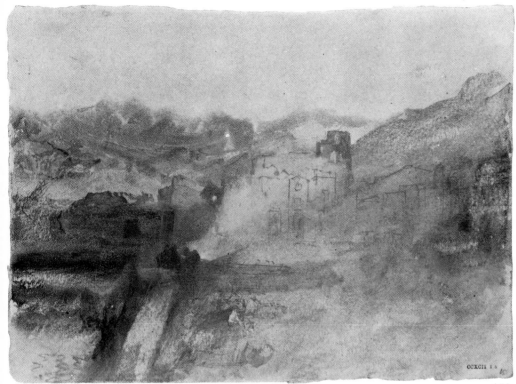

152

152

A large building on a cliff above a lake
*c.*1829
bodycolour with some pen on grey paper
136×189 mm
T.B.CCXCII–15

This study should perhaps be grouped with the 'Marseilles' drawings, Nos.149, 150 etc., and perhaps represents a scene on the French coast in that area.

153

A fortress on a rocky shore *c.*1829
watercolour and bodycolour over pencil on grey paper, 137×188 mm
T.B.CCXCII–71

The colouring of this study suggests that it was made at the same time as No.149, which appears to be a view of Marseilles. If so, it may represent a scene on the southern coast of France and relate to Turner's journey to Rome in 1828.

154

A harbour on a rocky coast *c.*1829
bodycolour with some pen on grey paper,
140×189 mm
T.B.CCLIX–213

Possibly a view on the Mediterranean coast of France, or in Italy, The grey paper and range of the palette connect this drawing with the 'Marseilles' view, No.149.

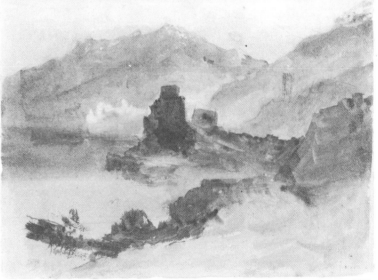

153

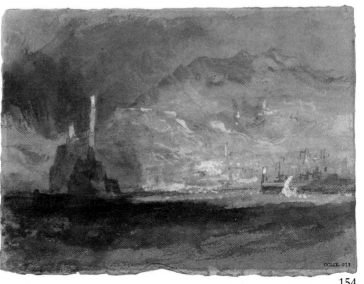

154

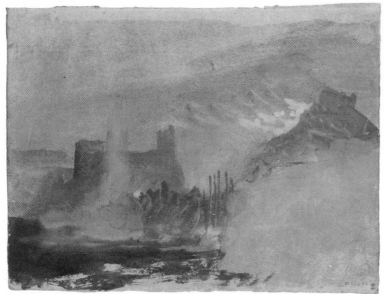

155

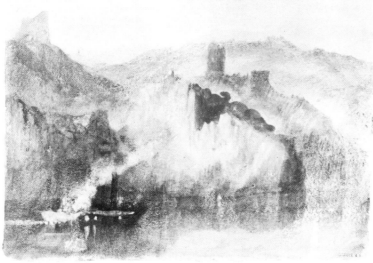

156

155

Scarlet buildings, and an orange tower, above a harbour *c.*1829
bodycolour on grey paper, 140 × 190 mm
T.B.CCXCII–18

Apparently executed at the same time as No. 156, and probably also a view on the south coast of France.

156

Ruined buildings on cliffs by a river with a steamboat *c.*1829
bodycolour on grey paper, 139 × 182 mm
T.B.CCXCII–48

This study may belong, with T.B.CCXCII–15 and 18 (Nos.152 and 155), to the series of views in southern France; it uses a darker, greener palette than many of that group, but seems to have been produced together with the drawings mentioned. It is possible that the building in the top left corner is the same as that on the right of No.155.

157

A castle on a cliff in sunlight *c.*1829
bodycolour on grey paper, 140 × 192 mm
T.B.CCXCII–35

Probably connected, like the other studies on grey paper in this format, with the 1828 journey from Marseille to Genoa *en route* for Rome. The delicate colouring of the study confirms this, though the castle has not been identified.

158

A ruined castle and other buildings on cliffs beside an inlet *c.*1829
pencil and bodycolour on grey paper
138 × 192 mm
T.B.CCXCII–52

The colouring of this drawing associates it with the series provisionally identified as showing the southern coast of France (see No. 149). The pencil underdrawing has the character more of an extremely rough guide for the laying in of colour, rather than of a record made on the spot; but Turner may have made the brief note while travelling.

159

Soldiers in the upper room of a café
*c.*1829
watercolour and bodycolour with some pen on blue paper, 140 × 190 mm
T.B.CCLIX–263(b)

Studies like this one or the *Peasants dancing in the street* (No.160) suggest that many of

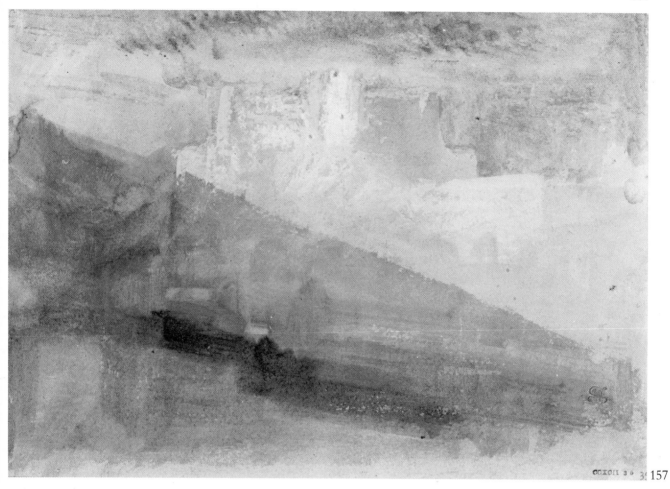

CCXCII 3 b 157

CCXCII 158

159

160

161

Turner's preparatory drawings for the series of the 'French Rivers' were executed in this way on the spot; there are similar drawings in pencil in the *Dieppe, Rouen and Paris* sketchbook of 1821 (T.B.CCLVIII, f.24 *verso*, etc.). In this case the use of blue paper similar to that of the East Cowes and Petworth drawings (see No.116) indicates a date around 1827 or 1828. It may even be possible to associate some of these drawings with the tour of the north French coast which Turner made in 1826 (see Finberg, *Life*, p.300) with a view to publishing 'a work to be entitled THE ENGLISH CHANNEL, or LA MANCHE, to consist of views taken by him from Dunkirk to Ushant, and places adjacent; together with others, on the opposite shore of England.' This never appeared. If Turner was collecting French material for such a purpose as early as this, he would have incorporated it into his later plans for the three volumes of the *Rivers of France*, or *Wanderings by the Loire and the Seine* published in 1833, 1834 and 1835, finished drawings for which are catalogued here as Nos.190–6. Other series were projected (see Nos.109, 149) but came to nothing. Many sketchbooks were drawn on for the 'French Rivers' views, including the *Dieppe, Rouen and Paris* book; see R.A.1974 nos.363–9.

160

Peasants dancing in the street *c*.1829
pencil, pen and brown ink, watercolour and bodycolour on blue paper (discoloured), 132 × 188 mm
T.B.CCLIX–197

See No.159.

161

A Gothic screen, Rouen Cathedral
?*c*.1829
pen and watercolour and bodycolour on blue paper, 141 × 192 mm
T.B.CCLIX–149

Derived from a pencil sketch on f.10 *recto* of the *Dieppe, Rouen and Paris* sketchbook (T.B.CCLVIII). Although executed on blue paper in the manner of the designs for the 'French Rivers' engravings, this drawing is unlikely to have been intended as a subject for the publication, and shows Turner working up a pencil sketch in this way for some other purpose, probably simply for private reference.

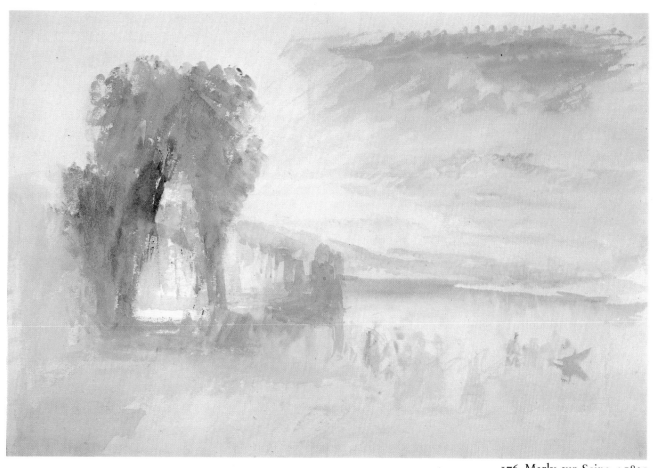

176 Marly-sur-Seine, *c.*1831

175 Marly-sur-Seine, *c.*1831

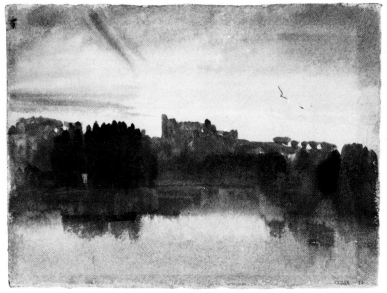

162

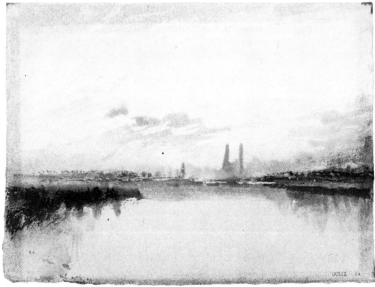

163

164

162

A large building near the Seine at sunset
*c.*1829
bodycolour on blue paper, 138 × 189 mm
T.B.CCLIX-70

Very close in treatment to some of the small bodycolour landscapes made at Petworth (see No.116). As the scene has not been identified its association with the 'Seine' series is largely conjectural. Its likeness to the view apparently of Jumièges (No.163), however, corroborates the supposition.

163

Sunset on the Seine: ?Jumièges *c.*1829
bodycolour on blue paper (faded),
138 × 190 mm
T.B.CCLIX-69

Studies of Jumièges from the river are on ff.69 *verso* and 71 *recto* of the *Seine and Paris* sketchbook (T.B.CCLIV); a finished drawing of the view, in daylight with an approaching storm, was engraved for the 1834 *Annual Tour* by J.C. Armytage (Rawlinson No.463); it is in the Turner Bequest, CCLIX-131.

164

A rainbow over the sea ?*c.*1830
bodycolour on blue paper, 190 × 277 mm
T.B.CCCLXIV-409

Finberg suggests that this drawing, and a group of fourteen others, were made on the south coast of England. It is hard to assign a date to the series, but the use of blue paper suggests a connection with Petworth and 'Rivers of France' drawings of the late 1820s or early 1830s. These studies are in general broader than those, and concentrate on more specific single effects; there is no attempt to create 'scenes'; but the use of bodycolour is often similar. There are also affinities with the *Little Liber* watercolours of *c.*1825 (see No.88).

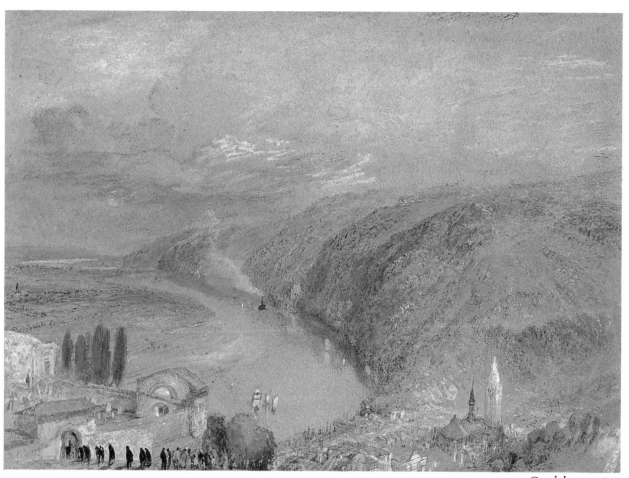

190 Caudebec, c.1832

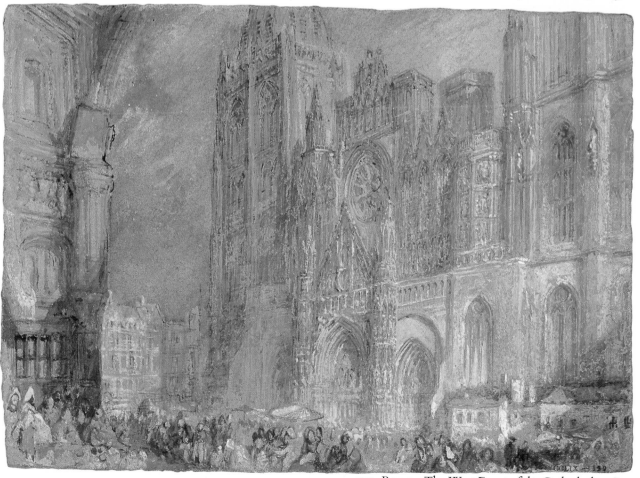

192 Rouen: The West Front of the Cathedral, c.1832

165

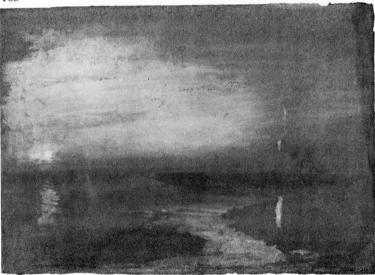

166

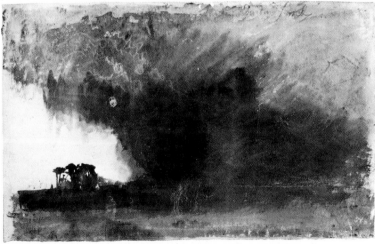

167

165
A breaking wave ?*c*.1830
watercolour and bodycolour on blue paper,
190×278 mm
T.B.CCLXIV-417

See the *Rainbow* in the same series, No.164.

166
Sunset on the coast with a crescent moon
?*c*.1830
bodycolour on blue paper, 193×277 mm
T.B.CCCLXIV-410

See the *Rainbow* in the same series, No.154.

167
Duddon Sands ?*c*.1830
watercolour and white chalk, 277×452 mm
inscr. upper right: *Duddon Sands*
T.B.CCLXIII-104

One of a number of markedly broad colour-
beginnings which are inscribed with place-
names or other titles; *Cartmel Sands*, for in-
stance, is on paper watermarked *1828* (T.B.
CCLXIII-160). The chalk marks indicate
figures on the sand in the centre foreground,
and apparently a ship in the mid-distance to
the right. The white dot to the left may in-
dicate the position of the sun.

168
Saumur *c*.1830
watercolour, 283×423 mm
coll: Ruskin; Munro of Novar; sale, Foster,
1855; J. Dillon; sale, Foster, 7 June 1856 (144);
J.H. Maw, 1857; Hon W.F.D. Smith; Sir
Joseph Beecham; sale, Christie, 4 May 1917
(153), bt. in; sale, Christie, 10 May 1918 (87);
R.W. Lloyd, by whom bequeathed to
B.M.1958-7-12-430
engr: by R. Wallis, 1830, for the *Keepsake*
(Rawlinson, Vol. II, p.224, No.324)

A drawing in the 'French Rivers' series, T.B.
CCLIX-145, is a view of Saumur from the
same spot, and was evidently used as the
basis of this watercolour, which was de-
scribed in John Dillon's sale catalogue, 1858,
as 'the celebrated drawing from the Keepsake'.
This and *Richmond Hill and Bridge* are speci-
mens of the very broad, coarse technique
which Turner introduced into the handling of
his finished watercolours about 1830. It
seems to have been a temporary mannerism

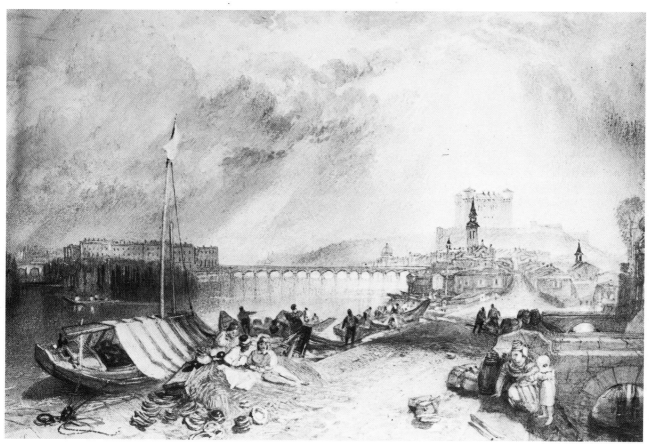

168

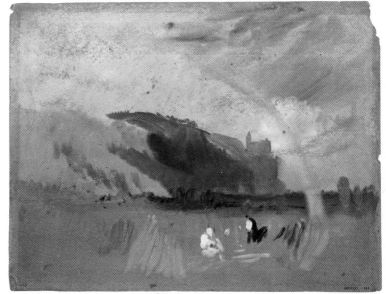

169

rather than a step towards a generally looser style, as later watercolours of the same type revert to a more delicate treatment (see, for instance, *Derwentwater*, No.203). Another view of Saumur was engraved for *Turner's Annual Tour – the Loire*, 1833 (Rawlinson No.443).

169
Figures in a cornfield, with a rainbow
?*c*.1830
bodycolour on grey paper, 223 × 294 mm
T.B.CCCLXIV–339

This drawing is difficult to place; it has many points of resemblance with the Fawkes Rhine drawings of 1817, and the treatment of the building on the cliff and the cloud behind it suggests a fairly early date. In colouring, too, it reflects some of the features of work of that period (compare *La Bastiaz near Martigny*, No.75). The extremely free and elliptical handling of the foreground, however, indicates a rather later date, perhaps in the early 1830s. Finberg placed it with miscellaneous drawings of the 1830s. A similar study is T.B.CCCLXIV–267.

171

170

A sailing-boat and buildings against a sunset sky *?c.*1830
bodycolour on (?) buff paper, 150×184 mm
T.B.CCCLXIV–241

Apparently a view in Holland, and therefore possibly done about 1817; but the drawing was probably made in connection with a later visit, perhaps that of 1825 or one in the early 1830s. A similar drawing is T.B. CCLXIII–197.

171

Study for a vignette: A woman in a prison cell *c.*1830
pencil and watercolour, vignette,
75×105 mm approx.; sheet 253×340 mm
T.B.CCLXXX–10

Perhaps connected with the series of illustrations to Rogers's *Poems*, published in 1834 (see No.114).

170

172
Study for a vignette: A sailing-boat in a storm *c.*1830

watercolour, vignette, 135 × 145 mm approx.;
sheet 215 × 293 mm
T.B.CCLXXX-7

Perhaps connected with the series of illustrations to Rogers's *Poems* (see No.114).

173
Lichfield from St Michael's *c.*1830–35

watercolour, 351 × 510 mm
T.B.CCLXIII-99

Based directly on the pencil drawing in the 1830 *Kenilworth* sketchbook (T.B.CCXXXVIII, f.51 b. *recto*) which is inscribed: *St Michaels Grey* (?) *Hill*. This study is very similar in colouring to the series of *The High Street, Oxford* (see R.A.1974, nos.442–7), and other colour-beginnings related to the *England and Wales* series. This subject, unlike the *Oxford*, was apparently never taken beyond the stage of a very broad tonal layout, and no other essays on the same theme have been identified in the Turner Bequest, but it was nevertheless probably executed with an *England and Wales* illustration in mind. Finberg (*Inventory*, Vol. II, p.731) refers to a watercolour of Lichfield based on another sketch in the *Kenilworth* book but not engraved for *England and Wales*; it belonged to Munro of Novar but is now untraced.

174
Richmond Hill and Bridge *c.*1831

watercolour with some bodycolour,
291 × 435 mm
coll: Ruskin; Agnew 1900; G.P. Dewhurst;
bt Agnew, 1916; R.W. Lloyd, by whom
bequeathed to B.M.1958-7-12-435
engr: by W.R. Smith, 1832, for *Picturesque Views in England and Wales*, Part XIII, No.1 (Rawlinson, Vol. I, p.144, No.257)

A very slight pencil sketch of this view is in T.B.CXLI, f.14, but there is no reason to connect it directly with the watercolour.

Ruskin, in his notes to the Fine Art Society Exhibition, where *Richmond Hill and Bridge* was No.29, says that 'it was the first [drawing by Turner] I ever possessed; my father buying it for me, thinking I should not ask for another, – we both agreeing that it had nearly everything *characteristic* of Turner in it, and more especially the gay figures!' Finberg thought it 'breezy, reckless, splendid, & a trifle vulgar' (manuscript note in the British Museum). The subject is an outstanding example of Turner's ability to invent human figures which amplify and explain the significance of the landscape.

172

173

175

Marly-sur-Seine *c.*1831
watercolour and some bodycolour,
286 × 426 mm
coll: Munro of Novar; sale, Christie, 2 June
1877 (37), bt White; John Heugh; sale,
Christie, 10 May 1878 (157); Rev J.W.R.
Brocklebank; R.W. Lloyd, by whom
bequeathed to B.M.1958-7-12-433
engr: by W. Miller, 1832, for the *Keepsake*
(Rawlinson, Vol.II, p.225, No.327)

Based on the drawing in pencil and pen and
brown ink on blue paper in the 'French
Rivers' series T.B.CCLX-58. A colour-begin-
ning of the subject is T.B.CCLXIII-30 (No.
176). The acid green used for some of the
foreground detail is probably the emerald
green which was developed at about the date
of the drawing: it occurs in the vignette *St
Anne's Hill - the Garden* (No.182), engraved
for the 1834 edition of Rogers's *Poems*, and in
the *England and Wales* watercolour of *Margate*
(Herbert Art Gallery, Coventry).

Ruskin (*Modern Painters*, Vol. I, p.393)
points to the group of trees on the left of this
watercolour as 'a fair standard of Turner's
tree-painting. We have in it the admirably
drawn stems . . . full, transparent, boundless
intricacy . . . and misty depth of intermingled
light and leafage'. Elsewhere (ibid., p.79) he
suggests that the group is 'I believe accident-
ally . . . repeated nearly mass for mass' from a
similar group in Tintoretto's *Death of Abel* in
the Accademia, Venice. Gage (*Colour in
Turner*, p.96 and note 89) cites *Marly* as a
watercolour which shows that Turner's
hatching reveals 'a strong interest in the
tempera and fresco work of the Trecento and
Quattrocento'. It can also be seen in *Saumur*
(No.168) and *Richmond* (No.174). Such
hatching was, of course, a commonplace of
watercolour technique in the early nine-
teenth century, though usually found in
miniature portraiture, and never employed
with such imagination and flexibility as
Turner's. For Colour Plate, see p.103

176

Marly-sur-Seine ?*c.*1831
watercolour, 355 × 510 mm
T.B.CCLXIII-30

Described by Finberg as of 'an Italian Lake',
this colour-beginning is a paraphrase of the
design engraved for the *Keepsake* in 1832
(No.175). Its scheme of clear yellows and
blues corresponds closely to the finished
watercolour. The abrupt termination of the
design at the left suggests that it was perhaps

modelled on the watercolour and did not
precede it; but the preparation of broad
colour layouts as steps towards a finished
watercolour was characteristic of Turner's
procedure, especially at this period.
For Colour Plate, see p.103

177

**The Acropolis, Athens; and a study of
pink and blue cloud** ?*c.*1831
watercolour, 372 × 223 mm; the sheet has
been folded across the centre
watermarked: *1828*
T.B.CCLXIII-253

This study of the Acropolis, and the related
one T.B.CCCLXIV-402, are presumably con-
nected with the illustration which Turner
made for Vol. III of Finden's *Byron* after a
sketch by T. Allason, engraved in 1832 by J.
Cousen (Rawlinson No.408). The finished
drawing belonged to Munro of Novar. The
colouring is similar to that of certain other
preliminary studies for illustrations, particu-
larly those for Moore's *Epicurean*, on which,
however, Turner was not working until
some years after the *Byron* (see Nos.214, 215).

178

Loch Katrine *c.*1832
watercolour, 96 × 149 mm
coll: Munro of Novar; sale, Christie,
6 April 1878 (73); C. Wheeley Lea; Mrs C.
Wheeley Lea; sale, Christie, 11 May 1917
(39); R.W. Lloyd, by whom bequeathed to
B.M.1958-7-12-436
engr: by W. Miller, 1834, as the frontispiece
to Vol. VIII of Cadell's *Scott's Poetical Works*
(Rawlinson, Vol. II, p.282, No.507)

In 1831 Turner was commissioned by the
Edinburgh publisher Robert Cadell to illu-
strate a series of books incorporating the
works of Sir Walter Scott. Turner had already
made designs for Scott's *Provincial Antiquities
of Scotland*, published 1818-26 (see R.A.1974
nos.204-6) but had not formed any close
relationship with the author. Under the
guidance of Cadell, however, he made two
tours of Scotland, in 1831 and 1834; the
Poetical Works appeared in 1834 with twenty-
four illustrations, and the *Prose Works* during
the following two years, with forty illustra-
tions. Turner also contributed to Fisher's
Illustrations to the Waverley Novels of 1836-7,
and to Lockhart's *Life of Scott* which ap-
peared in 1839. See Gerald Finley, 'Kindred
Spirits in Scotland: Turner and Scott',
Connoisseur, August 1973, pp.238-47; and
'Turner's Illustrations to Napoleon', *Journal
of the Warburg and Courtauld Institutes*, Vol.

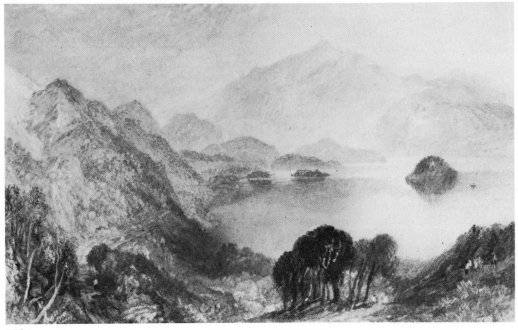

178

XXXVI, 1973, pp.390–6; also Adele M. Holcomb, *Turner and Scott*, ibid. Vol. XXXIV, 1971, pp.386–97. This design illustrates Scott's narrative poem *The Lady of the Lake*, and, like all Turner's illustrations to works of literature, is executed on a scale reduced almost to that of the engraving. It is finished, however, with the same minute attention to detail that Turner brought to his large watercolours, though it is noteworthy that he does not here introduce the elaborate human incident that characterizes most of these designs.

Among numerous pencil sketches in the *Stirling and the West* sketchbook (T.B.CCLXX) which appear to show the same portion of Loch Katrine, that on f.47 *recto* is evidently Turner's principal source for this drawing.

179
A village fair *c.*1832
pencil and watercolour, vignette,
115 × 120 mm approx.; sheet 279 × 309 mm

inscr: *Avenues of booths up the wide street or road thro a village – signs here & there/A Conjuror's or Quack doctor's booth* and *A Players stage* with small pencil sketch of the stage
engr: by E. Goodall for Rogers's *Poems*, 1834, p.84 (Rawlinson, Vol. II, p.241, No.382)
T.B.CCLXXX–200

Illustrating lines from Rogers's *Human Life*:
 'A Wake – the booths whitening the village-green,
 Where Punch and Scaramouche are seen;
 Sign beyond sign in close array unfurled
 Picturing at large the wonders of the world . . .'
The church in this vignette design is reminis-

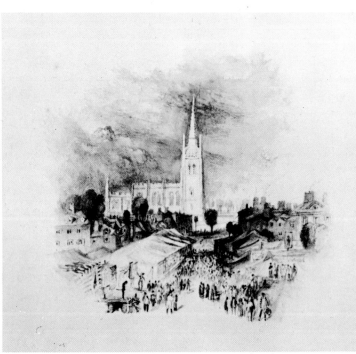

179

cent of Louth, Lincolnshire, and the whole subject recalls the watercolour of *c*.1828 for the *England and Wales* series (R.A.1974 no.422). For Turner's work for Rogers see No.114.

180
The English manor house *c*.1832
pencil and watercolour, vignette,
105 × 100 mm approx.; sheet 260 × 218 mm
engr: by W. Miller for Rogers's *Poems*, 1834,
p.63 (Rawlinson, Vol. II, p.241, No.380)
T.B.CCLXXX–201

The headpiece to Rogers's poem *Human Life*.

181
St Anne's Hill – the House *c*.1832
pencil and watercolour, vignette,
100 × 175 mm approx.; sheet 232 × 305 mm
inscr: across top of sheet with numerals 1 to 16
engr: by E. Goodall for Rogers's *Poems*, 1834,
p.91 (Rawlinson, Vol. II, p.242, No.384)
T.B.CCLXXX–170

Illustrating Rogers's poem *Human Life*. The pencil drawing for this vignette is in the *Windsor and St Anne's Hill* sketchbook, T.B.CCXXV, f.26 *recto*. See also No.182.

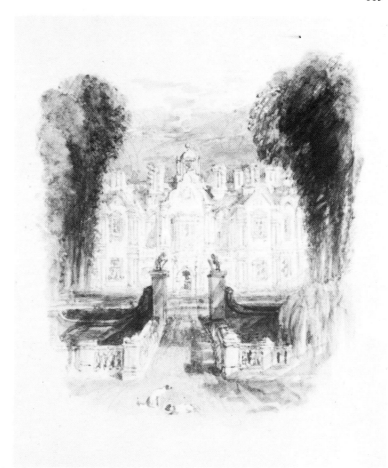

180

181

182

182
St Anne's Hill – the Garden *c.*1832
pencil and watercolour, vignette,
150×165 mm approx.; sheet 245×308 mm
engr: by E. Goodall for Rogers's *Poems*, 1834,
p.214 (Rawlinson, Vol. II, p.245, No.397)
T.B.CCLXXX–171

The tailpiece to lines *Written in Westminster Abbey* (after the funeral of the Rt Hon. Charles James Fox, 10 October 1806). St Anne's Hill was Fox's home. A reference to it, and to Fox, in *Human Life* is illustrated with another view (No.181).
 From a pencil drawing in the *Guildford and St Anne's Hill* sketchbook, T.B.CCXXV–25 *recto*.

183
A village evening *c.*1832
watercolour, vignette, 75×110 mm approx.;
sheet 242×306 mm
engr: by E. Goodall for Rogers's *Poems*, 1834,
p.7 (Rawlinson, Vol. II, p.239, No.374)
T.B.CCLXXX–168

Used as a headpiece to Part I of *The Pleasures of Memory:*
 'Twilight's soft dews steal o'er the village-green,
 With magic tints to harmonise the scene.'

183

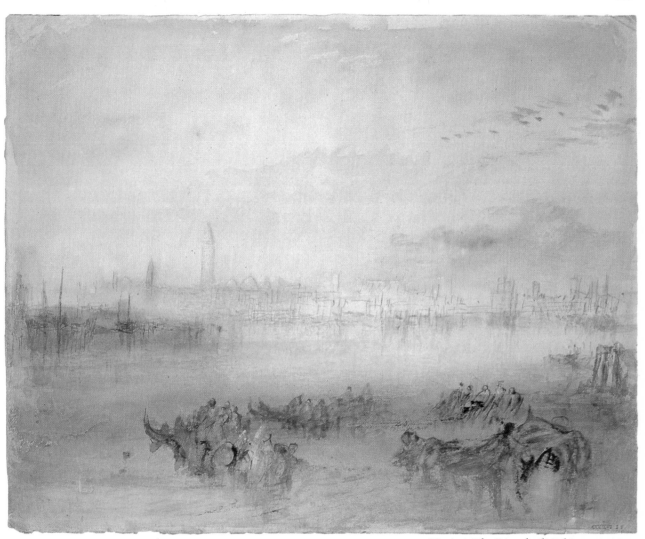

237 Venice: The Riva degli Schiavoni, 1840

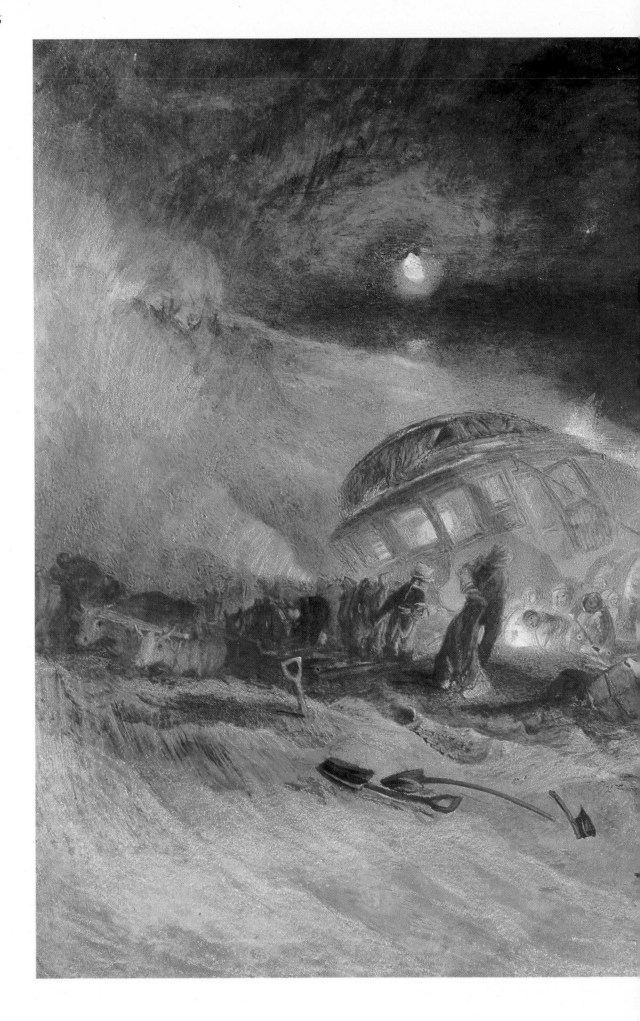

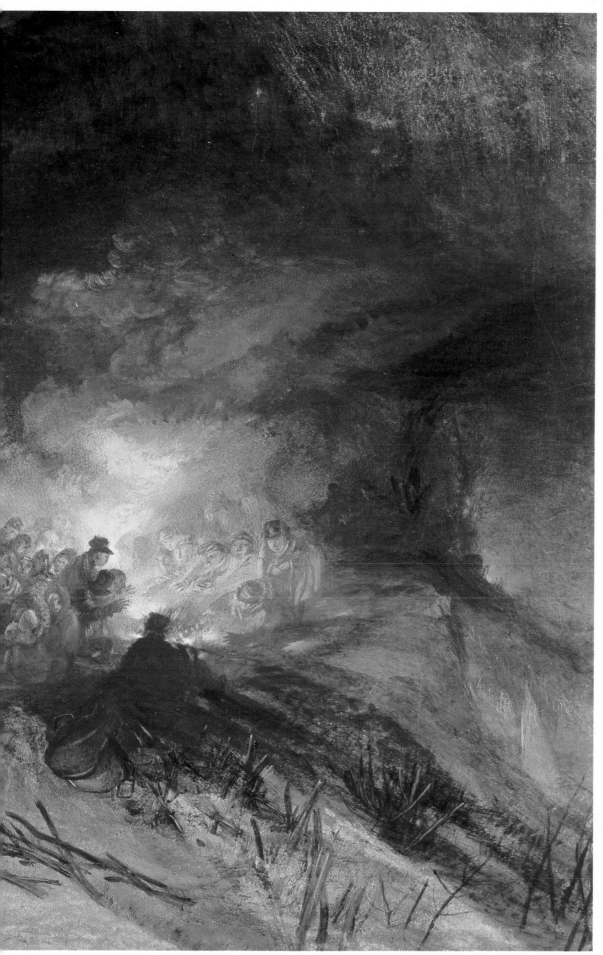

147 Messieurs les Voyageurs in a snow drift upon mount Tarrar, 1829

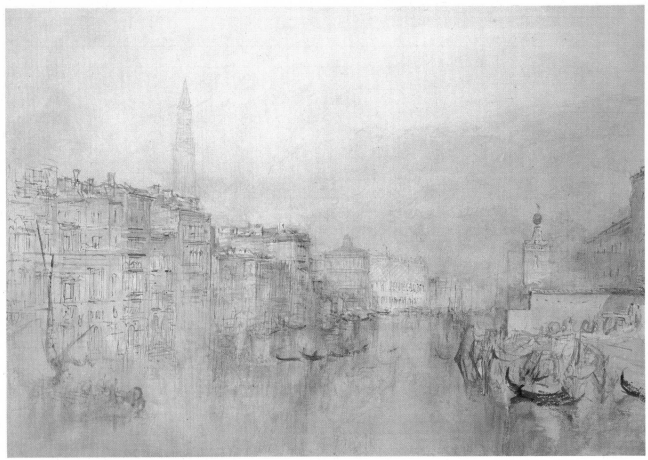

259 Venice: The Grand Canal, looking towards the Dogana, 1840

185

184
The old oak *c.*1832
pencil and watercolour, vignette,
115 × 130 mm approx.; sheet 238 × 307 mm
engr: by E. Goodall for Rogers's *Poems*, 1834,
p.176 (Rawlinson, Vol. II, p.243, No.391)
T.B.CCLXXX–174

Illustrating *To an Old Oak:*
 'Then Culture came, and days serene:
 and village-sports, and garlands gay . . .'
This vignette was used as the headpiece;
another, *The Old Oak in Death* (T.B.CCLXXX-
175) forms the tailpiece to the poem.

185
Apparitions at sunset *c.*1832
pencil and watercolour, vignette,
125 × 165 mm approx.; sheet 243 × 310 mm
T.B.CCLXXX–204

See No.186.

186
Apparitions at Sunset *c.*1832
pencil and watercolour, vignette,
85 × 115 mm approx; sheet 242 × 296 mm
T.B.CCLXXX–203

This and No.185 are preliminary designs for an illustration to Rogers's *Voyage of Columbus*. The final version of the vignette is T.B. CCLXXX–197 (repr. Gage, *Turner and Water-colour* p.4, No.34). It was engraved by E. Goodall (Rawlinson No.400) and published on p.233 of the 1834 edition of Rogers's *Poems*, illustrating the lines:

> '... armed shapes of god-like stature passed!
> Slowly along the evening sky they went,
> As on the edge of some vast battlement;
> Helmet and shield and spear and gonfalon,
> Streaming a baleful light that was not of the sun!'

The vignette combines the features of the two studies, with Columbus standing on his ship, silhouetted against the sky as in No.185, and the apparitions behind as in No.186, but much enlarged so as to dominate the design. The pencil sketch at the top of No.185 roughly indicates a row of warriors with their shields.

187

Loch Lomond *c*.1832
watercolour, vignette, 90 × 155 mm approx.;
sheet 220 × 240 mm
engr: by W. Miller for Rogers's *Poems*, 1834,
p.203 (Rawlinson, Vol. II, p.245, No.396)
T.B.CCLXXX–182

Used as a headpiece to lines *Written in the Highlands of Scotland, September 2, 1812*:
> 'Blue was the loch, the clouds were gone,
> Ben Lomond in glory shone ...'

188

Keswick Lake *c*.1832
pencil and watercolour, vignette,
115 × 140 mm approx.; sheet 245 × 305 mm
engr: by E. Goodall for Rogers's *Poems*, 1834,
p.36 (Rawlinson, Vol. II, p.240, No.378)
T.B.CCLXXX–181

An illustration to the *Pleasures of Memory*, Part II:
> '... the rapt youth, recoiling from the roar,
> Gazed on the tumbling tide of dread Lodore;
> And thro' the rifted cliffs, that scaled the sky,
> Derwent's clear mirror charmed his dazzled eye.'

189

Figures on a flight of steps in an architectural setting ?*c*.1832
watercolour and bodycolour on grey paper,
100 × 222 mm
T.B.CCCLXIV–243

186

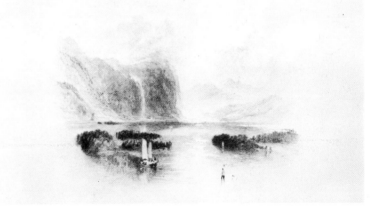

187

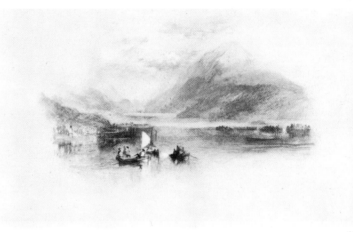

188

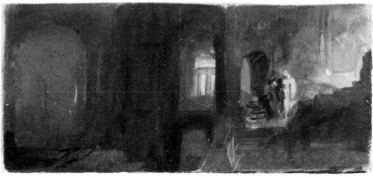

189

This drawing may be connected with one of Turner's visits to Venice; it has some technical characteristics in common with the bodycolour drawings of Venice (see Nos.216, 243 etc), although it is much tighter than any of the works in that group. Two pencil drawings in the *Mouth of the Thames* sketchbook of about 1832 (T.B.CCLXXVIII, ff.1 *verso*, 2 *recto*), tentatively entitled by Finberg 'Hero and Leander', seem to be treatments of the same theme. The motif may perhaps be traced back to the small composition sketch on f.30 *verso* of the *Ports of England* sketchbook in use between about 1818 and 1823 (T.B. CCII; R.A.1974 no.260).

190

Caudebec *c.*1832

bodycolour on blue paper, 139 × 190 mm
engr: by J.B. Allen for *Turner's Annual Tour – the Seine*, 1834 (Rawlinson, Vol. II, p.267, No.462)
T.B.CCLIX–105

This view is noted in pencil on a double-page spread of the *Guernsey* sketchbook of 1829 (T.B.CCLII, ff.17 *verso*, 18 *recto*). It occurs again in a smaller sketch, inscribed *Caudebec*, on f.18 *verso*, where there is also a study of the view along the Seine in the other direction. A detailed study of the church which appears in the lower right corner of the finished design is on f.17 *recto* of the same book. Turner has greatly exaggerated the height of his viewpoint in the final drawing.

Although Turner had probably made many of his preliminary studies for the 'French Rivers' series in the late 1820s when he was executing similar drawings elsewhere in France and at Petworth (see Nos. 116 and 159), it is likely that the finished designs for the published works were still in preparation until shortly before they were engraved. Almost certainly, the *Loire* drawings were prepared first, since they appeared a year before the first *Seine* volume (see R.A.1974 nos.383–7 and Herrmann, *Ruskin and Turner*, No.29). In palette they are much closer to the Meuse/Moselle studies (see Nos.109, etc.) than are the *Seine* series, which are often as brilliant in colour and detail as the Rogers vignettes (Nos.114, 115, 179, etc.).
For Colour Plate, see p.105

191

La Chaire de Gargantua, near Duclair
*c.*1832

bodycolour on blue paper, 137 × 188 mm
engr: by R. Brandard for *Turner's Annual Tour – the Seine*, 1834 (Rawlinson, Vol. II, p.268, No.464)
T.B.CCLIX–106

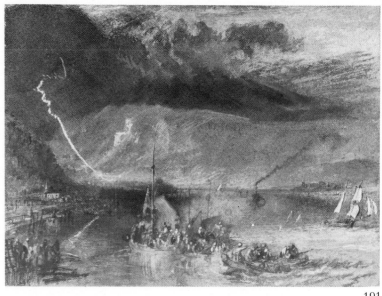

191

There is a group of very slight pencil sketches of Duclair and the 'Giant's Chair', as Turner calls it, in the *Tancarville and Lillebonne* sketchbook, T.B.CCLIII, ff.67–70. Further studies of this stretch of the Seine are on ff.67–9 of the *Seine and Paris* sketchbook (T.B.CCLIV).

192

Rouen: The West Front of the Cathedral
*c.*1832

watercolour and bodycolour with some pen on blue paper, 140 × 194 mm
engr: by T. Higham for *Turner's Annual Tour – The Seine*, 1834 (Rawlinson, Vol. II, p.268, No.467)
T.B.CCLIX–109

There are a number of sketches of Rouen cathedral in the *Dieppe, Rouen and Paris* sketchbook of 1821, T.B.CCLVIII; in particular, the study of the façade on f.22 *recto* probably provided Turner with the basic information for this very dramatic treatment of the subject.
For Colour Plate, see p.105

193

Honfleur *c.*1832

watercolour and bodycolour with some pen and brown colour on blue paper,
140 × 191 mm
engr: by J. Cousen for *Turner's Annual Tour – the Seine*, 1834 (Rawlinson, Vol. II, p.270, No.472)
T.B.CCLIX–135

Turner sketched extensively along the estuary of the Seine on his way back from Rome in 1829; the *Tancarville and Lillebonne* and *Seine and Paris* sketchbooks (T.B.CCLIII, CCLIV) in particular were used in that area. There is no

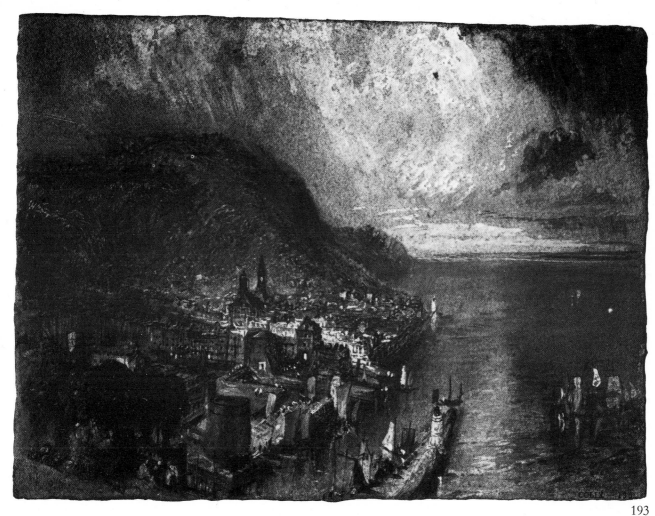

193

identifiable drawing of Honfleur, however, though Turner made several colour designs showing the town for the 1834 *Annual Tour*. Only this one was engraved.

194

Château Gaillard *c.*1832
bodycolour, with some pen, on blue paper, 140×191 mm
engr: by J. Smith for *Turner's Annual Tour – the Seine*, 1835 (Rawlinson, Vol. II, p.271, No.474)
T.B.CCLIX–113

An especially dramatic use of Turner's favourite device of articulating a broad panorama with the loop of a river; compare *Dryburgh*, R.A.1974 no.290, and *The crook of Lune*, in the Courtauld Institute Galleries (Kitson, *Turner Watercolours from the Collection of Stephen Courtauld*, 1974, No.6). Pencil studies of Château Gaillard occur in the *Seine and Paris* sketchbook, T.B.CCLIV, ff.44–57; in particular ff.55, 56 *recto* and *verso* appear to show the view from the castle ruins along the two reaches of the Seine as Turner portrays it in the finished drawing.

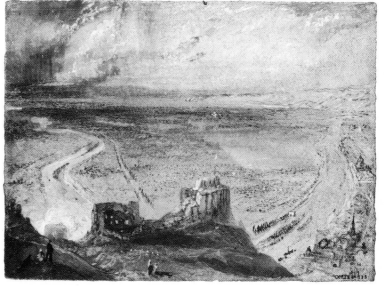

194

197

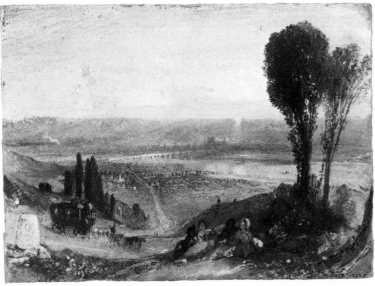

195

195
Pont de l'Arche *c.*1832
bodycolour on blue paper, 139 × 192 mm
engr: by J.T. Willmore for *Turner's Annual
Tour – the Seine*, 1835 (Rawlinson, Vol. II,
p.271, No.476)
T.B.CCLIX–112

196
**View over a town at sunset; a cemetery in
the foreground** *c.*1832
bodycolour on blue paper, 140 × 190 mm
T.B.CCLIX–192

There are sketches of the cemetery of Père
Lachaise, with views of Paris in the back-
ground, on ff.24 *verso*, 27 *verso* of the *Seine
and Paris* sketchbook, T.B.CCLIV. This draw-
ing cannot be definitely identified as being
related to them, however. It was not engraved
and should perhaps be placed with the un-
finished French views here dated to *c.*1829
(Nos.159, etc).

197
Coventry – Warwickshire *c.*1832
watercolour, 288 × 437 mm
exh: Moon, Boys and Graves Gallery, 1833(62)
coll: C. Heath: Munro of Novar; sale, Christie,

2 June 1877 (49); C. Wheeley Lea; sale, Christie, 11 May 1917 (33); Agnew, 1919; R.W. Lloyd, by whom bequeathed to B.M. 1958-7-12-434
engr: by S. Fisher, 1833, for *Picturesque Views in England and Wales* (Part XVII, No.2) (Rawlinson, Vol. 1, p.154, No.273)

Two views of Coventry relating to this composition are in the *Birmingham and Coventry* sketchbook, T.B.CCXL, ff.25 *verso* and 26 *recto*; and f.26 *verso* and 27 *recto*. The same sketchbook also contains a more detailed study of two of the church spires (f.15 *verso*) and other general views of the town.

Ruskin devoted much space to the treatment of cloud and atmosphere in 'this noble picture' (*Modern Painters*, Vol. 1, p.250 ff.):

'Impetuous clouds, twisted rain, flickering sunshine, fleeting shadow, gushing water, and oppressed cattle, all speak the same story of tumult, fitfulness, power, and velocity. Only one thing is wanted, a passage of repose to contrast with it all; and it is given. High and far above the dark volumes of the swift rain-cloud, are seen on the left, through their opening, the quiet, horizontal, silent flakes of the highest cirrus, resting in the repose of the deep sky.'

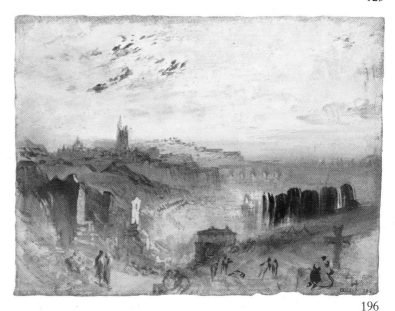

196

198

198

A castle by a river or lake ?1832
watercolour, 345 × 478 mm
T.B.CCLXIII-9

It is possible that this is a view of Caernarvon Castle. The scheme of pale purple, blue and yellow is comparable with that of the finished *Caernarvon* (of about 1833) for the *England and Wales* series (No.199). It may be, however, that it is the same motif as CCLXIII-34, an essay in pale creamy yellow and grey-green, which Finberg calls 'Windsor Castle' and which is certainly more suggestive of Windsor than of Caernarvon, though it does not relate obviously to the *England and Wales* watercolour (No.148).

199

Caernarvon Castle *c.*1833
watercolour over traces of pencil, 278 × 418 mm
coll: Ruskin; Munro of Novar; sale, Christie, 2 June 1877 (46); R.E. Tatham; sale, Christie, 7 March 1908 (85); Walter Jones; Agnew, 1912; bt 1913 R.W. Lloyd, by whom bequeathed to B.M.1958-7-12-439
engr: by W. Radclyffe, 1835, for *Picturesque*

Views in England and Wales, Part XIX, No.1 (Rawlinson, Vol. 1, p.158, No.281)

Turner made numerous studies of Caernarvon Castle during his Welsh tours of the late 1790s, in the *Dolbadern* and *Academical* sketchbooks for example (T.B.XLVI, XLIII), which already suggest that he was particularly interested in the atmospheric effects that he observed there. The two watercolours of the castle shown at the Royal Academy in 1799 (57) and 1800 (64) were remarkable for the inventiveness of their lighting, and one of them may be seen as a forerunner of the present drawing in terms of composition and atmosphere (see R.A.1974 no.42). The colour-beginning tentatively identified as showing Caernarvon in this exhibition (No. 198) shares its delicacy of light and colour with the *England and Wales* subject, one of Turner's most idyllic evocations of summer twilight. **For Colour Plate, see p.128**

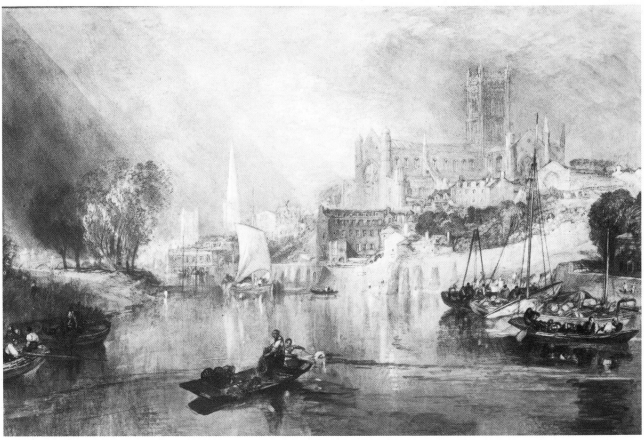

200

200
Worcester *c*.1833
watercolour, 292 × 439 mm
coll: Hon. W.F.D. Smith; Agnew, 1908;
Joseph Beecham, Christie, 4 May 1917 (151)
bt in; Christie, 10 May 1918 (86); R.W.
Lloyd, by whom bequeathed to B.M.1958-7-12-438
engr: by T. Jeavons, 1835-6, for *Picturesque
views in England and Wales* (Part xx, No.2)
(Rawlinson, Vol. I, p.160, No.286)

The composition is derived from sketches in
the *Worcester and Shrewsbury* sketchbook,
T.B.CCXXXIX ff.80 *verso*, 81 and 83 *recto* and
82 *verso*. That book, together with the *Kenilworth* sketchbook (T.B.CCXXXVIII) and the
Birmingham and Coventry sketchbook (T.B.
CCXL), was used by Turner on his Midland
tour of 1830 in search of new material for the
England and Wales series (see R.A.1974 no.442;
and *Coventry* in this exhibition, No. 197).

201
Classical landscape ('The Golden Bough')
?*c*.1834
watercolour and bodycolour, 305 × 484 mm
T.B.CCLXIII-323

A variant of the subject exhibited at the
Royal Academy in 1834 (75) now in the Tate
Gallery (Vernon Bequest), but similar to
many colour-beginnings of classical landscapes in the Turner Bequest (see for example
No.146, and R.A.1974 no.468), which may
relate to any of several such pictures from the
Bay of Baiae (R.A.1974 no.237) onwards.
These studies do not seem to have been made
as preparatory sketches for paintings, however, and at this date Turner was producing
few watercolours of an explicitly classical
type for sale to patrons. It is possible that the
exploration of the theme of a picture on which
he was currently working was a natural and
frequent motive for Turner's watercolour
studies.

202
An interior with three figures ?*c*.1834
bodycolour on grey paper, 131 × 227 mm
T.B.CCCLXIV-392

This drawing has much in common with the
series of bodycolour studies made at Petworth
in about 1828-30, but its more restricted
colour range recalls the shadowy bedroom
scenes in the *Colour Studies* sketchbook No.1
(T.B.CCXCI (b)), which seems to have been in
use a few years later (see R.A.1974 no.455).

203
Derwentwater *c*.1835
watercolour, 276 × 438 mm

202

coll: Ruskin; J.E. Taylor; sale, Christie,
5 July 1912 (43); bt Agnew; Baron
Goldschmidt Rothschild; H.E. Walters,
1914; A.E. Lawley, sale, Christie, 25 February
1921 (123); R.W. Lloyd, by whom
bequeathed to B.M. 1958–7–12–442
engr: by W. Radclyffe, 1837, for *Picturesque
Views in England and Wales* (Part XXII, No.3)
(Rawlinson, Vol. I, p.165, No.295)

Turner made a vignette of the subject in about
1832 for Rogers's *Poems* (No.188). He visited
the Lakes in 1831 on the way to Edinburgh,
but it is possible that for both these designs he
relied on views of Derwentwater with Lodore
Falls made in 1797 (T.B.XXXV–82 *recto*, and
XXXVI–4). There is a marked difference in
handling between the stormy intricacy of this
design, which anticipates Turner's water-
colour manner of about 1842, and the view of
Ullswater (R.A.1974 no.428), made for the
England and Wales series about two years
earlier than *Derwentwater*, which is one of his
most placid and delicate creations.

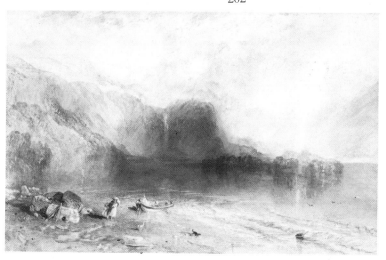

203

204

?A burning warehouse *?c.*1835
watercolour, 305 × 489 mm
T.B.CCLXIII–89

Finberg's description of this colour-beginning
as 'Sunlight on ruins' seems mistaken. The
composition is close to that of the 'Easby'
series (see No.83), but a conflagration is clearly
indicated, and the sky is apparently dark. The
drawing may be connected with the *Burning of
the Houses of Parliament* in 1834, or perhaps
with the fire at Fenning's wharf in 1836, of
which a watercolour by Turner is in the
Whitworth Art Gallery, Manchester (D.100–

204

1892). There are general similarities with the colour-beginnings of the early 1830s associated with the *England and Wales* designs, e.g. that of *Tamworth Castle*, T.B.CCLXIII–184.

205
Sea and sky ?*c*.1835
watercolour, 487×615 mm
watermarked: *1828*
T.B.CCLXIII–333

Probably executed at the same time as CCLXIII–334, a similar seascape. There may be some connection between this colour-beginning and the view of *Criccieth Castle* which Turner made for the *England and Wales* series in about 1835 (No.206).

206
Criccieth Castle *c*.1835
watercolour, 290×425 mm
signed lower right: *IMW*
coll: Munro of Novar; sale, Christie, 2 June 1877 (40); W. Dunlop; W.J. Holdsworth; sale, Christie, 4 June 1889, bt Gooden; William Newall; sale, Christie, 30 June 1922 (74), bt King; J.B. Gaskell; sale, 30 April 1926 (77), bt Sampson; Gilbert Lees Hardcastle; sale, Christie, 4 May 1933 (34); R.W. Lloyd, by whom bequeathed to B.M.1958–7–12–440 engr: by S. Fisher, 1837, for *Picturesque Views*

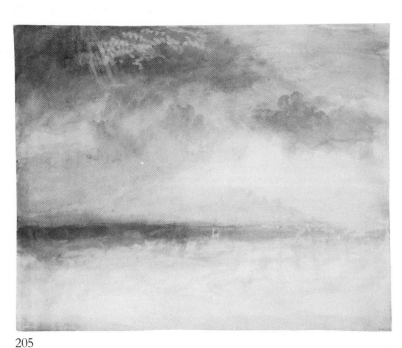

205

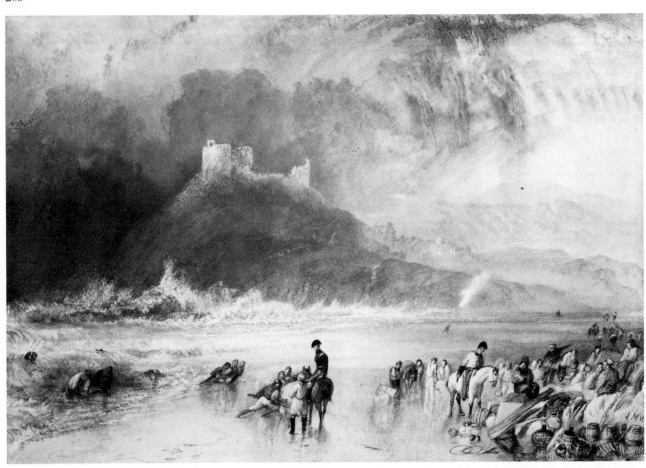

206

262 Small boats on a lake, ?1840

in England and Wales, Part XXIII, No.4
(Rawlinson, Vol. I, p.167, No.300)

The drawing appears to have been cut slightly
at the right, where the last of Turner's initials
is missing. Turner made studies of Criccieth
during his tour of 1798 (T.B.XXXIX, ff.23–5),
but none corresponds with this view. Various
colour-beginnings in the Turner Bequest
have been associated with Criccieth (e.g.
CCLXIII–54) but no precise identification has
been made, and no preparatory drawings for
this composition have been noted. As so often
when depicting the coast, Turner has chosen
an incident which reflects the interrelation-
ship of land and sea: revenue officers inspect-
ing goods salvaged from a wreck.

207
Stormy sky over the sea ?c.1835
watercolour, 489 × 612 mm
watermarked: *1828*
T.B.CCLXIII–334

See CCLXIII–333 (No.205). The view repre-
sented is possibly of Folkestone.

207

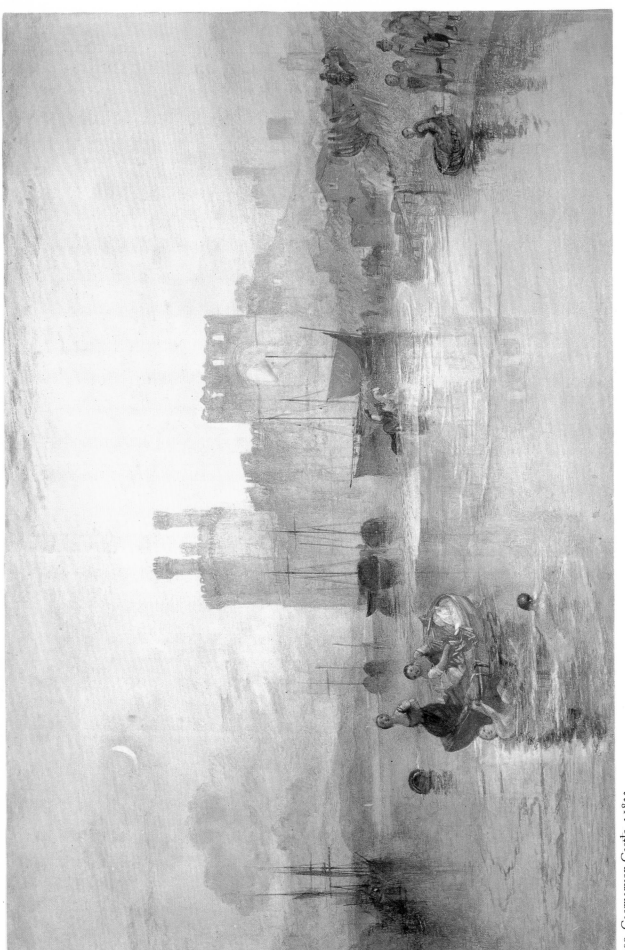

199 Caernarvon Castle, *c.*1833

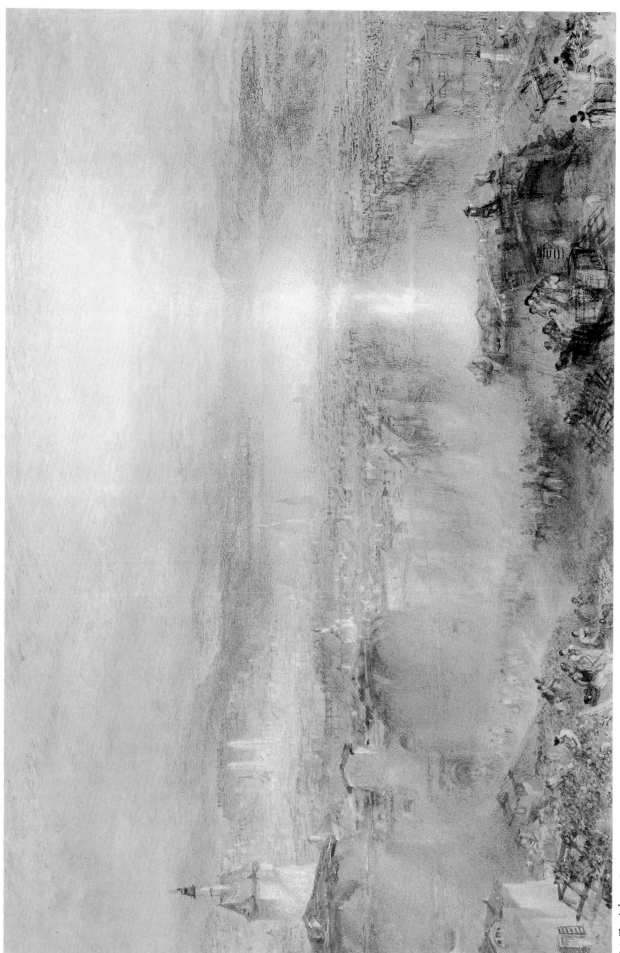

286 Zurich, c.1842

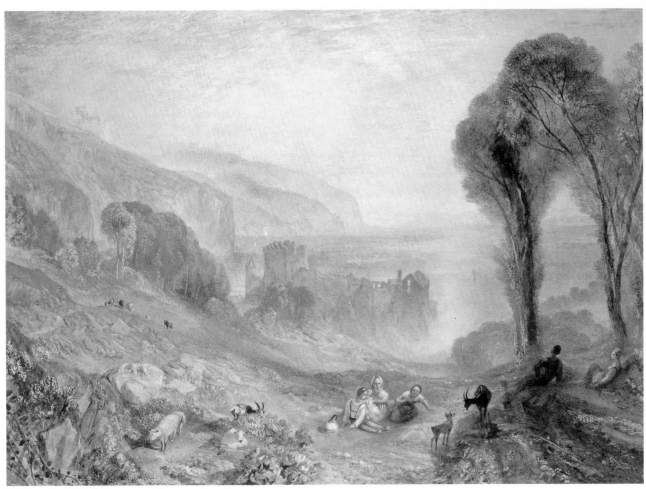

264 Tancarville on the Seine, 1840

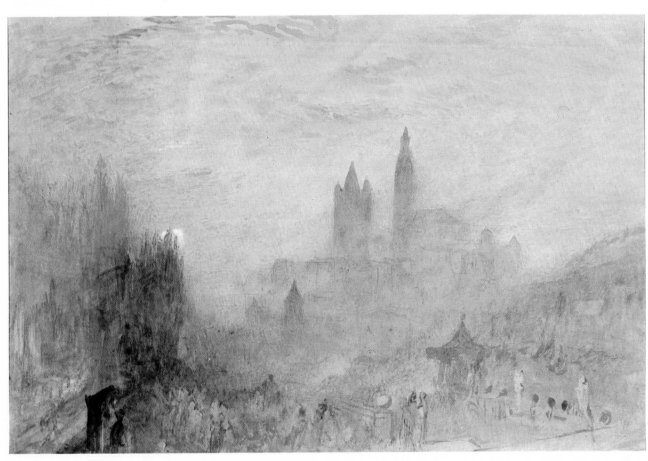

265 Lausanne: Sunset, c.1841

208
Lowestoft *c.*1835
watercolour, 275 × 427 mm
coll: Munro of Novar; sale, Christie, 6 April
1878 (92); Rev. Charles Sale; Mrs Sale; sale,
Christie, 9 July 1915 (85); R.W. Lloyd, by
whom bequeathed to B.M.1958-7-12-441
engr: by W.R. Smith, 1837, for·*Picturesque
Views in England and Wales*, Part XXII,
No.1.

Studies of a lighthouse on a cliff, apparently
at Lowestoft, occur in the *Norfolk, Suffolk and
Essex* sketchbook (T.B.CCIX, ff.35 *verso*, 36
recto and *verso*), but the only general view of
Lowestoft from the sea so far identified in the
Bequest is the distant glimpse on f.2 *recto* of
the *King's Visit to Scotland* sketchbook (T.B.
CC). In this dramatic watercolour, one of the
latest of the *England and Wales* series,
Turner has suggested a much higher and
rockier coast than actually exists at Lowestoft.
Ruskin describes the scene (*Modern Painters*,
Vol. I, p.262) as 'An hour before sunrise in
winter. Violent storm, with rain, on the sea.'

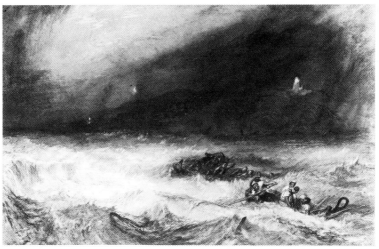

208

209
View near the Pass of Faido *c.*1836
pencil and watercolour, 255 × 280 mm
T.B.CCCLXIV-128

This drawing is similar in certain aspects,
especially in the handling of the figures, to the
Faido in the Fitzwilliam Museum (No.1763).
T.B.CCCLXIV-40, a study of mountains,
using the same colour range and technique,
probably belongs to the same group. The date
1836 is suggested here only because the
solidity of modelling and colouring in the
figures may indicate that the drawing was
made earlier than Turner's Swiss views of the
1840s, perhaps on his tour of Switzerland with
Munro of Novar in 1836. A view of the *Pass
of Faido, St Gothard* was one of the five sub-
jects sold for Turner by Griffith in 1843; it
was based on the drawing T.B.CCCLXIV-209
(see R.A.1974 no.612).

209

210
**The Lake of Lucerne looking from
Brunnen towards Uri; the Schillerstein
on the right** *c.*1836-40
watercolour, 223 × 280 mm
T.B.CCCLXIV-127

One of a series of studies of this view, e.g.
CCCLXIV-14, 89, 90 and perhaps 101. It is
very close in colour-scheme to CCCLXIV-44,
which, like this one, is folded across the
centre. The whole group appears to be based on
the pencil drawings CCCXXXIII-14. See also
No.211.

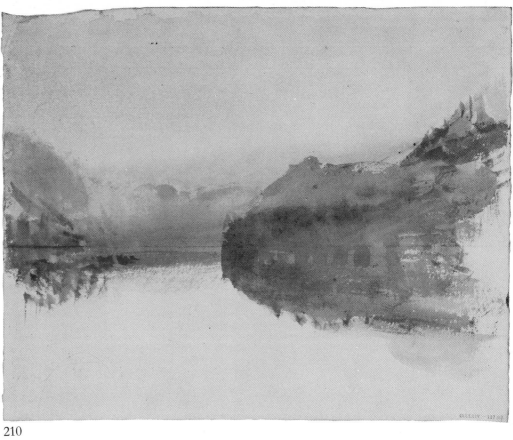

210

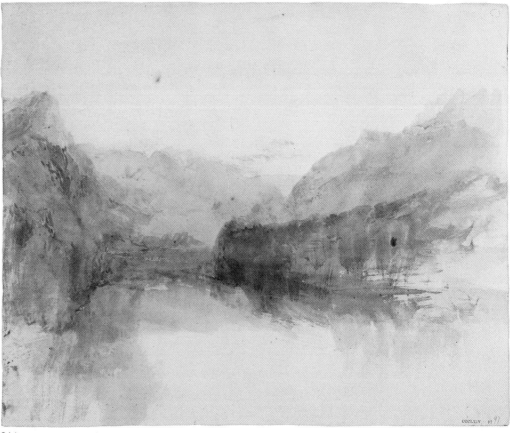

211

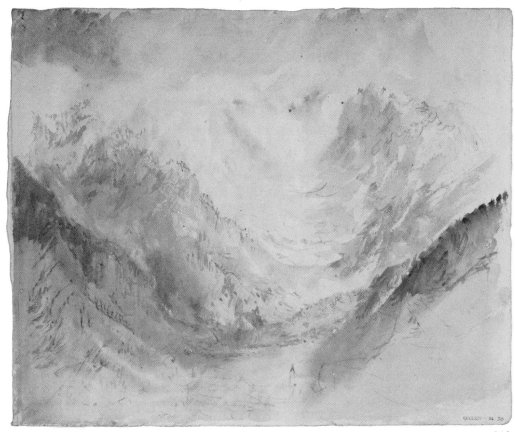

213

211
**The Lake of Lucerne looking from
Brunnen towards Uri; the Schillerstein
on the right** *c.*1836–40
watercolour, 242 × 298 mm
T.B.CCCLXIV–97

Another treatment of the same subject as
No.210.

212
A pink mountain beyond a lake ?*c.*1836
pencil and watercolour, 217 × 270 mm
T.B.CCCLXIV–73

Probably a view in Switzerland or north
Italy.

213
A Swiss valley ?*c.*1838
pencil and watercolour, 242 × 298 mm
T.B.CCLXIV–30

Possibly connected with Turner's tour of
Switzerland with H.A.J. Munro of Novar in
the summer of 1836, but perhaps made a
little later, this drawing, which is one of the
airiest and most spacious of his mountain
studies, belongs to the large group that
Turner made at various times during the
second half of the 1830s. It may even have
been executed with the series of 1840–1.

214

215

214

Design for Moore's 'Epicurean' *c.*1838
pencil and watercolour, vignette,
100 × 75 mm approx.; sheet 199 × 290 mm
T.B.CCLXXX–128

The subject of this sketch for a vignette is
Alciphron's Swoon; it was not used in
Macrone's edition of the *Epicurean* (see No.
215).

215

Design for Moore's 'Epicurean' *c.*1838
pencil and watercolour, vignette,
110 × 70 mm approx.; sheet 218 × 212 mm
T.B.CCLXXX–138

A preliminary sketch for the last of Turner's
four illustrations to the *Epicurean – The
Chaplet*, much modified before reaching its
final form, which was engraved by E. Goodall
(Rawlinson No.637). This edition of the
poem was published by Macrone, 1839; *The
Chaplet* appeared on p.206.

216

Venice: The Piazza of St Mark's 1840
watercolour and bodycolour on brown paper,
148 × 228 mm
T.B.CCCXVIII–1

Perhaps connected with the pencil sketch on
f.12 *verso* of the *Venice and Botzen* sketchbook
(T.B.CCCXIII). This drawing is in a style
rather different both from the small grey-
paper views of Venice (T.B.CCCXVII) and

from the other brown-paper views (T.B.
CCCXVIII), though it shares some of the
freedom and brilliant colour of the latter. The
theatrical quality of the composition and the
lighting, reminiscent of the *Storm in the
Piazzetta* (Edinburgh, Vaughan Bequest), and
the summary indication of the figures, sug-
gest that Turner was consciously recalling
the Venetian views of Canaletto or Guardi.
Compare also No.189.

Turner's late drawings of Venetian subjects
in watercolour or bodycolour (T.B.CCCXV,
CCCXVI, CCCXVII, CCCXVIII, CCCXIX) have
not yet been conclusively distributed between
the two visits of 1833 and 1840, although a
watermark of 1834 on the roll sketchbook
CCCXV gives a documentary indication
that many belong to the second date. In the
R.A.1974 catalogue, pp.154–5, it was sug-
gested that the whole series may be assigned
either to the 1840 visit or to a time shortly
after it. The Venetian drawings catalogued
here have been given the same date on the
same tentative assumption, and it is hoped
that their arrangement in the exhibition, and
other facts pointed out in the relevant entries,
will strengthen the case for this view.

217

**Venice: The Church of S. Stefano from
the Rio di S. Stefano** 1840
watercolour and bodycolour on grey paper,
278 × 191 mm
T.B.CCCXVII–32

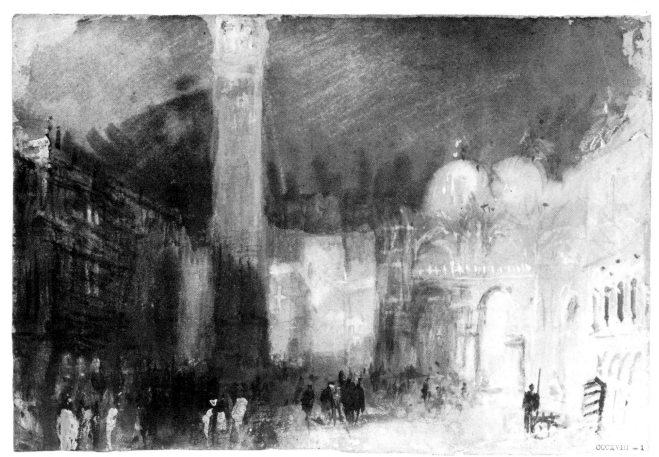

216

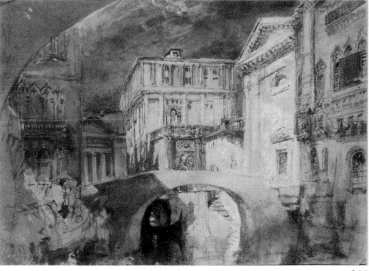

218

Apparently executed from memory, with the aid of a slight sketch on f.91 *verso* of the *Rotterdam and Venice* sketchbook (T.B.CCCXX) which is inscribed *Ponte Maurizio*, referring to the foremost of the two bridges visible in the drawing. If this progression, from sketch to watercolour, is correct, the present drawing must be dated 1840 or after since the sketchbook has been shown to belong to that year (see R.A.1974 no.580), and this dating affects many other Venetian studies in bodycolour on grey paper, e.g. *A view on a cross-canal near the Arsenal*, No.218 and *Looking across the Giudecca to the Zattere, with the Salute and Dogana* (No.222).

218
Venice: View on a cross-canal near the Arsenal (?) 1840
pencil, watercolour and bodycolour with some pen and red, brown, green and purple colour on grey paper, 188 × 278 mm
T.B.CCCXVII–29

This subject occurs in the *Venice and Botzen* sketchbook of 1840 (T.B.CCCXIII, f.57 *verso*). It seems probable therefore that this and the rest of the series of grey-paper studies of Venetian and other continental subjects (see No.222) were all done on this journey or soon after.

219

Venice: The Ponte della Guerra with the Palazzo Tasca-Papafava beyond 1840
pencil, watercolour and bodycolour on grey paper, 192 × 275 mm
verso: a study in pencil and white bodycolour of the view in T.B.CCCXVII-31 (No.220)
T.B.CCCXVII-30

220

Venice: The Palazzo Tasca-Papafava
1840
watercolour and bodycolour on grey paper, 191 × 282 mm
T.B.CCCXVII-31

A very similar view is sketched in pencil with white bodycolour on T.B.CCCXVII-30 *verso* (see No.219).

221

Venice: The Piazzetta 1840
watercolour and bodycolour with coloured chalk on grey paper, 193 × 276 mm
T.B.CCCXVII-1

222

Venice: Looking across the Giudecca to the Zattere, with the Salute and Dogana
1840
pencil, watercolour and bodycolour with pen and reddish-brown, mauve and yellow colour on grey paper, 190 × 280 mm
T.B.CCCXVII-21

This drawing and *The Giudecca, with the Redentore*, No.223, belong to a group of watercolours executed with white heightening and pen dipped in colour on smallish sheets of grey paper, showing views not only in Venice but on the Rhine and elsewhere. Although it is possible that they were done at different times during Turner's travels, it seems more probable that they were worked up as a sequence or series from notes or from memory after Turner had returned to England from his 1840 tour. If so, it is possible that some of the other Venetian views, which have features in common with these, particularly in respect of colour, may have been produced in England.

223

Venice: The Giudecca, with the Redentore 1840
watercolour and bodycolour on grey paper, 192 × 279 mm
T.B.CCCXVII-4
See No.222.

224

Venice: View over roofs from the Hotel Europa, with the towers of S. Maurizio, S. Moisè and S. Marco 1840
pencil and watercolour with some bodycolour, 194 × 281 mm
inscr. *verso: From my Bedroom, Venice*
T.B.CCCXVI-3

Similar in size and handling to the *S. Giorgio Maggiore* (CCCXVI-28) and one of a group of views from Turner's window in the Hotel Europa. See No.225; compare also the *Sunset* (R.A.1974 no.550) which seems to belong

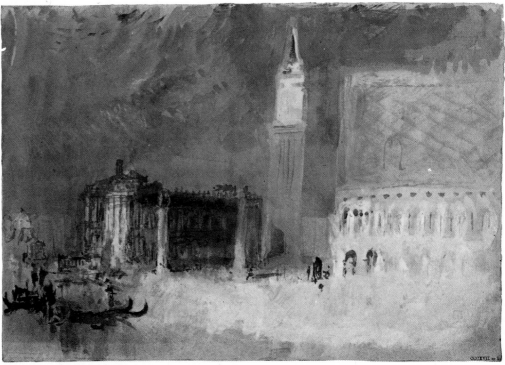

221

to the same series. According to C.F. Bell (manuscript notes, British Museum) the tower of St Mark's would only have been included in this view by turning 'at least three quarters to the right' while making the drawing.

225

Venice: From the Hotel Europa 1840
watercolour, 193 × 284 mm
T.B.CCCLXIV–43

Turner made numerous studies of this view, which appears to be that from the room which he occupied in the Hotel Europa in 1840, though it is not precisely the same view as that inscribed *'From my Bedroom, Venice'*, No.224. A detailed pencil drawing of the view, touched with some colour, is T.B. CCCXVI–42; broader treatments are CCCXVI–5 and CCCXVI–36 (R.A.1974 no.557). Another treatment, on brown paper, is CCCXVIII–5 (R.A.1974 no.562). The subject has been associated with the roof-top view of Venice in Turner's oil painting of *Juliet and her nurse*, shown at the Royal Academy in 1836 (73; repr. Rothenstein and Butlin, 1964, pl.102), especially because of the figures which occur in T.B.CCCXVI–36; but there is no specific similarity between the drawings and the painting, which shows a very different view over the Piazza S. Marco.

226

Venice: Distant view of S. Giorgio Maggiore and the Salute, with the Redentore at the right 1840
pencil and watercolour, 242 × 306 mm
inscr. centre: *S Giaco* (?)
T.B.CCCXVI–4

In the *Inventory* Finberg entitles this drawing *From the Giudecca, with San Giacomo on the right and San Giorgio in the distance*; elsewhere (*Venice*, p.173) he calls it *The Redentore, Zitelle and S. Giorgio, from the Giudecca*. Although Turner's own inscription against the church at the right of the drawing seems to read 'S. *Giaco*[mo]', it is difficult to identify the building to which it can refer. The façade strongly resembles (though with some points of difference) that of Palladio's Redentore on the Giudecca. It seems clear, however, that the view in the background of the drawing shows S. Giorgio Maggiore and the Salute in positions different from those in which they are in fact seen from the Redentore (cf. the pencil sketch in T.B.CLXXV, f.61 *recto*). The church nearest to the point of vision suggested by that identification is perhaps S. Biagio. It is possible that Turner introduced the façade of the Redentore capriciously in order

224

225

228

to provide a *repoussoir*; it may indeed have been an unrelated sketch (like the architectural fragment immediately above it) which Turner incorporated into the design when he added colour.

A drawing closely related in colouring is the *View of the Salute and S. Giorgio Maggiore from the Giudecca*, T.B.CCLXVI–2 (No.227).

227

Venice: View of the Salute and S. Giorgio Maggiore from the Giudecca 1840
watercolour with some pencil, 241 × 304 mm
T.B.CCCXVI–2

Related in its colouring to T.B.CCCXVI–4 (No. 226).

228

Venice: The Dogana, Campanile and Doge's Palace from the Giudecca 1840
watercolour with some pencil on off-white paper, 218 × 296 mm
T.B.CCCXVI–14

This and *The Mouth of the Grand Canal, sunset* (No.229) are from a group of five listed together by Finberg in the *Inventory* (T.B. CCCXVI–11 to 15), all of which are on rough creamy paper and have misty, purplish colouring. Turner seems, however, to have used similar paper in *The Approach to Venice: Sunset*, T.B.CCCXVI–16 (No.241), which has been grouped in this exhibition with T.B CCCXV–13, the *View along the Canale della Giudecca towards Fusina* (No.239).

229

Venice: The mouth of the Grand Canal, sunset 1840
watercolour with some bodycolour on off-white paper, 229 × 301 mm
inscr. by Ruskin along top edge, *recto*: *Preserve this drawing exactly as it is as evidence of the way he worked, the turned edge of paper painted upon*
T.B.CCCXVI–15

One of the five drawings on coarse creamy paper grouped together by Finberg, T.B. CCCXVI–11 to 15 (see Nos.228, 251).

230

Venice: The Bacino di S. Marco, looking towards the Grand Canal 1840
watercolour, 222 × 320 mm
T.B.CCCXV–4

From the Venice roll sketchbook; see No.231.

231

Venice: Moonrise 1840
watercolour, 221 × 319 mm
T.B.CCCXV–10

The drawing shows a distant view of the Giudecca and the Zitelle, with perhaps the Salute to the right. The campanile in the foreground may be that of Sta. Zaccaria. One of the most poetic of the Venetian watercolours, this drawing comes from the roll sketchbook watermarked 1834 which provides the principal evidence of Turner's style when he was working in Venice in 1840 (see R.A.1974, pp.154–5). The other Venetian views were

made either on loose sheets or, more often, in roll sketchbooks which were subsequently broken up, probably so that certain leaves could be removed for sale. But nearly all of them can be related, through common features of handling or palette, to the work in the roll sketchbook, and on the basis of such comparisons it seems likely that 1840 is the date of all these drawings. Particular points of similarity are noted in the relevant catalogue entries.

For Colour Plate, see p.140

232
Venice: Looking towards the Giudecca, from the lagoon 1840
watercolour with some pen, 221 × 320 mm
T.B.CCCXV–12

This, and T.B.CCCXV, 4, 11 and 13 (Nos.230, 234 and 239) are very similar in mood and treatment. They are all from the roll sketchbook of 1840; see No.231.

233
Venice: The mouth of the Grand Canal, with a corner of the Salute 1840
pencil and watercolour, 243 × 302 mm
T.B.CCCXVI–26

Grouped in this exhibition with T.B.CCCXV–4, 10, 11 and 12 (Nos.230, 231, 234 and 232) which make use of an almost identical palette.

234
Venice: The Canale della Giudecca 1840
watercolour with some pen, 221 × 319 mm
T.B.CCCXV–11

From the Venice roll sketchbook; see No.231.

235
Venice: The Lagoon 1840
watercolour with some bodycolour,
245 × 305 mm
T.B.CCCXVI–31

See *Venice: Shipping on the Riva degli Schiavoni*, No.236.

236
Venice: Shipping on the Riva degli Schiavoni 1840
watercolour over traces of pencil,
242 × 305 mm
T.B.CCCXVI–20

This and the *Lagoon*, No.235, belong to a group of Venetian views which make use of a rather cooler colour range than usual, and in which detail is very slightly and nervously indicated; compare the treatment of the warmer-coloured *Approach to Venice: Sunset*

229

233

231 Venice: Moonrise, 1840

281 Constance, c.1841

238

(No.241). These drawings are linked stylistically with a further group which is dominated by a honey-coloured glow across the middle distance, e.g. T.B.CCCXVI–18, 21 (Nos.237, 238).

237
Venice: The Riva degli Schiavoni from the channel to the Lido 1840
watercolour with pen and red and yellow ink, 245 × 305 mm
T.B.CCCXVI–18
For Colour Plate, see p.115

238
Venice: The Riva degli Schiavoni from near the Public Gardens 1840
watercolour with pen and red and brown ink, 241 × 304 mm
watermarked: *1828*
inscr. *verso*: *Beppo Club*
T.B.CCCXVI–21

239
Venice: View along the Canale della Giudecca towards Fusina 1840
pencil, watercolour and coloured chalks, 221 × 321 mm
T.B.CCCXV–13

Cf. the oil painting *San Benedetto, looking towards Fusina*, shown at the Royal Academy in 1843 (554). If, as Ruskin states, this drawing was the 'original sketch' for the painting, it may date from after the 1840 visit to Venice. The mixed watercolour and chalk technique occurs in some Swiss drawings of about 1841. This drawing has much in common with CCCXV–4 (No.230), 11 (No.234), 12 (No.232) and others, but is generally coarser in finish. It is grouped in this exhibition with T.B. CCCXVI–16 (No.241), which shares its palette and rather sharp, rough treatment of details. T.B.CCCXVI–16 is however on the same creamy, rough paper as T.B.CCCXVI–11 to 15 (See Nos.228, 229, 251).

240
Venice: Buildings seen across water, with the Campanile of St Mark's(?)
1840
pencil and watercolour, 245 × 305 mm
T.B.CCCXVI–38

In its extreme reticence and simplicity, this drawing (which has evidently faded considerably) is unlike most of the Venetian studies of 1840; but it has affinities with the view of *The Mouth of the Grand Canal, with a corner of the Salute* (T.B.CCCXVI–26; No.233) especially in its use of blurred washes of yellow and pink. CCCXVI–26 is grouped with several other drawings which use similar colours in a comparable manner.

241
The approach to Venice: Sunset 1840
watercolour and bodycolour over traces of

pencil on off-white paper, 228 × 322 mm
T.B.CCCXVI–16

Similar in many features of style and palette to T.B.CCCXV–13 (No.239) which comes from the roll sketchbook (see No.231) but on coarse, slightly coloured paper which suggests a connection with the group T.B. CCCXVI–11 to 15 (see Nos.228, 229, 251).

242

Venice: The Salute and the Dogana: Early morning 1840

watercolour, 221 × 321 mm
T.B.CCCXV–14

From the roll sketchbook; see No.231. This drawing is very similar in viewpoint, colouring and treatment to T.B.CCCXV–17 (R.A. 1974 no.544).

243

Venice: The Salute from the Calle del Ridotto, moonlight 1840

pen and black ink, watercolour, bodycolour and white chalk on brown paper,
244 × 305 mm
inscr. (?) *verso: 15*
T.B.CCCXVIII–11

The series of Venetian drawings in bodycolour on dark brown paper which make up the section CCCXVIII of the Turner Bequest (29 items) are among the most astonishing and the most puzzling in Turner's output. Many of them contain specific allusions to the architecture of Venice, and it has always been assumed that they were executed on the spot.

240

241

242

243

245

Some of them do indeed have the appearance of being careful records – *The Campanile from the Atrio of the Palazzo Reale* (No.245), for instance – but in the main their extraordinary freedom, and the fact that they deal with such subjects as firework displays and theatrical performances, suggest that they are rapid sketches made from memory with the object of presenting very general, though powerful, impressions. The firework display which occurs in T.B.CCCXVIII-10 (R.A.1974 no.563) might possibly be connected with the painting of *Juliet and her nurse*, shown at the Royal Academy in 1836 (see No.225); this would suggest either that the series were all made in Venice in 1833, or that they were done from memory subsequently in England. It has been suggested that the use of bodycolour in these drawings is evidence for the earlier date; but other Venetian studies using bodycolour appear to have been made in 1840 (see No.217) and that date has therefore been retained in the case of the brown-paper drawings.

244

Venice: An evening entertainment(?)
1840
watercolour and bodycolour with pen and black ink and white and coloured chalks on brown paper,
242 × 302 mm
inscr. (?) *verso*: *28*
T.B.CCCXVIII-22

Difficult to identify, the subject of this drawing has been thought by Finberg to be 'a Canal scene', and by C.F. Bell to show a canal with a lofty bridge and gondolas; but the illuminations suggest some specific festivity, perhaps connected with the theatrical performance, or the fireworks, which appear in drawings of this series. See No.243.

245

Venice: The Campanile, from the Atrio of the Palazzo Reale 1840
watercolour and bodycolour, with some white chalk, on brown paper, 305 × 233 mm
T.B.CCCXVIII-26
See No.243.

246

Venice: The interior of St Mark's, looking towards the north transept 1840
watercolour and bodycolour on brown paper,
295 × 223 mm
T.B.CCCXVIII-7
See No.243.

247

Venice: View through medieval arches on to a moonlit canal 1840
watercolour and bodycolour, with some white chalk, on brown paper, 305 × 235 mm
T.B.CCCXVIII-27
See No.243.

248

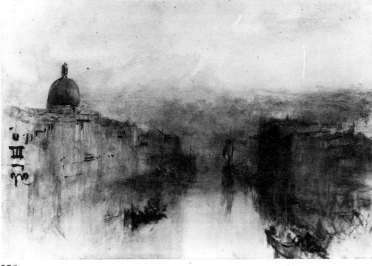

250

251

248

Venice: The interior of a theatre 1840
bodycolour on brown paper, 224×292 mm
inscr. (?) *verso*: *24*
T.B.CCCXLVIII-18

Another bodycolour study showing the in-
terior of a theatre is T.B.CCCXLVIII-4 (R.A.
1974 no.566), and several of the drawings in
this group (see No.249) are apparently con-
nected with a theatrical production.

249

Venice: A scene at the play 1840
watercolour and bodycolour with some
white chalk on brown paper, 215×282 mm
inscr. (?) *verso* :*21*
T.B.CCCXVIII-17

Finberg (*Venice*, p.176 and *Inventory*) suggests
that this drawing shows a theatrical represen-
tation of a murder, and *Othello* has been sug-
gested. See Nos.243 and 248.

250

**Venice: The Grand Canal, with
S. Simeone Piccolo: Dusk** 1840
watercolour, 221×318 mm
T.B.CCCXV-8

A comparatively highly finished watercolour
from the roll sketchbook (see No.231).

251

Venice: The Canale di S. Marco 1840
watercolour and bodycolour with brown
chalk on off-white paper, 228×297 mm
T.B.CCCXVI-11

An unusually schematized view of the Cam-
panile of St Mark's and the Doge's Palace, in
which the buildings are a blank strip between
the flat washes of blue and green. Compare
the watercolour of 1819, T.B.CLXXXI-7
(R.A.1974 no.214). The drawing is one of
the five grouped together by Finberg as
using coarse, slightly tinted paper (seeNos. 228,
229). Although it is different from most of
the late Venetian views in being less atmos-
pheric and more explicitly concerned with
composition, it makes use of colours charac-
teristic of the 1840 drawings; compare T.B.
CCCXVI-10, 35 (Nos.253, 254) etc.

252

Venice: View on a canal 1840
pencil and watercolour, 220×321 mm
T.B.CCCXVI-41

Very close in treatment to such roll sketch-
book drawings as *The Grand Canal* (No.254).
The colour was almost certainly applied first

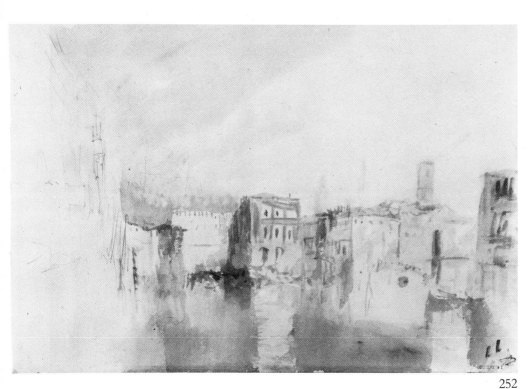

252

253

and pencil added subsequently; the sketch in the sky to the left, which suggests buildings, may have been on the paper before Turner began the drawing; it does not seem to be related to the subject.

253
Venice: The Dogana and Campanile of St Mark's from the Giudecca 1840
pencil and watercolour, 244 × 305 mm
T.B.CCCXVI-10

Compare this drawing with the *Buildings seen across water, with the Campanile of St Mark's(?)*, T.B.CCCXVI-38 (No.240). Turner reduces his colour here to a minimum of pale pink, yellow, green and blue, dissolving forms almost completely in vaporous light. Definition is provided by an equally slight pencil outline; but it is difficult to determine whether pencil or colour was applied first. Each is dependent on the other in the representation of the view and would be incomprehensible alone. See, for instance, *The Grand Canal*, T.B.CCCXV-19 (No.255), where pencil has been added to a watercolour sketch in the interest of sharper definition of a few details.

254
Venice: The Dogana, St Mark's and the Doge's Palace 1840
watercolour, 246 × 307 mm
T.B.CCCXVI-35

Compare *The Dogana and Campanile of St Mark's from the Giudecca* T.B.CCCXVI-10; No.253). The greater part of the composition is suggested with barely defined washes of

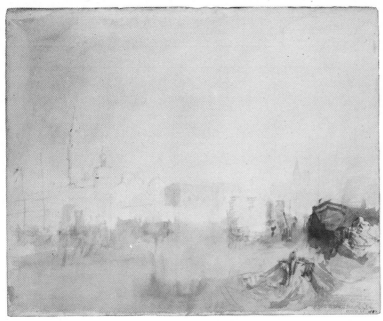

254

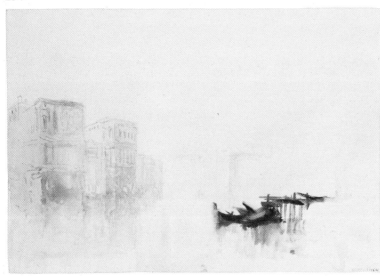

255

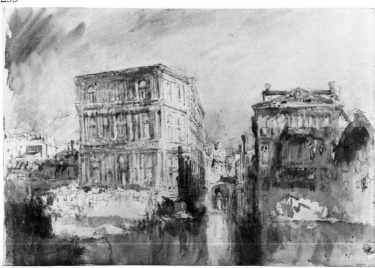

257

pale colour; Turner relies on a few rapid touches of blue, ochre and grey, with some unmixed red, to provide a minimum of guidance for the eye.

255
Venice: The Grand Canal 1840
pencil and watercolour, 220 × 322 mm
T.B.CCCXV–19

A sketch evidently executed entirely in watercolour, to which pencil was added in order to provide greater definition of the architecture on the left. It comes from the roll sketchbook of Venice (see No.231).

256
Venice: Looking down the Grand Canal from opposite the Accademia 1840
pencil and watercolour, 220 × 321 mm
T.B.CCCXV–15

From the roll sketchbook of Venice; see No. 231.

257
Venice: The Casa Grimani and the entrance to the Rio S. Luca 1840
pencil and watercolour, 220 × 332 mm
T.B.CCCXV–7

The roll sketchbook, T.B.CCCXV, contains several studies of buildings along the Grand Canal (see also T.B.CCCXV–15, No.256 and 18, No.258) which seem to have been made with the intention of recording architecture rather than with conveying atmosphere. The colours used in this drawing are very similar to those which occur in some of the grey-paper studies, T.B.CCCXVII (Nos.217–223), especially the orange and blue seen in the central vista of the Rio S. Luca. Compare particularly *The Church of S. Stefano from the Rio di S. Stefano* (No.217), and the *View on a cross-canal near the Arsenal(?)* (No.218).

258
Venice: The Grand Canal from near Palazzo Mocenigo 1840
pencil and watercolour, 221 × 318 mm
inscr. top centre: *C N Rock;* below: *Foscar*[i];
Balic(?) and *Ralli*
T.B.CCCXV–18

From the roll sketchbook of Venice; see No. 231.

259
Venice: The Grand Canal, looking towards the Dogana 1840
watercolour, 221 × 320 mm
coll: Hon. W.F.D. Smith; Sir Joseph

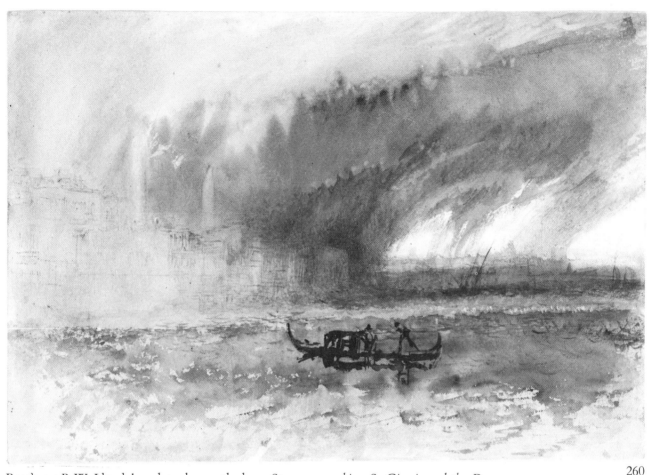

260

Beecham; R.W. Lloyd, by whom bequeathed to B.M.1958-7-12-443

Turner made a pencil sketch from almost the same spot (at the foot of the steps of Sta. Maria della Salute) on his first visit to Venice in 1819 (T.B.CLXXV, f.67 *verso*), but the present drawing was no doubt itself a sketch made directly from the subject. It fits stylistically with the series of Venetian subjects made in 1840, especially in the use of pen and colour to provide detail. A similar view, showing S. Giorgio Maggiore in the distance, is in the collection of Mr and Mrs Paul Mellon. See No.227, where a comparison is drawn between the treatment of architecture in this drawing and in a Venetian watercolour hitherto dated to 1833.

For Colour Plate, see p.118

260

Venice: A storm 1840
watercolour, 218 × 318 mm
coll: William Quilter; sale, Christie, 8 April 1878 (240); Rev C.J. Sale, by whom bequeathed to B.M.1958-3-13-50

This study of a storm at Venice seems to belong to a group of drawings executed in a similar style, and all showing scenes of storm. The others are the Ruskin *Storm at Sunset* (Cambridge, Fitzwilliam Museum, 590); the

Storm approaching S. Giorgio and the Dogana (Lord Brooke); and perhaps the *Storm in the Piazzetta* (Edinburgh, Vaughan Bequest, 871). Drawings from the group have been assigned to 1833 rather than to 1840, but for no clear reason, except perhaps that the use of systematic hatching in the darker areas of these watercolours suggests an earlier date than does the looser, lighter wash of the roll sketchbook, T.B.CCCXV. Turner in fact used careful hatching in his watercolours until the end of his productive life (see R.A.1974 no.616). More specific evidence to associate the 'storm' drawings with 1840 is provided by the treatment of the architecture at the left of this subject, which is very similar to that of *The Grand Canal, looking towards the Dogana* (No. 259). There is, however, a slight sketch on a small sheet of blue paper, probably belonging to the early 1830s, which shows the Dogana and the Salute with a storm of rain (T.B. CCCXLI-183), and which may be connected with the 'storm' watercolours. It has a landscape study *verso*, not apparently Italian, and the sheet provides too little evidence to establish a date.

261

261

A raft and a rowing boat on a lake by moonlight ?1840
watercolour, 192 × 280 mm
inscr. *verso: Now from a . . .* [illegible]/
thrills [?] *. . .*/ *as the Moon descends* [?] *yet
Venice gleams of many winking lights*/*and like
the . . . sails when she wanes* [?]
T.B.CCCLXIV-334

If the word 'Venice' does appear, as conjectured, in the inscription on the back of this drawing it might be concluded that the lines refer in some way to the subject. Butlin (*Turner Watercolours*, 1962, No.21) points out similarities between this drawing and such Venetian studies as *Venice from Fusina* (T.B. CCCXVI-25, repr. Butlin, 1962, No.19). The drawing may show the Lagoon with a very faint indication of a campanile towards the right. Butlin, however, sees a suggestion of hills on the horizon, and observes that the view might be of one of the Swiss lakes. In that context the boats, and indeed the whole design, can be compared with the finished watercolour of the *Lake of Brientz by moonlight*, of about 1804 (now in a private collection, ex. Fawkes; repr. Finberg, *Farnley*, pl.XII). The drawing is dated here to 1840 in order to conform with the provisional dating of the Venetian watercolours. Butlin associates it with Turner's previous visit to Venice.

262

Small boats on a lake ?1840
watercolour, 245 × 307 mm
watermarked: *1828*
T.B.CCCLXIV-137

Probably a view on the Lagoon at Venice. This watercolour is rather different in character from the main groups of Venice subjects of 1840, and may belong to an earlier visit (compare No.261).
For Colour Plate, see p.127

263

Lake Nemi *c.*1840
watercolour with scraping-out,
347 × 515 mm
coll: J.E. Fordham; Sir John Fowler;
B.G. Windus; sale, Christie, 6 May 1899 (29)
bt Vokins; William Cooke; sale, Christie,
8 June 1917 (66); R.W. Lloyd, by whom
bequeathed to B.M.1958-7-12-444
engr: by R. Wallis, 1842, for Finden's *Royal
Gallery of British Art* (Rawlinson, Vol. II,
p.341, No.659)

Turner had made a view of Lake Nemi for Hakewill in about 1818, before his first visit to Italy. He made drawings of the lake on the spot in 1819, presumably in the *Albano, Nemi, Rome* sketchbook, T.B.CLXXXII, although it is difficult to be certain whether specific drawings show Nemi or Albano (e.g. ff.21 *verso* to 25) and in the *Gandolfo to Naples* sketchbook, T.B.CLXXXIV, e.g. ff.7 *verso* to 11.

Lake Nemi figures in Ruskin's catalogue of 'Effects of Light Rendered by Turner' (*Modern Painters*, Vol. I, p.263) where it is described as showing 'Afternoon of cloudless day, with heat', along with the *Oberwesel* from the same series of watercolours for Finden's *Royal Gallery* (R.A.1974 no.583). *Oberwesel* is signed and dated 1840. Compare the composition and technique of *Tancarville on the Seine* (No.264).

264

Tancarville on the Seine *c.*1840
watercolour, 344 × 477 mm
coll: drawn 'for a member of the Swinburne family'; Julia Swinburne; H.E. Hayman; Agnew, 1912; R.W. Lloyd, by whom bequeathed to B.M.1958-7-12-423

A rough sketch of the same view in body-colour on blue paper, made when Turner was working on the designs for the *Wanderings by the Seine*, 1834-5, is T.B.CCLIX-169. The whole composition is broadly stated in a colour-beginning, T.B.CCLXIII-17. Turner made rapid pencil sketches of the castle itself in the *Tancarville and Lillebonne* sketchbook, T.B.CCLIII, ff.46 *verso*, etc. Another view looking down on the castle from higher up the hill and further to the right is T.B.CCLIX-130 and was engraved in 1834 by R. Brandard for the *Seine* tour (Rawlinson No.459). CCLIX is a sketch of the castle from below.

The composition of this drawing has much in common with that of *Oberwesel*, dated

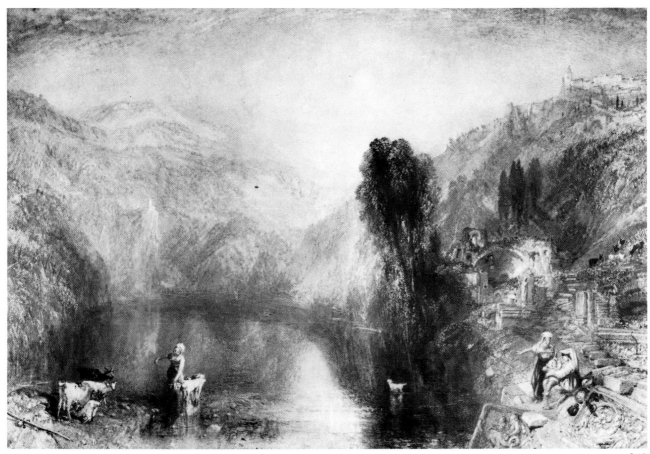

263

1840 (R.A.1974 no.583), and in its florid technique and overall golden colouring it can be grouped with the 'classical' watercolours of that year. See also *Lake Nemi*, No.263.
For Colour Plate, see p.130

265
Lausanne: Sunset *c.*1841
pencil and watercolour, 251 × 365 mm
T.B.CCCLXIV–350

Identified tentatively by Finberg as Lausanne, but subsequently renamed 'Thun', this water-colour must in fact be a view of Lausanne similar to those in the *Rhine, Flushing and Lausanne* sketchbook of about 1841 (T.B.CCCXXX, ff.12 *verso*, 13 *recto*, etc). The broad composition and free execution suggest that the drawing belongs to the group of Swiss drawings made by Turner in about 1841. The crowded foreground, like those of some of the finished views of 1842 (see Nos.271 and 286), and the degree of detail in the treatment of the sky, indicate that Turner may have intended this drawing as a preliminary study for a larger, finished work; it may have been

one of the 'specimen' drawings offered to Griffith (see No.281).
For Colour Plate, see p.130

266
A Swiss subject *c.*1841
watercolour, 244 × 312 mm approx.
T.B.CCCLXIV–217

Ruskin gave this drawing the title *Red Cliff*, but the view that it shows has not been identified.

267
Geneva: The Mole, with Savoy Hills 1841
pencil and watercolour, 228 × 295 mm
T.B.CCCXXXII–8

From the *Fribourg, Lausanne and Geneva* sketchbook used in 1841. This and the other views of Geneva shown here are typical of the colour studies Turner produced during his Swiss tour of 1841, though they have a style of their own and illustrate well his capacity to change his manner in response to different places. There are various rough pencil drawings of Geneva in sketchbooks in the Turner Bequest (see R.A.1964 no.616).

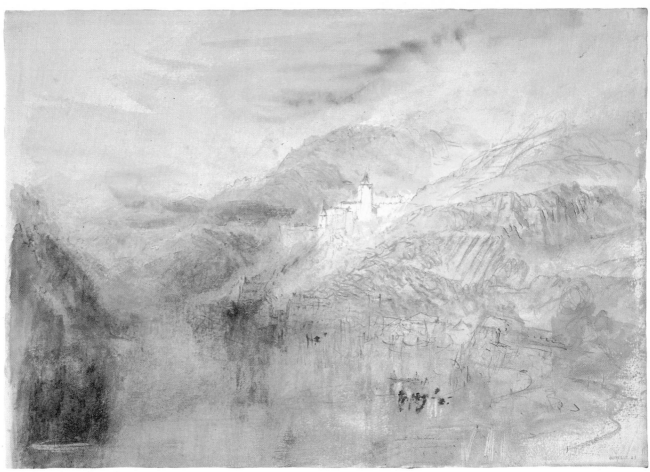

294 A view on the Rhine or Neckar, 1844

269

Turner had spent some time making sketches of the city when he was there in 1836 (see Finberg, 'With Turner in Geneva', *Apollo*, January 1925, pp.38–42).

268
Geneva: Sunset over the Jura 1841
pencil and watercolour, 227 × 293 mm
T.B.CCCXXXII–9
See No.267.

269
Fort l'Ecluse from the old walls of Geneva 1841
pencil and watercolour, 228 × 291 mm
T.B.CCCXXXII–11
See No.267.

270
Geneva 1841
pencil and watercolour with pen and red, yellow and brown colour, 228 × 292 mm
T.B.CCCXXXII–20
See No.267.

271
Fribourg 1841
pencil and watercolour, 232 × 335 mm
T.B.CCCXXXV–7

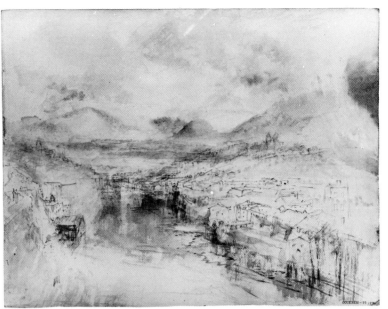

270

From a roll sketchbook apparently in use during Turner's stay in Switzerland in the summer of 1841 and recorded by Ruskin as containing '23 sketches of Fribourg, of which 15 are coloured and eight are pencil (or pencil with red ink)'. Finberg called the book *Freiburg* and spelt the name of the town somewhat erratically in his list of its contents (*Inventory*, Vol. II, pp.1059–60); but there is no doubt from Turner's drawings that they show Fribourg in Switzerland and not Freiburg in Germany. Although this sketch is less easy to identify than most of the others it seems likely that it also shows Fribourg: the towers that are visible, and the steep ravine on the right, correspond to features of the town. The drawing includes what appears to be a crowded social event, taking place by lamplight, in the foreground. Such features are typical of some of the finished watercolours that Turner made from his Swiss sketches (see *Zürich*, No.286) and he sometimes included them in the notes he took on the spot (compare *Bellinzona from the South*, No.280). This may indicate that when he added colour to the very slight pencil outline here he was thinking of using the subject for a more elaborate composition, though no other version of it is known. A late oil painting which similarly makes use of the crowd motif is the *Heidelberg* of about 1840–45 (R.A.1974 no.574).

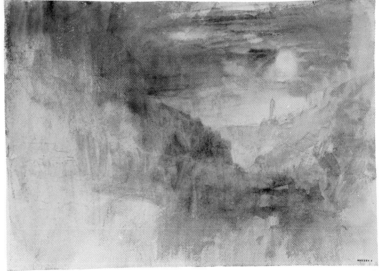

272

272
Fribourg: Moonlight 1841
pencil and watercolour, 321 × 332 mm
T.B.CCCXXXV–3

From the *Fribourg* sketchbook, in use on Turner's tour to Switzerland of 1841. For another view of the town at night see No.271.

273
A town on a hill: Moonlight 1841
pencil and watercolour, 228 × 292 mm
T.B.CCCXXXII–33

From the *Fribourg, Lausanne and Geneva* sketchbook watermarked 1841. This drawing has much in common with the view of Fribourg, No.271, and it may be that it also shows that town.

274
Martigny 1841
pencil and watercolour with pen and reddish-brown colour, 228 × 288 mm
T.B.CCCXXXII–23

From the *Fribourg, Lausanne and Geneva* sketchbook of 1841. The comparatively care-

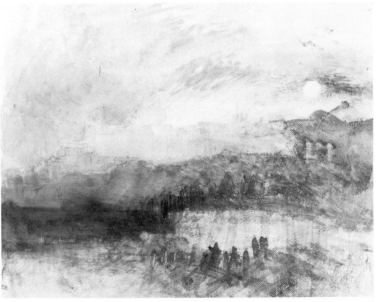

273

ful notation of the mountain peaks has been partly altered by Turner with colour to suggest a more exaggerated diagonal sweep downwards towards the right.

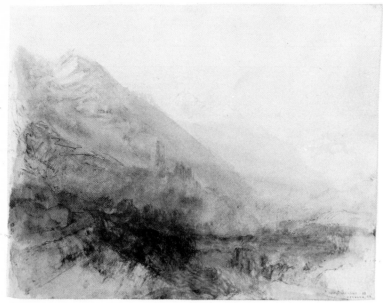

274

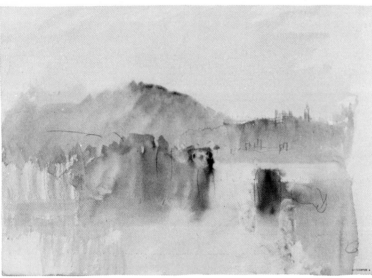

275

275
Lake Como: Yellow and grey *c.*1841
pencil and watercolour, 231 × 330 mm
watermarked: *1839*
T.B.CCCXXXVIII–4

From the *Como and Splügen* sketchbook.
Drawings such as this and the *Church Tower among Mountains* (No.305) belong to a category different from that of most of the Swiss watercolour studies of this period; their intention is not to evoke a complete landscape, but rather to suggest the mood of a scene with a minimal use of simple washes of colour. It is difficult to know whether they were made in front of some particular natural effect, or noted from memory immediately afterwards, or whether they were 'souvenirs' which may have been jotted down much later, more as a result of Turner's habitual activity with a brush than as a direct response to a specific occasion.

276
Mont Pilatus ?1841
watercolour, 228 × 292 mm
T.B.CCCXXXII–34

Turner here treats Mont Pilatus as the subject of an impromptu poem in the vein of some of his studies of the Rigi. Both in colouring and technique this drawing seems to be related to certain Venetian watercolours of 1840, e.g. Nos.237, 238.

277
A rainstorm over Lake Maggiore, seen from near Mogadino *c.*1841
pencil, watercolour and black, blue and brown chalks, 217 × 270 mm
T.B.CCCXXXVII–28

From the *Bellinzona, Sion &c* sketchbook, which does not seem to represent a coherent sequence, being apparently a collection of odd sheets kept in the covers of a roll sketchbook. The combination of watercolour with coloured chalks which characterizes this drawing occurs in a number of studies which seem to date from Turner's 1841 visit to Switzerland; see *Recess Bridge and Mont Pilatus*, No.278, for another example. Compare also the effect that Turner achieves with watercolour and pen in the more elaborate view of *Bellinzona from the Road to Locarno*, No.279.

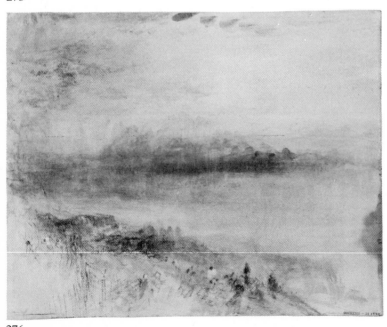

276

278

Recess Bridge and Mont Pilatus *c.*1841
watercolour and coloured chalks,
210 × 346 mm
inscr. lower right: *L 20* (?)
T.B.CCCLXIV–223

One of a small group of drawings probably
made in 1841 during Turner's visit to Lucerne
which use coloured chalks in a somewhat un-
characteristic way, instead of the usual
touches of pen. A number of pencil sketches
of Switzerland done at that date or possibly a
little later are touched with blue chalk or
crayon which is used to indicate water.
For Colour Plate, see p.79

279

Bellinzona from the road to Locarno
*c.*1841
pencil and watercolour with some pen,
228 × 287 mm
inscr. *verso*: *Bellinzona, No. 12; Mr Munro*
T.B.CCCXXXII–25

This watercolour was used as the basis for a
larger and more elaborate version of the sub-
ject which was executed for H.A.J. Munro in
1843 and is now in the Aberdeen Art Gallery
(R.A.1974 no.613). Turner made many
drawings of Bellinzona during his visits to
Switzerland and north Italy in the 1840s; a
pencil drawing of the town from a similar
viewpoint just to the right of the bridge is
T.B.CCCXLIV–423; its measurements are al-
most the same as those of this watercolour
and the two leaves may have been from the
same roll sketchbook. See also No.280.

280

Bellinzona from the south *c.*1841
pencil, watercolour with pen, 230 × 288 mm
T.B.CCCLXIV–343

Turner drew Bellinzona on numerous occa-
sions, especially during his summer in
Switzerland in 1841; see for example the
Bellinzona sketchbook, T.B.CCCXXXVI, and
the *Bellinzona, Sion &c* sketchbook, T.B.
CCCXXXVII. A panoramic view of *Bellinzona
from the road to Locarno* was made for Munro of
Novar in 1843; see No.279. This drawing is
an example of Turner's occasional suggestion
of a crowded foreground in a rapid water-
colour note (compare the view of *Fribourg*,
No.271).

281

Constance *c.*1841
watercolour, 244 × 309 mm
T.B.CCCLXIV–288

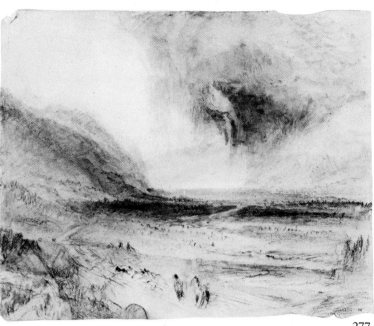

277

The basis for the large *Constance*, now in a
private collection, bought from Griffith by
Ruskin who listed it as No.8 of the set of ten
Swiss views of 1842, discussed in his *Epilogue*
to the Fine Art Society's Exhibitions of his
Turner drawings in 1878 and 1900 (see In-
troduction, p.19).
For Colour Plate, see p.141

282

The bridge over the Moselle at Coblenz
*c.*1841
watercolour with some coloured chalk,
248 × 347 mm
inscr. lower right: *Cob 23* (?)
T.B.CCCLXIV–336

One of Turner's favourite views, along with
Ehrenbreitstein, which is visible in the back-
ground of this composition. A more elaborate
version of the subject is CCCLXIV–286 (No.
283).

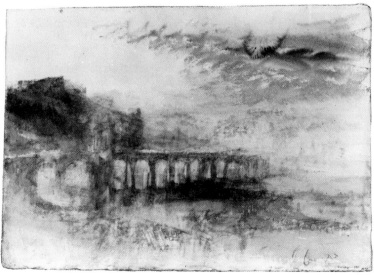

282

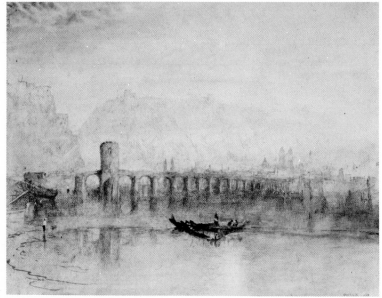

283

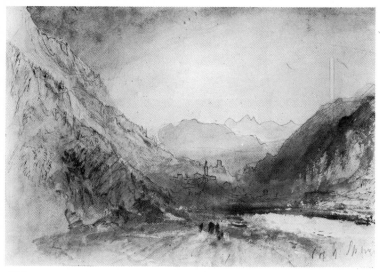

284

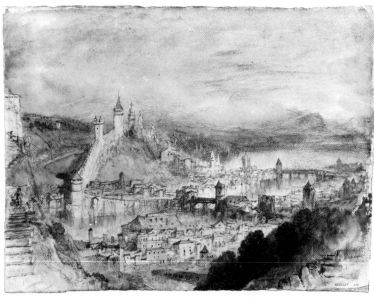

285

283

Coblenz *c*.1841
watercolour, 234 × 294 mm
inscr. *verso*: *J. Ruskin Jun. Esqre*
T.B.CCCLXIV–286

A large watercolour based on this 'specimen' drawing was executed in 1842 and bought by Ruskin, who listed it as No.7 of the Swiss views of that year (see No.281), and subjected the composition to an extended analysis in his *Elements of Drawing* (1860, pp.252–4). Turner's first sketch of the bridge, with Ehrenbreitstein beyond, is a pencil outline on ff.6 *verso* to 7 *recto* of the *Rhine* sketchbook of 1817 (T.B.CLXI). He visited the town again during his continental tours of 1826 and 1834, thereafter he must frequently have passed through it on his way from Holland to Switzerland, and pencil studies of this city and bridge occur in several sketchbooks. Another watercolour sketch of it is No.282.

284

The Pass of Splügen *c*.1841
pencil and watercolour with pen and red and yellow ink, 225 × 329 mm
inscr. lower right: *P of of* [sic] *Splugen*
T.B.CCCXXXVI–11

Splügen was the subject of one of the ten Swiss watercolours of 1842, the first in Ruskin's list, bought by H.A.J. Munro of Novar and now in a private collection, U.S.A. The drawing for it is T.B.CCCLXIV–277 (see R.A.1974 no.604). This subject in fact shows a different view; but Turner has employed a very similar composition, with a road receding into the distance along the central axis and steep diagonals on either side. The sheet was associated by Finberg with the *Bellinzona* sketchbook of 1841, and it seems most likely that Turner made the drawing on a tour of that year, although it is very similar in style to the drawings of Heidelberg and elsewhere of 1844 (see Nos.293–299).

285

Lucerne from the walls *c*.1841
watercolour and pencil, 232 × 304 mm
inscr. *verso*: *J. Ruskin junr Esqre* and *17*
T.B.CCCLXIV–290

The basis for the large watercolour bought by Ruskin in 1842 and now in the Lady Lever Art Gallery, Port Sunlight (see R.A. 1974 no.607). Pencil sketches of Lucerne and its medieval walls occur in the *Lucerne and Berne* sketchbook of 1841 (T.B.CCCXXVIII, ff.3 *verso*, 4 *recto* ff.). Although this study was evidently one of the 'specimens' presented to

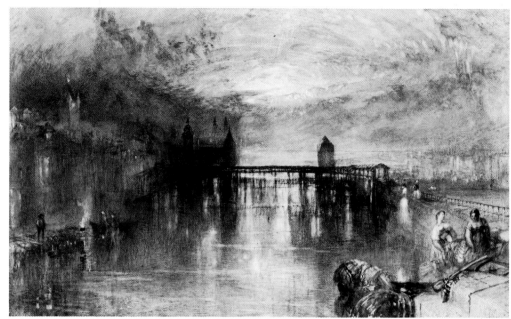

292

Thomas Griffith in the winter of 1841–2, it
appears to have been worked up on a pencil
drawing made on the spot, and this observa-
tion is possibly applicable to the other 'speci-
men' drawings (see Nos.283, 284). The paper
on which they are made is that of the roll
sketchbook which Turner used in Switzer-
land and on many of his other tours in the
late 1830s and 1840s.

286
Zürich *c*.1842
watercolour, 300 × 456 mm
coll: Munro of Novar; sale, Christie, 6 April
1878 (87); J. Irvine Smith; Agnew, 1907; Sir
George Drummond; sale, Christie, 26 June
1919 (129); C. Morland Agnew; R.W. Lloyd,
1924, by whom bequeathed to B.M.
1958–7–12–445

This watercolour was worked up as one of the
ten drawings sold on commission through
Thomas Griffith in 1842 (No.10 in Ruskin's
list, *Epilogue*, p.364), from the watercolour
sketch T.B.CCCLXIV–291. Ruskin described it
as 'a Zürich, with white sunshine in the dis-
tance'. In *Modern Painters* he referred to the
whole group as 'not to be described by any
words . . . presenting records of lake effect on
a grander scale, and of more imaginative
character, than any other of his works' (Vol. I,
p.361).
 This and the *Splügen* (private collection,
U.S.A.) were the most coveted by Ruskin
on his visit to Munro's collection on 13 April
1844. A watercolour sketch of a similar view
with yellower light and more human activity
in the foreground is CCCLXIV–289 (No.291).
For Colour Plate, see p.129

287
Fluelen on the Lake of Lucerne *c*.1842
pencil and watercolour with some pen,
240 × 293 mm
inscr. *verso*: *Altorf; Windus*
T.B.CCCLXIV–381

The inscription on the back of this drawing
suggests that it was used as the pattern for a
finished watercolour executed for Turner's
regular patron, B.G. Windus, and this is
presumably identifiable with *Fluelen from the
Bay of Uri*, which later belonged to the Rev C.
Upham Barry and Ralph Brocklebank and is
now in the Cleveland Museum of Art. A
similar view of Fluelen, in windier weather, is
in the Fitzwilliam Museum, Cambridge (585;
given by Ruskin in 1861).

288
Near Bellinzona *c*.1843
pencil and watercolour with pen and red ink,
226 × 325 mm
T.B.CCCXXXVI–13

This drawing, and Nos.289 and 290 are exe-
cuted in a palette dominated by greyish-
mauve and ochre, heightened with red ink
applied with a pen; they form part of a group
of Swiss subjects rather different in mood
from those usually associated with the 1841
tour, and seem closer in some respects,
especially in their narrow colour range and
extensive use of pen, to the Rhine and
Neckar drawings of 1844 (see Nos.293–9). It
is possible, therefore, that they also belong to
that year, or perhaps to 1843. The view of
The Devil's Bridge in the Fitzwilliam Museum
(586) may also belong to this group.

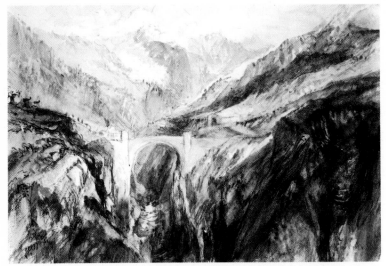

289

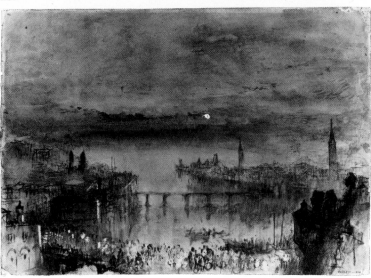

291

289

A bridge over a river in a gorge, Switzerland *c.*1843
pencil and watercolour with pen and red and brown ink and some scraping-out,
224 × 327 mm
T.B.CCCXXXVI–17

See No.288. This watercolour may be connected with the pencil drawings on T.B. CCCXLI–17 *recto* and *verso.*

290

?The Via Mala *c.*1843
pencil and watercolour with some scratching-out, 244 × 305 mm
T.B.CCCLXIV–362
See No.288.

291

Zürich 1843
watercolour, 232 × 326 mm
inscr. *verso* (not in Turner's hand):
Windus/Zurich
T.B.CCCLXIV–289

A watercolour based on this drawing was executed in about 1845 and purchased by Windus. Turner had already made a large view of Zürich for Munro of Novar in 1842, one of the ten Swiss watercolours of that year listed by Ruskin (No.286).

The drawing has suffered a little from exposure to light.

292

Lucerne: Moonlight 1843
watercolour, 290 × 476 mm
coll: Munro of Novar; sale, Christie, 2 June 1877 (34); J. Irvine Smith; R.E. Tatham; by whom bequeathed to W.G. Gibbs; Agnew 1920; R.W. Lloyd, by whom bequeathed to B.M.1958–7–12–446.

In his *Epilogue* to the catalogue of the Fine Art Society Exhibitions, 1878 and 1900, Ruskin talks of the five watercolours which Turner executed on commission in 1843, three of which were bought by H.A.J. Munro of Novar: '(I forget at this moment Munro's third.) I think it was the Zurich by moonlight, level over the rippling Limmat; a noble drawing but not up to the mark of the rest: Thornbury's list of drawings in Munro's collection (Vol. II, p.396) gives 'Lucerne (or Zurich) – Moonlight.' Finberg tentatively identified this with the *Lucerne: Moonlight.*

A watercolour of a similar though not identical view of Lucerne is T.B.CCCXLIV–

324; another from a roll sketchbook *c.*1841 is in the Art Institute of Chicago (repr. Gowing, 1961, p.62).

293

View on the Rhine 1844
pencil and watercolour with pen and red, yellow and blue ink, 228 × 329 mm
inscr. upper centre: *Blue*, and upper right: *Town against the sky* (?)
T.B.CCCXLIX–20

From the *Rheinfelden* sketchbook watermarked 1844 and used in that year (see Nos. 294 and 295).

294

A view on the Rhine or Neckar 1844
pencil and watercolour with pen and red ink, 229 × 328 mm
T.B.CCCXLIX–27

From the *Rheinfelden* sketchbook (see No. 293).
For Colour Plate, see p.152

295

View of Rheinfelden (?) 1844
pencil and watercolour, 229 × 327 mm
T.B.CCCXLIX–28

From the *Rheinfelden* sketchbook (see No. 293).

296

Heidelberg: Looking west, with a low sun 1844
pencil and watercolour with some red and yellow ink, 228 × 327 mm
T.B.CCCLII–9

This and Nos.297, 298 and 299 are from the *Heidelberg* sketchbook, used by Turner on what seems to have been his last tour in Germany and Switzerland. The book is watermarked 1844, like a group of others evidently used on the same journey: the *Lucerne* (CCCXLV), *Thun, Interlaken, Lauterbrunnen and Grindelwald* (CCCXLVII), *Rheinfelden* (CCCXLIX; see Nos.294–6), *Olten and Basel* (CCCL) and *Rhine and Rhine castles* (CCCLII) sketchbooks. Finberg quotes two letters (*Life*, 1961, p.402) which show that Turner made the journey in August and September of 1844. Turner had visited Heidelberg often before, and produced a number of finished watercolours of the city in the late 1830s or early 1840s; the oil painting in the Turner Bequest (Tate Gallery; R.A.1974 no.588) shows a view from very much the same position as this drawing, looking west along the Neckar from above the castle.

297

299

297

Heidelberg: The city seen from the opposite bank of the Neckar 1844
pencil and watercolour, 230 × 328 mm
T.B.CCCLII–17

From the *Heidelberg* sketchbook of 1844 (see No.296). Finberg thought that this drawing showed Fribourg, but there seems to be no doubt that the view is of Heidelberg.

298

Heidelberg: Looking down on the city and the castle 1844
pencil and watercolour with some pen and red and yellow ink, 228 × 327 mm
T.B.CCCLII–15

From the *Heidelberg* sketchbook of 1844; see No.296. A similar view of the castle, in yellow with a touch of rose-pink, is CCCLII–8.

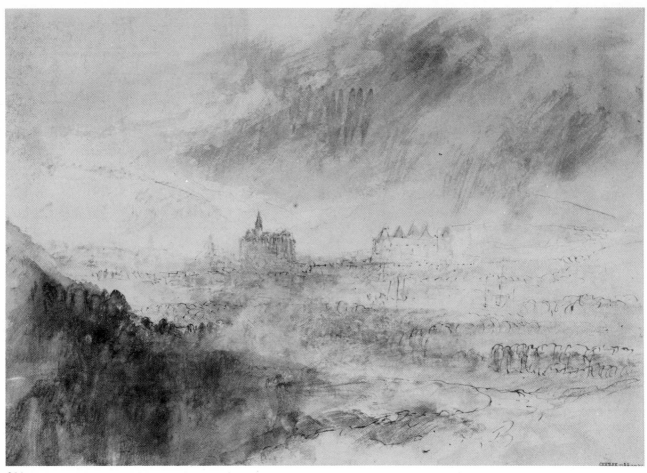

301

299
Heidelberg: The castle from the river
1844
pencil and watercolour, 227 × 327 mm
T.B.CCCLII–13

From the *Heidelberg* sketchbook of 1844; see No.196.

300
Cliffs on the coast of France 1845
pencil and watercolour, 230 × 329 mm
T.B.CCCLIX–14

Turner visted Dieppe, Eu and Tréport in September 1845; it was his last continental tour, and produced at least five sketchbooks, all of the 'roll' type which he more and more favoured during the later years of his life: the *Ambleteuse and Wimereux* sketchbook (CCCLVII); the *Boulogne* sketchbook (CCCLX) and the *Dieppe and Kent* sketchbook (CCCLXI) which, though watermarked 1842, contains a drawing dated 'Sept 11 1845'. Other late sketchbooks were probably also used in that year, in Margate, Folkestone and the neighbouring country; though the *Kent* sketchbook (CCCLXIII) which Finberg dates to about 1845–6 almost certainly belongs to an earlier period, perhaps in the late 1820s.

The majority of Turner's drawings in the late roll sketchbooks are very broad and often so slight as to be indecipherable. The series which he produced at Eu and Tréport are for the most part comparatively elaborate, with evocations of atmospheric effect which sometimes approach those of the Venetian series of 1840.

301
Eu with the cathedral and Château de Louis Philippe 1845
pencil and watercolour with pen and red, blue and yellow ink, 230 × 332 mm
T.B.CCCLIX–15

From the *Eu and Tréport* sketchbook of 1845. For an anecdote describing Turner's invitation to dine with Louis Philippe at Eu, see Finberg, *Life*, 1961, pp.410–11, and R.A. 1974 no.632.

302
Interior of a church (?Eu Cathedral) 1845
pencil and watercolour, 328 × 231 mm
T.B.CCCLIX–7

Very similar to CCCLIX–10. Both drawings are assigned by Finberg to the *Eu and Tréport* sketchbook of 1845. Turner's response to a large ecclesiastical interior here is surprisingly similar to watercolours in the *Naples, Rome*

Colour Studies sketchbook of 1819 (T.B. CLXXXVII, ff.52, 53, see R.A.1974 no.218).

303
Rain and sunshine over the sea *c.*1845
watercolour, 290 × 437 mm
T.B.CCCLXV–19

Similar in subject to CCCLXV–20 (R.A.1974 no.634). On the evidence of a watermark dated 1842 in the paper of one drawing in this series (No.11) the whole group may be assigned to a period shortly after that date. Their uniformly free, often rather rough, technique, and the regular size of the sheets, suggest that they were executed together.

304
Stormy sky over the sea *c.*1845
watercolour, 237 × 336 mm
T.B.CCCLVII–12

From the *Ambleteuse and Wimereux* sketchbook of 1845 (see No.300).

305
A church tower among mountains
?*c.*1846
watercolour, 231 × 323 mm
T.B.CCCXXXIX–3

From the *Mountain Fortress* sketchbook, which is watermarked 1839. This drawing is extremely free, many of its principal features having been put in with the fingers, which, in the case of the central vertical, were evidently licked first. This kind of drawing, which generalizes a Swiss scene into the simplest and most fleeting form, was very possibly made in England some time after the tour it recalls. It has the character of one of Turner's very latest drawings and may possibly be related to the view of *Pallanza* (R.A. 1974 no.615) which has been dated to about 1845 but may well have been executed even later, since it closely resembles in technique and palette a *Lake of Geneva* (R.A.1974 no. 616) which is watermarked 1846. Both these drawings, though they have the status of large, finished watercolours, are handled with a freedom unlike comparable works known to date from the years up to 1845. Other studies in the *Mountain Fortress* sketchbook have a basis of pencil drawing which may have been made on the continent in 1844.

The same subject from a slightly different position appears on f.9 of the same sketchbook.

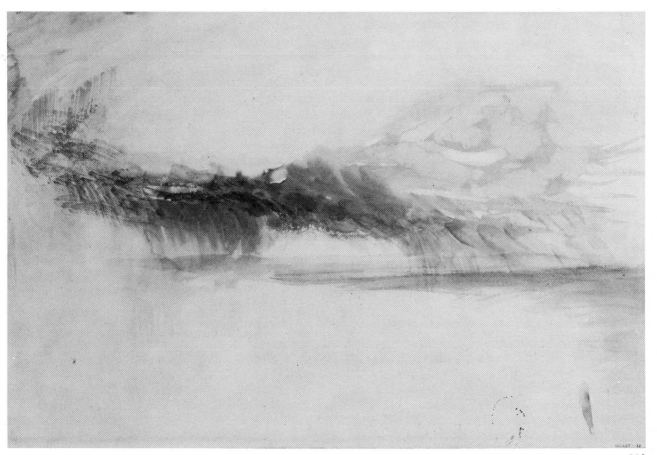

Select Bibliography

Including Publications referred to in
Abbreviated Form in the Catalogue Entries

Edmund Burke,
A Philosophical Enquiry into the Origin
of our Ideas of the Sublime and Beautiful, 1757

Sir Joshua Reynolds,
Discourses delivered to Students of the Royal
Academy,
ed. Roger Fry, 1905.

John Ruskin, *Modern Painters*, 5 vols. 1843–60;
2nd ed., 6 vols. 1888.

John Burnet,
Turner and his Works,
with a 'Memoir' by Peter Cunningham, 1852;
2nd ed., 1859.

John Ruskin,
Notes on the Turner Gallery
at Marlborough House 1856, 1857;
Library Edition, Vol. XIII, 1904.

John Ruskin,
The Elements of Drawing
in three Lectures to Beginners, 1857.

Walter Thornbury,
The Life of J.M.W. Turner R.A.,
2 vols., 1862; 2nd ed. in one volume, 1876.

Henry Quilter,
Sententiae Artis, First Principles of Art
for Painters and Picture Lovers, 1886.

John Ruskin,
Lectures on Landscape,
Delivered at Oxford in Lent Term, 1871, 1897

Frederick Wedmore,
A Descriptive Catalogue of Drawings, Prints,
Pictures and Porcelain . . . in the Turner House,
Penarth, 1900.

Sir Walter Armstrong,
Turner, 2 vols., 1902.

W. G. Rawlinson,
The Engraved Work of J.M.W. Turner, R.A.,
2 vols., 1908 and 1913.

A.J. Finberg,
Complete Inventory of the Drawings
of the Turner Bequest, 2 vols., 1909.

A.J. Finberg,
Turner's Sketches and Drawings,
1910; paperback reissue with an
introduction by Lawrence Gowing, 1968.

A.J. Finberg,
Turner's Water-Colours at Farnley Hall,
n.d. (1912).

D.S. MacColl,
National Gallery, Millbank: Catalogue;
Turner Collection, 1920.

A. J. Finberg,
The History of Turner's Liber Studiorum
with a New Catalogue Raisonné, 1924;
this retains the numbering of
W.G. Rawlinson's
Turner's Liber Studiorum, 1878.

A.J. Finberg,
In Venice with Turner, 1930.

A.J. Finberg,
The Life of J.M.W. Turner, R.A., 1939;
2nd ed., 1961.

Martin Davies,
National Gallery Catalogues:
The British School, 1946.

Martin Butlin,
Turner Watercolours, 1962
and subsequent editions.

Adrian Stokes,
'The Art of Turner (1775–1851)', in
Painting and the Inner World, 1963.

Jerrold Ziff,
'Turner and Poussin', in
Burlington Magazine, Vol. CV, 1963,
pp. 215–21.

Jerrold Ziff,
'"Backgrounds, Introduction of Architecture
and Landscape": a Lecture' in
Journal of the Warburg and Courtauld Institutes,
Vol. XXVI, 1963, pp. 124–47.

Michael Kitson,
Turner, 1964.

John Rothenstein and Martin Butlin,
Turner, 1964.

John Gage,
'Turner and the Picturesque', in
Burlington Magazine, Vol. CVII, 1965,
pp. 16–26, 75–81.

Jack Lindsay,
J.M.W. Turner, His Life and Work, 1966.

Lawrence Gowing,
Turner: Imagination and Reality, 1966.

Gerald Finley,
'Turner: an Early Experiment with Colour Theory', in *Journal of the Warburg and Courtauld Institutes*, Vol. xxx, 1967, pp.357–66.

John Gage,
'Turner's Academic Friendships: C.L. Eastlake', in *Burlington Magazine* Vol. cx, 1968, pp. 677–85.

Luke Herrmann,
Ruskin and Turner, 1968.

John Gage,
Colour in Turner, 1969.

Graham Reynolds,
Turner, 1969.

Graham Reynolds,
'Turner at East Cowes Castle', in *Victoria & Albert Museum Yearbook*, Vol. i, 1969, pp. 67–79.

Hardy George,
'Turner in Venice', in *Art Bulletin*, Vol. liii, 1971, pp.84–7.

Gerald Wilkinson,
Turner's Early Sketchbooks, 1972.

Gerald Finley,
'Turner's Colour and Optics: a "New Route" in 1822', in *Journal of the Warburg and Courtauld Institutes*, Vol. xxxvi, 1973, pp.385–90.

A.G.H. Bachrach,
Turner and Rotterdam 1817, 1825, 1841, 1974.

John Gage,
'Turner and Stourhead: The Making of a Classicist?', in *Art Quarterly*, Vol. xxxvii, 1974, pp.29–52.

Gerald Wilkinson,
The Sketches of Turner R.A., 1802–20, 1974.

John Gage,
Turner and Watercolour, Arts Council Touring Exhibition, 1974.

Michael Kitson,
Turner Watercolours from the Collection of Stephen Courtauld, Courtauld Institute Galleries, 1974.

Royal Academy,
Turner Exhibition Catalogue, 1974–5.

Chronology

1775
23 April: Joseph Mallord William Turner born at 21 Maiden Lane, Covent Garden, London, the son of a barber and wig-maker.

1786
Probably went to live with his uncle at Brentford, Middlesex, in this year.

1787
First signed and dated drawings, some apparently made in and around Margate.

1789
Probable date of first extant sketchbook from nature made in London and the neighbourhood of his uncle's house in Sunningwell, near Oxford.
11 December: Admitted as a student of the Royal Academy Schools after a term's probation. Probably began to study with the watercolour painter of architectural subjects Thomas Malton at about the same time.

1790
First exhibit, a watercolour of *The Archbishop's Palace, Lambeth*, at Royal Academy.

1791
September: Sketched at Bristol, Bath, Malmesbury, etc.

1792
Summer: First sketching tour in South and Central Wales.

1793
27 March: Awarded the 'Greater Silver Pallet' for landscape drawing by the Society of Arts.

1794
May: Publication of first engraving from one of his drawings.
His watercolours at the Royal Academy attract the attention of the press for the first time.
First Midland tour, largely to make drawings for engraving.
His employment in winter evenings, together with Girtin and others, by Dr Monro to copy drawings by J.R. Cozens and other artists, probably began in this year; it lasted for about three years.

1795
Tour in South Wales *c.*June–July and the Isle of Wight *c.*August–September, in part to execute private commissions for topographical drawings as well as for engravings.

1796
First oil painting at the Royal Academy.

1797
Exhibited two watercolours of Salisbury Cathedral, the first of nearly thirty commissions from Sir Richard Colt Hoare between now and 1805.
Summer: First tour in the North of England, including the Lake District.

1798
Summer: Trip to Malmesbury, Bristol and thence to North Wales.

1799
April: Recommended to Lord Elgin to make topographical drawings at Athens. Failed to agree on salary.
August–September: Stayed for three weeks with William Beckford at Fonthill.
(?) September–October: To Lancashire and North Wales.
4 November: Elected an Associate of the Royal Academy.
November–December: Took rooms at 64 Harley Street.

1800
Some of the verses appended to titles of pictures in the Royal Academy catalogue probably by Turner himself for the first time.
27 December: Turner's mother admitted to Bethlem Hospital.

1801
June–August: First tour of Scotland, returning through the Lakes.

1802
12 February: Elected a full member of the Royal Academy.
15 July–October: First visit to France and Switzerland; sketches and notes after pictures in the Louvre.

1804
15 April: Death of Turner's mother, probably at Bethlem Hospital.
April: Completed a gallery at 64 Harley Street for the exhibition of twenty to thirty of his own works.
Had a *pied-à-terre* on the Thames, at Sion Ferry House, Isleworth, by this year or 1805.

1806
Two oils at the first exhibition of the British Institution. Late summer and autumn: Stayed at Knockholt, Kent, with W.F. Wells, who suggested the *Liber Studiorum* project (see Nos. 24, 35).
*c.*October: Took a house at 6 West End, Upper Mall, Hammersmith, retaining his London home.

1807
11 June: First volume of *Liber Studiorum* published.
2 November: Elected Professor of Perspective at the Royal Academy.

1808
July (?): Stayed at Sir John Leicester's seat, Tabley Hall, Cheshire. Also sketched on the River Dee.

1809
Summer: First visit to Petworth House, the home of Lord Egremont, probably this year.

1810
Late summer: First recorded visit to Walter Fawkes of Farnley Hall, Yorkshire, repeated nearly every year till 1824.
Before 12 December: His town address changed to 47 Queen Ann Street West, round the corner from 64 Harley Street.

1811
7 January: First lecture as Professor of Perspective of the Royal Academy (see No.42).
July–September: Tour of Dorset, Devon, Cornwall and Somerset in connection with W.B. Cooke's *Picturesque Views of the Southern Coast of England*, a long series of topographical engravings issued in parts 1814–26.
Gave up Hammersmith home, and had temporary residence at Sun Ferry House, Isleworth, while building his house at Twickenham.

1812
First quotation in the Royal Academy catalogue from the 'Fallacies of Hope', a dis-

jointed series of passages of verse composed by Turner to amplify the titles of exhibited pictures.

1813
Solus (later Sandycombe) Lodge, Twickenham, completed from his designs.
Summer: Toured Devon.

1816
July–September: Visited Farnley Hall and travelled in the north of England, in part collecting material for Whitaker's *History of Richmondshire* (see No.55).

1817
10 August–*c.*15 September: First visit to Belgium, the Rhine between Cologne and Mainz, and Holland. Returned September– early December via County Durham, and stayed at Farnley Hall. Executed the series of fifty-one Rhine views acquired by Fawkes (see No.48).

1818
Commissioned to do watercolours of Italian subjects after drawings by James Hakewill for Hakewill's *Picturesque Tour in Italy*.
October–November: Visited Edinburgh in connection with Walter Scott's *The Provincial Antiquities of Scotland*.

1819
March: Eight of his oils on view in Sir John Leicester's London gallery; also in subsequent years.
April–June: Sixty or more watercolours on view in Walter Fawkes's London house, and again in 1820.
August–1 February 1820: First visit to Italy: Turin, Como, Venice, Rome, Naples; returned from Rome via Florence, Turin and the Mont Cenis pass.

1820
Enlarged and transformed his Queen Ann Street house, building a new gallery 1819–21.

1821
Late summer or autumn: Visit to Paris, Rouen, Dieppe, etc.

1822
1 February–August: A number of watercolours included in exhibition organised by the publisher W.B. Cooke, and again in 1823 and 1824.
August: Visited Edinburgh for George IV's State Visit, going by sea up the east coast.

1823
Sketched along the south-east coast.
The first plates of the mezzotint series *The Rivers of England* published; plates continued to appear until 1827.

1824
Summer and autumn: Toured east and south-east England.

1825
Possible date of the 'Little Liber' mezzotints (see No.88).
28 August: Set out on tour of Holland, the Rhine and Belgium.
25 October: Death of Walter Fawkes.

1826
The series of *Picturesque Views in England and Wales* begun for Charles Heath.
The Ports of England mezzotints issued this year and in 1827 and 1828.
10 August–early November: Visited the Meuse, the Moselle, Brittany and the Loire.
Commissioned by Samuel Rogers to illustrate his poem *Italy* (see No.114).

1827
18 June: Death of Lord de Tabley (Sir John Leicester). Late July–September: Stayed with John Nash at East Cowes Castle, Isle of Wight, probably returning via Petworth, where he was a regular visitor until 1837.

1828
January–February: Turner's last lectures as Professor of Perspective.
August–February 1829: Second visit to Italy: Paris, Lyons, Avignon, Florence, Rome, returning via Loreto, Ancona, Bologna, Turin, Mont Cenis, Mont Tarare (see No.147) and Lyons.

1829
Early June–18 July: About forty watercolours for the *England and Wales* engravings exhibited at the Egyptian Hall; some later shown at Birmingham.

August–early September: Visited Paris, Normandy and Brittany.
21 September: Death of Turner's father.

1830
Late August–September: Toured the Midlands.

1831
July–September: Toured Scotland, staying at Abbotsford in connection with his illustrations to Scott's poems (see No.178).

1832
March: Twelve illustrations to Scott exhibited at Messrs. Moon, Boys and Graves, Pall Mall; further watercolours were shown there in 1833 and 1834.

1833
First volume of *Turner's Annual Tour* published: *Wanderings by the Loire*.
August: Visited Paris; it was probably on this occasion that he went to see Delacroix.
September: Almost certainly in Venice, travelling via the Baltic, Berlin, Dresden, Prague and Vienna.

1834
Rogers's *Poems* published with vignettes by Turner.
Second volume of *Turner's Annual Tour* published: *Wanderings by the Seine*.
Illustrations to Byron's poems exhibited at Colnaghi's.
Late July: Set off on a tour of the Meuse, Moselle and Rhine.
Winter: Four of his early oils on view at the Society of British Artists.

1835
Third volume of *Turner's Annual Tour* published: *Wanderings by the Seine*.

1836
Summer: Toured France, Switzerland and the Val d'Aosta with H.A.J. Munro of Novar.
October: Ruskin's first letter to Turner, enclosing a reply to an attack in *Blackwood's Magazine*.

1837
One oil in the British Institution 'Old Masters' Exhibition.
11 November: Death of Lord Egremont.

28 December: Resigned post of Professor of Perspective.

1840
22 June: Met Ruskin for the first time.
Early August–early October: Third visit to Venice, going via Rotterdam and the Rhine and returning through Munich and Coburg.

1841
August–October: Visited Switzerland: Lucerne, Constance and Zurich.
Winter: showed his agent Thomas Griffith, fifteen 'specimen' subjects of Swiss views, from which finished watercolours were to be made on commission.

1842
August–October: Visited Switzerland.

1843
May: Publication of the first volume of Ruskin's *Modern Painters*, intended largely as a defence of Turner.

1844
*c.*August–early October: Visited Switzerland, Rheinfelden, Heidelberg and the Rhine.

1845
Walhalla shown at the 'Congress of European Art' at Munich.
May: Short visit to Boulogne and neighbourhood.
14 July: As eldest Academician was chosen to carry out duties of President during Shee's illness.
September–October: Visit to Dieppe and the coast of Picardy (his last trip abroad).

1846
Last firm date for a finished watercolour (see No.305). Took a cottage on the corner of Cremorne Road and Cheyne Walk, Chelsea, at about this time.

1848
January. One painting, a view in Venice, hung in the National Gallery to represent the Vernon Gift.

1851
No works at the Royal Academy.
19 December. Died at his cottage, 119 Cheyne Walk, Chelsea. Buried at St. Paul's on 30 December.

Index

This index lists place-names only, together
with the names of the four principal
authors for whom Turner made illustra-
tions. Places in England are listed
separately; those in Scotland, Wales,
France, Belgium, Germany, Switzerland
and Italy will be found listed under the
names of the respective countries. The
numbers refer to exhibition catalogue
entries.